In Her
Own Image

Women Working in the Arts

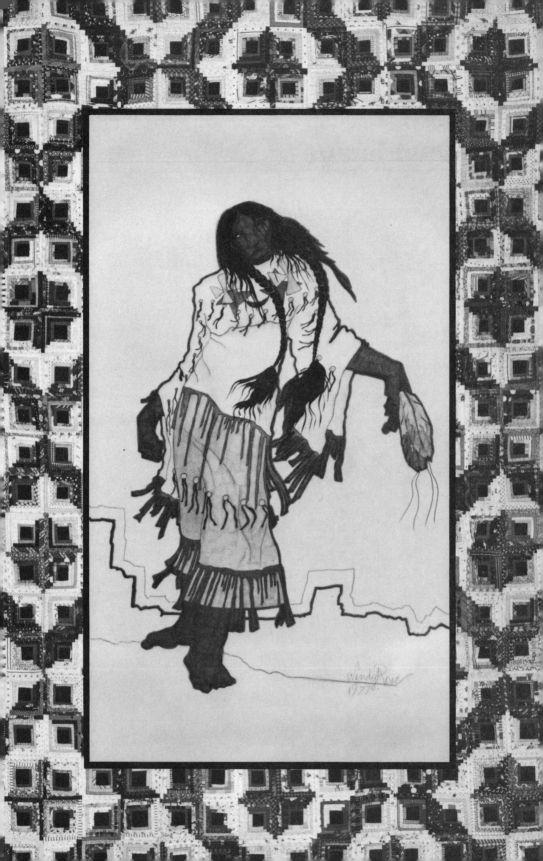

In Her Own Image

Women Working in the Arts

Elaine Hedges
Ingrid Wendt

The Feminist Press

NEW YORK

Distributed by The Talman Company, Inc., 150 Fifth Avenue, New York, NY 10011.

First edition, second printing

Library of Congress Cataloging-in-Publication Data

Main entry under title:
In her own image, women working in the arts.
 Includes bibliographical references and index.
 Summary: An anthology of visual and literary works by and about women artists and authors.
 1. Feminism and the arts—Addresses, essays, lectures. 2. Arts—Addresses, essays, lectures. 3. Women artists—Addresses, essays, lectures. [1. Women artists. 2. Women authors. 3. Feminism and the arts.] I. Hedges, Elaine. II. Wendt, Ingrid, 1944–
NX180.F415 700 79-17024
ISBN 0-912670-62-2 (pbk.)

Cover: *Portrait of the Artist with Two Pupils, Mlle. Gabrielle Capet (1761–1818), and Mlle. Carreaux de Rosemond (d. 1788),* by Adelaide Labille-Guiard. Reproduced with permission of the Metropolitan Museum of Art. (Gift of Julia A. Berwind, 1953.)

Frontispiece: *Log Cabin Quilt: Barn Raising,* by Mary Fish, 1879; from the Shelburne Museum, Inc., Shelburne, Vermont. Foreground: *Ghost Dance Woman,* by Wendy Rose, 1976; from a private collection, courtesy of the owner.

Table of Contents

167 **THREE: Their Own Images**
 Definitions and Discoveries

List of Plates

Publisher's Acknowledgments

EARLY IN 1973, Mariam Chamberlain and Terry Saario of the Ford Foundation spent one day visiting The Feminist Press on the campus of the State University of New York, College at Old Westbury. They heard staff members describe the early history of The Feminist Press and its goal—to change the sexist education of girls and boys, women and men, through publishing and other projects. They also heard about those books and projects then in progress; they felt our sense of frustration about how little we were able to do directly for the classroom teacher. Advising us about funding, Terry Sarrio was provocative. "You need to think of yourselves," she said, "in the manner of language labs, testing and developing new texts for students and new instructional materials for teachers." Our "language" was feminism, our intent to provide alternatives to the sexist texts used in schools. The conception was, in fact, precisely the one on which the Press had been founded.

Out of that 1973 meeting came the idea for the *Women's Lives / Women's Work* project. This project, which would not officially begin for more than two years, has allowed us to extend the original concept of The Feminist Press to a broader audience.

We spent the years from 1973 to 1975 assessing the needs for a publication project, writing a major funding proposal, steering it through two foundations, negotiating with the Webster Division of McGraw-Hill, our co-publisher. We could not have begun this process without the advice and encouragement of Marilyn Levy of the Rockefeller Family Fund, from which we received a planning grant in 1973. For one year, Phyllis Arlow, Marj Britt, Merle Froschl, and Florence Howe surveyed the needs of teachers for books about women, reviewed the sexist bias of widely used history and literature texts, and interviewed editorials staffs of major educational publishers about their intentions to publish material on women. The research accumulated provided a strong case for the grant proposal first submitted to the Ford Foundation in the summer of 1974.

During the winter of 1974–75, Merle Froschl, Florence Howe, Corrine Lucido, and attorney Janice Goodman (for The Feminist Press) negotiated a co-publishing contract with McGraw-Hill. We could not have proceeded without the strong interest of John Rothermich of McGraw-Hill's Webster Division. Our co-publishing agreement gives control over editorial content and design to The Feminist Press; McGraw-Hill is responsible for distribution of the series to the high

school audience, while The Feminist Press is responsible for distribution to colleges, bookstores, libraries, and the general public.

In the summer of 1975, the final proposal—to produce for copublication a series of twelve supplementary books and their accompanying teaching guides—was funded by the Ford Foundation and the Carnegie Corporation. Project officers Terry Saario and Vivien Stewart were supportive and helpful throughout the life of the project. In 1978, The Feminist Press received funds from the National Endowment for the Humanities to help complete the project. Additional funds also were received from the Edward W. Hazen Foundation and from the Rockefeller Family Fund.

Once initial funding was obtained, The Feminist Press began its search for additional staff to work on the project. The small nucleus of existing staff working on the project was expanded as The Feminist Press hired new employees. The *Women's Lives / Women's Work* project staff ultimately included eight people who remained for the duration of the project: Sue Davidson, Shirley Frank, Merle Froschl, Florence Howe, Mary Mulrooney, Elizabeth Phillips, Susan Trowbridge, and Alexandra Weinbaum. Two other people, Dora Janeway Odarenko and Michele Russell, were on the staff through 1977, and we wish to acknowledge their contributions. Helen Schrader, a Feminist Press staff member, participated on the project during its first year and kept financial records and wrote financial reports throughout the duration of the project.

The *Women's Lives / Women's Work* project staff adopted the methods of work and the decision-making structure developed by The Feminist Press staff as a whole. As a Press "work committee," the project met weekly to make decisions, review progress, discuss problems. The project staff refined the editorial direction of the project, conceptualized and devised guidelines for the books, and identified prospective authors. When proposals came in, the project staff read and evaluated the submissions, and made decisions regarding them. Similarly, when manuscripts arrived, the project staff read and commented on them. Project staff members took turns drafting memoranda, reports, and other documents. And the design of the series grew out of the discussions and the ideas generated at the project meetings. The books, teaching guides, and other informational materials had the advantage, at significant stages of development, of the committee's collective direction.

Throughout the life of the project, The Feminist Press itself continued to function and grow. Individuals on staff who were not part of the *Women's Lives / Women's Work* project provided support and advice to the project. All major project policy decisions about such

matters as finance and personnel were made by The Feminist Press
Board at its monthly meetings. The Board includes all Feminist Press
staff, and other individuals who have an ongoing relationship to the
Press: Phyllis Arlow, Jeanne Bracken, Brenda Carter, Toni Cerutti,
Ranice Crosby, Sue Davidson, Michelina Fitzmaurice, Jeanne Ford,
Shirley Frank, Merle Froschl, Barbara Gore, Brett Harvey, Ilene Hertz,
Florence Howe, Paul Lauter, Carol Levin, Corrine Lucido, Mary
Mulrooney, Ethel Johnston Phelps, Elizabeth Phillips, Helen Schrader,
Merryl Sloan, Susan Trowbridge, Alexandra Weinbaum, Sharon Wigu-
toff, Jane Williamson, Sophie Zimmerman.

The process of evaluation by teachers and students before final
publication was as important as the process for developing ideas into
books. To this end, we produced testing editions of the books. Field-
testing networks were set up throughout the United States in a variety
of schools—public, private, inner-city, small town, suburban, and
rural—to reach as diverse a student population as possible. We field
tested in the following cities, regions, and states: Boston, Massa-
chusetts; Tampa, Florida; Greensboro, North Carolina; Tucson,
Arizona; Los Angeles, California; Eugene, Oregon; Seattle, Washing-
ton; Shawnee Mission, Kansas; Martha's Vineyard, Massachusetts;
New York City; Long Island; New Jersey; Rhode Island, Michigan;
Minnesota. We also had an extensive network of educators—350
teachers across the country—who reviewed the books in the series,
often using sections of books in classrooms. From teachers' com-
ments, from students' questionnaires, and from tapes of teachers' dis-
cussions, we gained valuable information both for revising the books
and for developing the teaching guides.

Although there is no easy way to acknowledge the devotion and
enthusiasm of hundreds of teachers who willingly volunteered their
time and energies, we would like to thank the following teachers—
and their students—with whom we worked directly in the testing of
In Her Own Image: Women Working in the Arts. In Arizona, Sherry
O'Donnell, Acting Chairperson of the Women's Studies Committee,
the University of Arizona, and Betty Newlon, Professor of Education,
the University of Arizona—with the assistance of Kay Kavanaugh—
helped to contact the following teachers in the Tucson area: Mary
Lynn Hamilton, Mari Helen High, Dorothy Livieratos, Beverly Mid-
dleton-Johnson, Kristin Wallace. We also wish to acknowledge Myra
Dinnerstein, Chairperson of the Women's Studies Committee, for her
help in the development of the Tucson network. In California, Lilyan
Frank in the Department of English at the University of Southern Cali-
fornia helped to contact teachers in the Los Angeles area: Sharon
Geltner, Helen Kelly, Rhonda Nalisnik, Marion Walker, Ira West. In

Eugene, Oregon, Bev Melugin, Instructional Materials Analyst, and Anne Stewart, Coordinator of Women's Programs, Lane Community College, helped to contact the following teachers: Kate Barry, Yvonne Fasold, Orris L. Goode, Ann Monro, Ronalee Ramsay, Harriet Wilson. In Seattle, Washington, Audra Adelberger of Feminists Northwest, and Edith Ruby, Sex Balance Curriculum Consultant to the Seattle public schools, helped to contact the following teachers: Roxie Day, Shirley Dunphy, Sara Kaplan, Suzanna Kline, Nancy Mason, Laurel Ann Pickett. We also wish to acknowledge the participation of Joan Augerot, Eleanor Bilimoria, Larae Glennon, Sharon Greene, Cynthia Lambarth, Ruth Pelz, and Gisela E. Taber.

Three times during the life of the *Women's Lives / Women's Work* project, an Advisory Board composed of feminist educators and scholars met for a full day to discuss the books and teaching guides. The valuable criticisms and suggestions of the following people who participated in these meetings were essential to the project: Millie Alpern, Rosalynn Baxandall, Peggy Brick, Ellen Cantarow, Elizabeth Ewen, Barbara Gates, Clarisse Gillcrist, Elaine Hedges, Nancy Hoffman, Susan Klaw, Alice Kessler-Harris, Roberta Kronberger, Merle Levine, Eleanor Newirth, Judith Oksner, Naomi Rosenthal, Judith Schwartz, Judy Scott, Carroll Smith-Rosenberg, Adria Steinberg, Barbara Sussman, Amy Swerdlow. We also want to express our gratitude to Shirley McCune and Nida Thomas, who acted in a general advisory capacity and made many useful suggestions; and to Kathryn Girard and Kathy Salisbury, who helped to develop the teacher and student field-testing questionnaires.

Others whom we want to acknowledge for their work on *In Her Own Image* are Iskra Johnson, Virginia Kobler, Amy Freeman Lee, Martha Nishitani, and Mary Scott for cooperation in searching for selections; Judith H. McQuown, who prepared the index; Ruth Adam for restoration work on the photographs; Irwin Rabinowitz for the music engraving of "It Could Have Been Me" and "There's a New World Coming," pages 277–79 and 286–87; Carlos Ruiz of McGraw-Hill for administrative assistance; and Emerson W. Madairy of Monotype Composition Company for technical assistance.

The work of the many people mentioned in these acknowledgments has been invaluable to us. We would also like to thank all of you who read this book—because you helped to create the demand that made the *Women's Lives / Women's Work* project possible.

THE FEMINIST PRESS

Authors' Acknowledgments

IN CHOOSING THE SELECTION for this book, the editors have been generously helped by many people. They include friends, librarians, colleagues, students, and the contributors of this book, who have shared information and have given us their enthusiasm and support, Many of these same contributors, as well as executors, agents, and publishers, have generously made it possible for us to include material that we could not have used without their help. In the search for individual selections we were especially aided by Mary Faust, Florence A. Forst, Renee Hausmann, Florence Howe, Lawson Inada, Joan Jensen, Marty Kearns, Tillie Olsen, Michelle Russell, and Patricia Tubb. We wish to thank them all.

A special acknowledgment of indebtedness is due to certain scholars without whose recent anthologies and pioneer studies in women's literary and art history our search would have been longer, slower, and much less successful. These include Sharon Barba, Ellen Bass, Laura Chester, Ann Sutherland Harris, Florence Howe, Lucille Iverson, Ellen Moers, Cindy Nemser, Linda Nochlin, Karen Petersen, Kathryn Ruby, Patricia Meyer Spacks, Anne Tucker, and J. J. Wilson.

We also wish to thank Sue Davidson, not only for her skillful and conscientious editing, but for her help in finding selections, her useful suggestions regarding the book's organization, and for her good humor at all times. Her participation in the creation of this book went far beyond that ordinarily assumed by an editor.

Finally, a special expression of gratitude is due our husbands and children—Bill, Marietta, and Jimmy Hedges, and Ralph and Erin Salisbury—who encouraged and aided us daily in many different ways, and who learned to live with our deadlines and crises, our interminable phone calls, our weekends at the typewriter, our despairs, and our elations, as we worked for two years, across three thousand miles, to complete this book.

ELAINE HEDGES, *Baltimore, Maryland*
INGRID WENDT, *Eugene, Oregon*

Introduction

IN THE EARLY 1970s, two teachers discover that a standard collection of 1300 slides for use in art survey courses contains only eight slides of art by women, and that the most widely-used textbook has no references to women artists at all. Another teacher finds only three women writers in a two-volume text that covers six centuries of English literature. Only with difficulty do still other teachers find materials on women in music, in photography, and in the other arts. Where are the women artists?

Today, this question is not only more frequently asked; it is also being answered. The teachers who could not find slides of women's art did their own research, and have since published a book and close to 500 slides of work by women artists.[1] Collections of the work of women in different art forms, especially in literature, have increasingly begun to appear, as have new critical, biographical, and historical studies. Women artists have existed, and in large numbers, but their existence and their history have been hidden: overlooked, ignored, and often distorted.

Background and Purpose

In its broadest sense, this book is part of a larger current enterprise of rediscovering and rewriting the lost history of women in the arts. That we need such books is beginning to be evident. Not to have access to the art of women means that we are deprived of the imaginative responses to the world, the unique perceptions and points of view, of half of humankind. Our initial objective in composing this book was therefore to provide examples that would illustrate the nature, the breadth, and the

[1] Karen Petersen and J. J. Wilson, *Women Artists: Recognition and Reappraisal from the Early Middle Ages to the Twentieth Century*, New York University Press, New York, 1976; and J. J. Wilson and Karen Petersen, four sets of full-color 35-mm. slides and notes, *Women Artists: A Historical Survey* (Early Middle Ages to 1900); *Women Artists: The Twentieth Century; Women Artists: Third World; Women Artists: Images—Themes and Dreams*, Harper & Row Media Department, New York.

diversity of women's work in the arts. The book includes examples of the achievement of women artists in a variety of Western societies and historical periods, and the art forms represented include literature—poetry and fiction, autobiography, essay, journal and letter writing—as well as the visual arts of painting, graphics, sculpture, and photography; ceramics and needlework; and music and dance. Although the sampling that can be offered in this single volume is small, it demonstrates that women have indeed been contributors to the history of Western art.

As our work on this anthology progressed, however, we became aware that to say that women "contributed" to the "history" of art was not always an adequate or appropriate way of describing their artistic achievement. For such a statement implies that art "history" is a fixed progression of periods and categories into which all art by women, once it is discovered, can be fitted and then readily described. Two problems emerged that made the traditional artistic categories fairly useless. First, some genres are largely inapplicable to the work of women artists, since historically women were excluded from them. Painting from "the nude" is one example: until the end of the nineteenth century, women were not permitted to study anatomy from live, nude models, and thus were effectively barred from painting in that genre. Second, the traditional categories exclude genres and whole spheres of art that women have invented or have made especially their own. Quilting and other arts employing needlework illustrate the point. In sum, the categories which have defined art history apply mainly to the experiences and products of men.

As we undertook the composition of this book, therefore, we realized that our task went beyond that of providing examples of the excellent work of many women artists and placing in close proximity both literary and visual examples. In order to understand the ways that women have worked in the arts, we knew that we also needed to consider the ways in which women's lives and opportunities have historically differed from men's, and to ask how such differences have affected the emphases, subject matter, and traditions of their art.

The purpose of this book, then, is not to "add" women to existing art history. Rather, its purpose is to illustrate some major themes in the relationships between women's art and the conditions of women's lives. While the anthology does not purport to be an alternative social history of women's art, its selections shed light on important aspects of that emerging history.

The book rests upon the testimony of women artists; that testimony is its "method." In the selections we include, women express the artistic dreams and aspirations of women, describe their problems and struggles as artists, tell of their triumphs in becoming artists. "In her own image," each artist in this book recreates for us a part of the history of all women working in the arts.

Thematic Organization of the Book

As we identified some of the shared experiences of women artists, we began to choose and organize selections for this book according to basic themes that emerged, rather than according to time, place, or artistic field. Each of the four thematic sections of the book includes works of art in a variety of forms, by artists from different historical periods and from various national, ethnic, racial, and economic backgrounds. We titled the themes that unite our selections: 1, "Household Work and Women's Art"; 2, "Obstacles and Challenges"; 3, "Definitions and Discoveries"; 4, "Women's Art and Social Change."

The four sections, placed in the sequence above, present two simultaneous and parallel kinds of accounts. They provide a record—although one that is not strictly chronological—of important aspects of the social history of women working as artists: from household art, through self-consciousness about the obstacles to becoming a professional artist, to overcoming many of those obstacles, to working through art for larger social change. The sequence also serves as a record of some of the stages in the individual development of many women as they have become professional artists, especially in our own time. The introductions we have provided for each of the four sections reflect and elaborate this double pattern.

Overview of the Themes

Beginning with the early tribe or community and continuing into the present day, many women artists have first learned to create from materials available in the home, finding an expressive outlet in arts that are useful or decorative, and becoming aware at the same time of a tradition in which skills are passed from one woman and generation to the next. In such arts as quilting, the product reflects the collective effort and imagination of many women. Section 1, "Household Work and Women's Art," encompasses a wide range of art forms which have evolved out of household work, or in which the meaning or materials of that work are the bases for individual artistic expression. Section 2, "Obstacles and Challenges," documents a variety of conflicts between the needs of women artists to equip and assert themselves to work as artists, and at the same time to satisfy their own and others' emotional or social expectations of them as women. In section 3, "Definitions and Discoveries," women artists grapple more successfully with these conflicts, as they define themselves and their values with increasing confidence and strength. The artists in section 4, "Women's Art and Social Change," having clarified their personal values and discovered their ability to direct their own lives, have also become aware of their power to create art that will help others. Whether alone or working in the collective tradition of the household arts, each artist in section 4 has come full circle: out of work in the home and confinement to the exclusive functions of daughter, wife, or mother; beyond social barriers and the limitations of gender; through self-identification; and onto a public stage where her work has become useful in the largest sense of the word.

As a social record, the four sections provide only a very rough outline of certain aspects of the history of women working in the arts. In fact, in past centuries and up to present times, women have worked in the household arts; women have broken through the confines of home and family and the strictures of society to become professional artists; and women have used their art as social protest. Yet it is also true that between the period of the Renaissance, which saw the arts become an "intel-

lectual profession," and the late nineteenth century, relatively few women became recognized professionals, even though they continued in those same centuries to hold preeminence in such household arts as weaving and embroidery. And it is also true that no large body of social protest art by women developed until after long years of struggle by women as a group to attain social and political freedoms—a struggle in which women artists progressively gained ground in overcoming barriers to education and training, and in finding social acceptance as artists and public recognition as professionals. In one sense, then, the anthology is a record of increasing opportunities for Western women artists, although this does not mean that either the forms or the individual works produced at later stages are of more value or artistically more advanced than earlier ones.

Selection and Placement of the Works

Our objective was to bring together only selections which could tell us something about the work of Western women artists, from the viewpoint of the artists themselves. This being the case, many outstanding works by women fall outside the book's scope. Even within the book's focus, however, we found many more works than we could reproduce among the genres included here, nor had we space for the work of women playwrights and filmmakers. It was also necessary to limit our representation of women in the performing arts to a few selections in which the artists are the creators of the works they perform, or in which a performing artist is described by a writer.

Our placement of a selection for the sake of its contribution to one of the four themes does not signify that the artist and her work "belong" only in that section. We expect that readers will understand that potter Margaret Tafoya, working in the tradition of women's household arts, has turned her creative activity into a distinguished professional career; similarly that, as Muriel Rukeyser's concluding poem suggests, the social and political activity of women artists often goes hand-in-hand with nurturing—with the kind of creative care necessary to all human life. Most important, wherever the selections have been placed, they represent aesthetic achievement of a high order.

The Audience

Except in the concluding section of the book, the topic of the artist's audience is seldom addressed directly. Yet the need of artists for an audience is implicit in all of the selections; and the act of assembling the anthology raises the question explicitly. If women artists have been silenced, lost, hidden, or neglected through the centuries, that is in large part because they have lacked an audience aware of their existence or willing to consider their work. What of the woman artist of today, and those who will come tomorrow?

The future of these artists depends upon an audience that can bear to be shaken out of the "middle and accepted view of things," an audience willing to be challenged by the urgent need for changes in society—and in itself. An audience as responsive and responsible to the truths art can reveal as artists themselves must be.

That is the audience we hope this book can help to create.

In Her Own Image

Women Working in the Arts

We dedicate this book to all women artists:
whose courage, dedication, and creative works
have inspired and enlightened our own;
whose work we have yet to discover;
and whose work is yet to come.

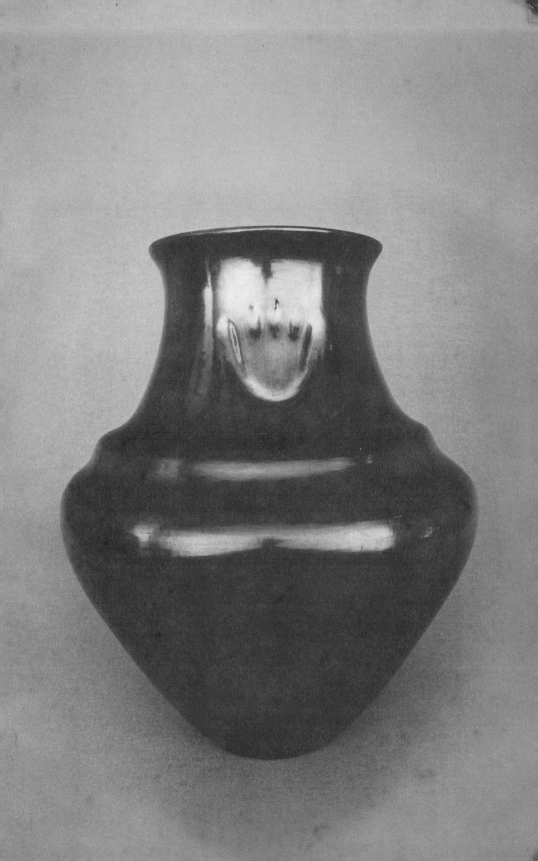

1: Everyday Use

Household Work and Women's Art

A HISTORY OF WOMEN'S ART would begin with survival needs. Women have always worked, and as far back as we can trace, their art has been an outgrowth of that work, work essential to the survival of human life, be it in the tribe, the family, the clan, the community, or the highly organized industrial society. In hunting-gathering societies, that pre-agricultural form of organized human life that has characterized 99 percent of human history, women, it is estimated, provided as much as 80 percent of the food—nuts, berries, roots and herbs. That they should have invented baskets and pots made of grasses, vegetable fibers, and clay to hold their foodstuffs, and fiber slings to hold their babies, was inevitable. And that they should have begun to shape these necessary containers with care and with love, embellish them with pattern and color, was equally inevitable, for the impulse to beauty, to esthetic expression, is universal. So too with the need to provide coverings for warmth, whether clothes or blankets. When, with the arrival of agriculture and the domestication of animals, sheep's wool, flax, and cotton replaced animal skins, these vegetable and animal fibers were spun and woven, colored with vegetable dyes, decoratively stitched, and turned into objects of beauty as well as use. In addition to their inventions in spinning, weaving, pottery-making, and cooking, women were often the architects, weaving the grass houses as part of their domestic work, later designing and

constructing the wigwams, the conical tents and the tipis of American Indian tribes and turning these, too, into forms that expressed beauty through their function.[1]

Since much of this early work by women was designed to serve group needs, it was probably collective work. Early societies were homogeneous, and sought to satisfy their basic needs— for plant and animal life, for human fertility—as a unified group. They might express these needs symbolically through songs or chants or rain dances, or through sacred designs on pots or blankets. Shaping the container, decorating the pot, could thus become a symbolic as well as a practical act: it could be a form of prayer, or a form of celebration. Pattern and design are orderly, give order to a mysterious, inexplicable world. Thus does art console, give courage, reinforce group identity. And thus could women's work, originating in the practical physical needs of the moment, serve also larger spiritual and emotional needs.

We begin this book therefore with a section on women's domestic work and with simple household objects—pots, quilts, a home-made vase—in tribute to women's work and in recognition of that work as a fundamental source of women's art. Much of this work, when it has reached a certain level of skill, is commonly referred to as "craft." Pottery, weaving, and quilt-making are thus frequently referred to as crafts, usually to distinguish them from art objects that do not originate in practical need, such as paintings or sculptures. These latter, referred to as "fine art" or "high art," are, in Western society, ordinarily accorded higher status than crafts, partly because they are divorced from use, are "useless" in any practical sense. One result of this hierarchy of values has been the denigration of much of women's art, since that art has been—and for a variety of reasons continues to be—more "homebound," more tied to manual labor and practical tasks. We hope the reader will ponder these distinctions and their implications. Meanwhile, our aim in this section is to show the natural evolution of women's

[1] Kathleen Gough, "The Origins of the Family," in Rayna R. Reiter, ed., *Toward an Anthropology of Women* (New York, 1975), *passim;* Doris Cole, *From Tipi to Skyscraper. A History of Women in Architecture* (Boston, Mass., 1973), p. 2; Elizabeth Weatherford, "Women's Traditional Architecture," *Heresies,* May, 1977, p. 35.

"art" out of the dailiness of women's lives and, indeed, therefore to suggest the evolution of all art out of our daily lives and our physical and emotional needs. In human terms there are no arbitrary categories, there is only a continuum.

The women of the Pueblo Indian tribes of the American Southwest are famous today for their pottery. As Margaret Tafoya, one of the most famous of contemporary potters, speaks to us of her work in the selection we include, we have a glimpse of the centuries-old tradition of craft and skill behind her, a tradition passed down through generations of women from mother to daughter, as specific designs and patterns were passed down within families. Those designs—the bear's paw she mentions, for example—often embodied sacred meanings, for storage jars, holding the water and grain essential to life, could become objects of reverence. Polishing the jars, therefore, while immensely time-consuming, as she says, might be an act of love and faith, as well as an act of pride in one's work.

Throughout western history, spinning, weaving, and sewing have always been among the most basic of women's domestic tasks. Indeed, the Bible defines the ideal or "virtuous" woman in Proverbs 31 (and the passage was quoted frequently in colonial America), as she who "seeks wool and flax, and works with willing hands, . . . puts her hands to the distaff, and her hands hold the spindle." A "spinster" was originally a spinner and an essential member of every family. In fact, the Massachusetts legislature at one point in the seventeenth century decreed that each household must contain at least one spinner, so important was this work. It is perhaps hard to realize that it is only within the last 100 to 150 years of human history, with the mass production of the sewing machine and the removal of textile making from the home to factories, that women have been released from the time-consuming chores of raising crops of flax and cotton, spinning the fibers into thread, weaving the thread into cloth, and sewing the cloth into clothing and blankets.

Meanwhile, the needle arts, such as quilting, embroidery, and tapestry weaving, as outgrowths of these basic activities of cloth making, have long provided women with a major creative

outlet. We have therefore chosen, in this first section of the book, to concentrate on one of those needle arts—one that has reached a level of exceptional beauty and skill in the United States—that of quilt making. There is today a renewed interest in women's quilts, partly as a result of the Bicentennial interest in the American past, partly because many artists today recognize in the geometric patterns of quilts an exciting forerunner of twentieth-century abstract painting. Quilts today hang in museums, and are collected at high prices. A uniquely woman's art form has thus achieved widespread recognition.

If one views quilts in a museum environment, however, it is important not to forget their origins in women's lives, where sewing could be oppressive as well as rewarding. We have therefore included in this section Alice Walker's short story "Everyday Use," which raises the question of how to look at quilts and, by extension, other art products emanating from women's work; and we have included an historical analysis of quilts and quilt making, as an example of the way in which all of women's art may be viewed and understood: that is, as emerging out of actual social and economic circumstances.

Marge Piercy's poem "Looking at Quilts" contains and is inspired by such a recognition. Her poem is a tribute from one creative artist to others, some of them forever anonymous except as their quilts recall their lives. As Piercy tells us, the quilts represent beauty wrested from dailiness. The materials used to piece a quilt might capture the history of a family through its clothing, becoming a tactile record of work and play, suffering and joy. The very names of quilts are a folk poetry, where humor often triumphs over adversity. And a quilt, as Piercy also recognizes, might be the one permanent piece of work a woman did. Many quilts that exist today have been handed down through families as treasured legacies, scarcely used, never washed, the tracing lines for the patterns still faintly visible. They link women through the generations.

The actual work of making the quilt linked women in their own time, in networks of friendship and support, through the quilting bee, which brought women together to complete the quilt. This collective aspect of the art was frequently what en-

deared it to many women, otherwise isolated on their frontier farms. But solitary sewing has also been a solace for isolated women—solace for inactivity and powerlessness, and sometimes a form of hidden resistance to such powerlessness. The woman in Diane Wakoski's poem "Medieval Tapestry with Questions" is living in a feudal, European society. Elevation to the rank of king's consort has cut her off from the community of women downstairs, but has not in return enlarged her opportunities for meaningful action. Confined within her room, garbed in some of her own elegant embroidery, she would seem to be no more than an ornamental object for male pleasure—except for what her "flashing needle" says and asks: questions about death and life (and so, by implication, questions about her own status and role) expressed through stitch and color. When access to action is denied, whether in medieval tower or suburban ranch house, sewing may provide expression.

The earliest crafts to be industrialized were spinning and weaving. Although cottage weavers like Doris Ulmann's *Virginia Howard* were still to be found in Appalachia in the 1930s, farm girls of New England had begun to follow their work out of the home and into the factory by the 1820s and 1830s. One such worker speaks to us in "Weaving," by Lucy Larcum, a poet who worked in the Lowell, Massachusetts textile mills for ten years. The time is the Civil War; and the speaker is aware that the cotton thread she weaves is obtained from the labor of women slaves in the Southern cotton fields. In a time of sectional strife, with men killing men in battle, this woman finds in her work of weaving a metaphor to communicate her sense of sisterhood with all of the oppressed, and her special identification with "the world of women." One contemporary woman artist has said that, "For women, the meaning of sewing and knotting is 'connecting'—connecting the parts of one's life, and connecting to other women—creating a sense of community and wholeness."[2] Perhaps this has not always been the case (witness the lady in Wakoski's poem, isolated in her tower), but

[2] Harmony Hammond, "Feminist Abstract Art—A Political Viewpoint," *Heresies*, January, 1977, p. 67.

Lucy Larcom's poem, with its familiar metaphor of the loom of life in which all of us are both separate threads and parts of a pattern, returns us to a sense of women's, and humanity's, common bonds.

So much of women's work is done only to be undone: the food cooked in order to be eaten, the dishes washed so that they may be used again, surfaces cleaned only to accumulate more dust. One impulse behind much art is surely the desire to out-wit time and disrepair, to make the transient permanent, to cap-ture the fleeting moment and memorialize it. In women's art, given the nature of their domestic work, this impulse may be especially strong. Marge Piercy is not alone in recognizing and respecting this impulse when she sees the quilter creating what may have been "the only perfect artifact a woman/ would ever see." Something of the same impulse impels the kitchen painter in Joan Aleshire's "Exhibition of Women Artists (1790–1900)" as she studies the shapes of vegetables and captures on canvas the fruits she will later "cut, peel and stew for dinner." Ale-shire's poem is a description of the circumstances in which many women have created, and in which many today still cre-ate, using their kitchens or their bedrooms as their work spaces, the tops of their washing machines as desks. The poem is also an expression of pleasure and pride in the achievement of one such woman, who could eventually see her "kitchen work" permanently ensconced on a museum wall.

Those women painters who have, especially in the last few hundred years, found it possible to devote to their art more time than fragmentary moments snatched from daily tasks, are to-day being rediscovered and their work displayed. Joan Aleshire's "Exhibition" poem was partially inspired by an actual exhibit held in 1977 in Los Angeles and in Brooklyn, New York, that covered four centuries of paintings produced by European and American women artists.[3] Organizing that exhibit meant fer-reting out and often painstakingly restoring works that had sometimes been left to moulder in museum cellars, works that

[3] Ann Sutherland Harris and Linda Nochlin, *Women Artists: 1550–1950* (New York, 1977), p. 11.

had rarely been viewed. Fede Galizia's still life *Basket of Peaches* was the poster picture for that historically significant exhibit, an especially appropriate choice in view of the domestic origins of much of women's art. While Galizia did not have to confine herself to her kitchen—she was an artist who achieved fame at an early age—the still life genre in which she pioneered in the late sixteenth and early seventeenth centuries became especially closely associated with women painters in the centuries that followed. Excluded from anatomy classes where they might learn to draw the human figure, women, once they began to enter the art world in significant numbers, were largely relegated to still life, considered a humbler, lowlier subject than the human form.

Following Galizia's painting by some 300 years, Mary Cassatt's mural *Young Women Plucking the Fruits of Knowledge and Science* elevated a humble task into an allegory for a high ideal. This painting decorated the Women's Building at the World's Columbian Exposition, held in Chicago in 1893. As the painting's title suggests, this was a period of national optimism and belief in progress. And in fact, by the end of the nineteenth century more women had become professional writers and artists, able, like Cassatt herself, to enjoy independent careers. (At what cost, however, and in the face of what obstacles, the selections in section 2 of this book will explore.)

Although opportunities for women artists gradually broadened, the connection between their work and the domestic arts of their mothers and grandmothers was not lost. Thus, Glen Corbett Povey and Sue Fuller, both of them contemporary creators of abstract art, have, as one of their sources of inspiration, women's traditional work in the home. Povey began weaving scarves and place mats on a family loom that was given to her, and Fuller recalls playing as a child with the threads and colored scraps of wool left over from her mother's sewing and knitting. Both artists create new spaces that take us beyond the confined domestic one. Povey creates abstract "landscapes" that the mind can enter, and Fuller's string constructions are endlessly explorable configurations of line and light. And where the knitted sweater, the appliquéd or patched quilt, the woven

carpet, the braided basket eventually wear out from use, crea-
tions like Povey's and Fuller's, framed, or encased in plastic,
achieve a permanence that helps immortalize the humble mate-
rials of female domestic art.

Not only visual artists, but contemporary writers as well
continue to find inspiration in such materials. For the speaker
in Bethami Auerbach's witty poem "The Search for the Perfect
Rye Bread," making rye bread is itself pleasurable and satisfy-
ing, and it can also be a creative prelude to the making of poems,
as in fact Auerbach has said it often is in her own life. The yeasty
"ferment" of the "rising" bread becomes the author's humor-
ous yet serious symbol for that sense of the "infiniteness of
possibility" which, at least in heightened moments, the cre-
ative artist is able to experience and aspire to.

The wife-mother, Eliza, in Jessamyn West's story "The
Vase" is too unassuming to put into words any such aspiration.
Yet we sense it in her devotion to the simple object that she
crafts. Her husband sees her vase as trivial, and it is indeed
simple, and even unfinished. Yet it has become Eliza's most
cherished possession, something "more to her than she under-
stood." She has created it in love and in joy, in sorrow and in
despair, in response to the realities of her life and as an expres-
sion of her dreams. Crude and incomplete though it may be, the
vase comes to symbolize that deep and enduring need for self-
and life-expression which lies within us all. It is a need that is
frequently derogated, deflected, even denied by the circum-
stances of life and by arbitrary definitions of what is "art."
West's story helps us to understand the strength of the need
and something of the circumstances of women's lives that have
frequently thwarted it.

We conclude this section with two paintings by the contem-
porary artist Miriam Schapiro, paintings whose genesis tells us
a great deal about women's experience as artists. Miriam Scha-
piro was already a successful abstract painter when, in the mid-
dle of her life, she found herself unable to paint for fourteen
months. Working with a group of women on an art project that
involved designing domestic interiors released her energies in a
new direction. She discovered a need to accept the "home-

making and nesting" that had been an essential part of her life as a daughter and a mother, but a part that, sharing a pervasive cultural prejudice, she had long denied. She began making collages out of scraps of fabric and out of such handicrafts as handkerchiefs and aprons, in a conscious desire, as she has explained, to connect with those "unknown women" who have done the "invisible work of civilization." Her desire was to "honor and acknowledge" such women, and she has continued to produce paintings, such as the two shown here, that are part of an ongoing creative collaboration with other women artists, both the well-known and the anonymous. Through such work as Schapiro's, the quilters, weavers, and potters of the past, women like Alice Walker's Grandma Dee and Jessamyn West's Eliza, become a new source of encouragement and inspiration. The urge to make, to build, to express, that began in their household work, lives on in the women we will follow in the pages of this book, as they take their art into worlds beyond the home.

A Pueblo Woman's Heritage

By Margaret Tafoya

Margaret Tafoya is one of many Pueblo craftswomen today who is working in a tradition of pottery making that extends back at least 1000 years. Agricultural Indian tribes like the Pueblo Indians of New Mexico, Arizona, Utah, and Colorado early developed skill in making pots as cooking, eating, and storage containers and as mortuary vessels to be buried with the dead. The techniques involved in the complex work of gathering clay and making paints, then kneading, shaping, firing, coloring, and polishing the pots, were temporarily submerged between the sixteenth and the early twentieth centuries, when first Spaniards and then white Americans introduced tin and iron vessels. Archaeological interest in the early 1900s led to a revival of the ancient skills, and today women in such pueblos as Santa Clara, San Idelfonso, San Juan, Santo Domingo, and Acoma once again produce such traditional varieties of pottery as the black on black, polished black, polished red, and black and red on buff, among others. Individual women artists such as Margaret Tafoya have achieved fame for their pots, whose simplified and strong design elements make many of them collectors' items and museum pieces.

I started learning pottery from my mother Sarafina Tafoya when I was a child and I now use my pottery for a living. My mother would make the pottery while my father, Geronimo, would work in the fields. We didn't have big fields like the white man, just enough for the family. I would work with my mother until I could do everything myself. I am the only one to do the large storage jars like my mother's. I never had anyone to show them off; now my work is famous.

My mother taught me to do good polishing and that's the way I teach my girls. We really go over them to see if there are any small cracks or places where the slip has peeled off before we bake them. I start polishing the big ones in the morning and

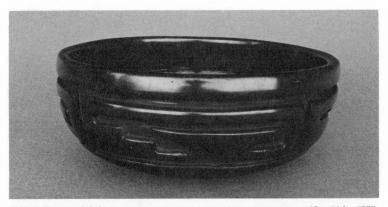

Plate 1. Margaret Tafoya. BLACK CARVED BOWL POLISHED INSIDE AND OUT. 14 × 11 in. 1977.

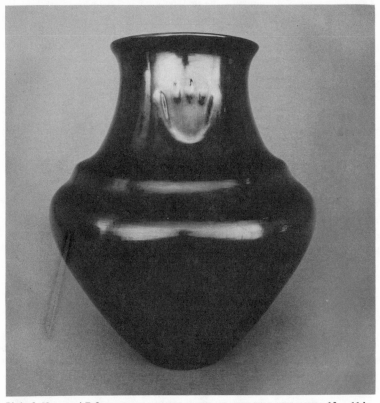

Plate 2. Margaret Tafoya. BLACK POLISHED WATER JAR WITH BEAR IMPRESSION. 14 × 11 in. 1977.

Photos, Herbert Lotz. Courtesy, Rick Dillingham.

if I don't finish by noon I won't eat. You have to polish them all at once. Sometimes I don't finish until 3:00 or 4:00 in the afternoon.

My daughter, Mary Ester Archuleta, married a San Juan man and does both kinds of pottery, the San Juan and the Santa Clara. We get our slip from the Santo Domingos for the black pottery.[1]

The bear paws are used on storage jars, water jars, and mixing bowls. It is a good luck symbol; the bear always knows where the water is. We use the kiva step, mountain, clear sky, and buffalo horn designs on our pottery.[2] Sometimes we use the matte painted style.[3]

[1] *Slip:* thin mixture of clay and water.
[2] *Kiva:* a ceremonial chamber lying underground.
[3] *Matte:* unpolished surface or detail.

Quilts and Women's Culture

By Elaine Hedges

*Born in Yonkers, New York, Elaine Hedges earned money for
her education (a B.A. from Barnard College, a Ph.D. from
Harvard University) through a combination of fellowships and
summer jobs, as postal money-order clerk, librarian, ghost
writer, waitress, and typist. She has taught, among other
places, at Harvard University, Wellesley College, and San
Francisco State College. Currently, she is professor of English
and coordinator of women's studies at Towson State
University in Baltimore, Maryland, where she lives with her
husband, also a college professor, and their two teen-age
children. She has been active in the women's movement since
1970, and in 1972–1973 chaired the Commission on the Status
of Women of the Modern Language Association.*

*Among her publications are books and articles on women's
studies and on nineteenth-century American fiction and
architecture; they include an edition of Charlotte Perkins
Gilman's* The Yellow Wallpaper *and an anthology,* Land
and Imagination: The American Rural Dream. *At present, she
is working on a book on nineteenth-century American women
and their sewing, under a grant from the American Council
of Learned Societies, and is completing an anthology of
the writings of midwest author Meridel Le Sueur.*

*The article that follows first appeared, in slightly different
form, in* The Radical Teacher *of March, 1977.*

Women's needlework has been a universal form of activity,
uniting women of different classes, races, and nations. Until the
era of manufactured textiles—very recent, in the long span of
history—it has always been necessary for women to sew, to
provide the clothing, linens and blankets for their families. And
wherever and whenever extra time and energy have allowed,
sewing has become "esthetic," has been an outlet for creativity.
Often this has been a creativity which a patriarchal society has
officially stifled. Where women have been denied literacy, let

alone access to higher education and the professions, their creative aspiration and need might find expression, as it often did for Black women in the pre-Civil War South, for instance, in the making of gardens, or blues songs, or quilts. Alice Walker has eloquently discussed these creative energies and frustrations of Black women in her article "In Search of Our Mothers' Gardens," and she comments on a quilt made one hundred years ago by an anonymous Black woman in Alabama and now hanging in the Smithsonian Museum in Washington. Its maker, as she says, was "an artist who left her mark in the only materials she could afford, and in the only medium her position in society allowed her to use."[1]

The origins of quilting are ancient: both the Egyptians and the Chinese quilted, as did the Persians, from whom it was introduced into Europe by the Crusaders. In the United States, from the colonial period through the nineteenth century, quilt making, or what is known as "patchwork," became a highly developed art, a unique female art, and *the* major creative outlet for women. Patchwork, like so much of women's original art, arose out of necessity: in this case the necessity for warmth, in clothing (which was sometimes quilted) and in bed covers, the form the quilt most commonly took. And it arose out of scarcity: there was little cloth in the American colonies in the seventeenth and early eighteenth centuries; what was imported from England and the continent was expensive; and so all scraps and fragments were saved, salvaged from worn-out items, and reused. The activity of quilting consisted of two main stages: designing and sewing the quilt top, which would be exposed on the bed; and doing the actual "quilting," which consisted of binding or stitching this finished top layer to a plain bottom layer, with filling or wadding in between. It was this triple thickness which gave warmth.

From the beginning, however, women expended time and care on the making of quilts beyond their utilitarian purpose. Artistry was possible, and was pursued in two areas. First, the quilt top offered nearly limitless possibilities of design and color as one pieced and sewed together small, straightedged bits

[1] Alice Walker, "In Search of Our Mothers' Gardens," *Ms.*, May, 1974.

of fabric to create an overall patterned top known as a "pieced" quilt; or as one "appliquéd," that is, sewed small pieces or patches of fabric according to some design on to a larger ground fabric. These were the two main kinds of "patchwork." Second, in the quilting or stitching together of the three layers, fine sewing could be practised. Small stitches and different, highly complex kinds of stitches were employed, often to create intricate designs of scrolls, flowers or feathers. In Emily Dickinson's words (Poem 617), "I'll do seams—a Queen's endeavor/Would not blush to own."

The results, as one looks at hundreds and hundreds of quilts, are varied and dazzling—truly a visual feast. There is an esthetic indigenous to quilts, and the more one knows about the craft and the techniques—the possibilities and limitations of various fabrics and ways of cutting them, the geometric intricacies of various designs, the various stitch patterns and color combinations—the more one can appreciate and even marvel at the skill, the sophistication, the inventiveness, the visual daring that quilts display. That women responded to the technical challenge implicit in quilt making, just as a painter might set and solve a technical problem of shading or perspective or design, is apparent when one learns, for instance, of a pieced quilt that contains 30,000 pieces, each ½ inch by ¾ inch in size.

The quilt involved both individual and collective artistry. Usually, an individual woman designed and executed the top layer. The work of quilting together the three layers, however, was a large collective effort. To the "quilting bee" would be invited the best sewers from the community. Quilting bees were usually festive occasions, opportunities to renew and cement friendships, to reestablish social bonds among women otherwise isolated, especially on the western frontier, to exchange news and ideas and to express feelings. Under the stimulus of friendly competition, women vied to do their best sewing, creating art within a context that had a broadly nourishing social function. Where men had the tavern or saloon, the marketplace or the courthouse square for bonding together, women had the quilting bee.

The origins of many quilt stitches and patterns go far back in time, and as an art form, therefore, much of it remains anony-

mous. It is, in its overall distinguishing features, more representative of a culture or a society than of an individual or any series of individuals. As such, it asserted and conveyed values of continuity, stability and tradition—all useful values in a country of immigrants and of geographic mobility.

Within its broad traditionalism and anonymity, however, variations and distinctions developed. There were regional variations, ethnic or religious variations, and finally, individual variations, in the works of specific quilt makers whose names are known to us. Regional variations would include, for example, what is known as the Baltimore quilt, an appliquéd Friendship quilt of the early nineteenth century with distinctive, recognizable designs, which reached an extremely high level of skill. Ethnic or religious variations would include the quilts of the Amish and of the Moravians; similar to and yet distinguishable from each other in their color ranges and patterns, these quilts are significantly different from those of other groups.

Regionally, too, distinctions were introduced into quilt making through the interesting process of renaming. Ordinarily quilts were given names, usually the name of the basic pattern chosen for the top layer. In the course of time, and with geographical movement within the United States, name changes and small design variations were introduced in response to local needs and to both sectional and national events. Thus, during the Civil War a traditional rose pattern (of which there were many) was modified by the addition of a black patch at its center and renamed the *Radical Rose,* in recognition of the slavery controversy. A chain or loop pattern originally called *Job's Tears*—one of many early pattern names taken from the Bible— was renamed the *Slave Chain* in the early 1820s; by 1840 the same pattern was being called *Texas Tears* in response to new political developments; and after the Civil War it was used to describe *The Rocky Road to Kansas.* Indeed, quilt names provide a capsule version of much nineteenth-century American history, not least the hardships of the western journey. A pattern made of rectangles inside diagonal bands, and known in pre-Revolutionary New England as *Jacob's Ladder,* from the Bible, became in western Kentucky *The Underground Railroad,*

and in Mississippi and the prairie states *Wagon Tracks* or the *Trail of the Covered Wagon.*

With equal inventiveness women renamed traditional patterns to accommodate them to the local landscape. Thus a pattern called *Duck's Foot in the Mud* on Long Island became *Bear's Paw* in western Pennsylvania and Ohio. Quilt names, indeed, give us insight into many aspects of the lives of the women who made them and their families. There are names of occupations, from farming to carpentry and mechanics, names (although fewer) of recreations and amusements, and names expressing moral beliefs and hopes and dreams. *Hens and Chickens* to *Trip around the World* encompass the polarities, real and ideal, of many women's lives. Whereas it has been estimated that the total of distinctively different quilt patterns is probably not more than three hundred, the names run into the thousands.

Finally, out of such regional and other variations come individual, signed achievements. Many women did sign their quilts: their skill was recognized; they responded with pride and aspiration; they aimed to create a work of art for posterity.

Quilts, then, were an outlet for creative energy, a source and emblem of sisterhood and solidarity, and a graphic response to historical and political change. The quilt could also serve as inspiration and imaginative stimulus. At the beginning of her semi-autobiographical novel, *Daughter of Earth,* Agnes Smedley describes her impoverished childhood:

I recall a crazy-quilt my mother once had. She made it from the remnants of gay and beautiful cotton materials. . . . [The] crazy-quilt held me for hours. It was an adventure.

It was also, of course, what Smedley and other working-class women had instead of books and paintings.

Finally, quilts, or women's sewing in general, can be seen as sometimes providing opportunities for political discussion and statement. Susan B. Anthony's first talk on equal rights for women was at a quilting bee, and she and Elizabeth Cady Stanton frequently used such gatherings to advocate political action and change. Earlier, Sarah Grimké advised women to embroider

anti-slavery slogans and images on domestic artifacts, urging "May the point of our needles prick the slave-owner's conscience." And there is the delightful story of the subversive wife who had her husband sleep under a quilt that bore, unknown to him, a pattern named after the political party he opposed.

But such freedoms or assertions must be ultimately interpreted in the larger context of women's work and oppression within a patriarchal society—an oppression of which needlework was not only symbol but actuality. Before the days of machine-made clothing and blankets, little girls were forced to learn to sew; and learning to sew often took precedence over, or was the female substitute for, learning to read and write. Sewing is thus used by Emily Dickinson in one of her poems (Number 508) as a symbol of the childhood and female bondage she rejects as she arrives at her own achieved status of poet. Sewing, for instance, of samplers with moral messages, was intended to inculcate in little girls their class or gender virtues of neatness, submissiveness, docility and patience. One learned quilting by working on one small square, sewing it, ripping out the stitching, sewing it again, over and over and over, until proficiency had been achieved. Many women learned to hate the work. In other countries, various kinds of needlework have amounted and still amount to sheer exploitation of girls and women: young girls painstakingly tying the innumerable fine knots in Persian rugs because their fingers are small enough to do the work; young girls seated in rows in convents in Belgium, making lace for hours on end, not allowed to raise their eyes from their work; Italian women going blind after a lifetime of lace making.

To return to this country, one must ask to what extent needlework had to substitute, for women, for what might have been more freely chosen work, or for various forms of political activism. Does one respond with admiration, or dismay, to that quilt of 30,000 pieces? One may admire the dexterity of Pennsylvania Dutch women, who challenged themselves with the sewing of convex and concave, rather than merely straight, edges. Their quilts show a higher degree of exacting sewing than do

the quilts of New England women, and may therefore receive higher accolades as art. But one realizes it was an art born of oppression: the Pennsylvania Dutch women were among the most severely confined, almost never allowed to learn to read, rarely venturing beyond the home.

In the Victorian era, when middle-class women lost the productive role they had held in an earlier agricultural economy, quilts became more and more decorative, more and more examples of conspicuous waste in their use of expensive fabrics such as satin, lace, brocade and velvet. They became an inadvertently ironic sign of woman as consumer rather than producer, and of her confinement to a narrowed and less functional domestic sphere. They became a badge of her oppression and even an unfortunate safety valve that could delay rebellion by diverting energy.

Our response to quilts as an art form rooted both in meaningful work and in cultural oppression will therefore inevitably be complex: a combination of admiration and awe at limitations overcome and of sorrow and anger at limitations imposed.

Star of Bethlehem Quilt

Anonymous

The star is one of the most popular of all quilt motifs. There are quilt patterns based on five-, six-, and eight-pointed stars, on repeated patterns of many tiny stars, and, as in the illustrated example, on one large star covering most of the quilt surface. This Star of Bethlehem quilt is very old, dating from the late eighteenth century, and is made of vari-colored chintzes, calicoes, and copperplate fabrics, some imported from England. Star patterns were frequently built up of hundreds, even thousands, of tiny, diamond-shaped pieces of material, allowing for a complexity and richness of color arrangement that would indeed make the star seem to "blaze." The work of piecing together these multitudinous and often minute diamonds, in which each diamond had to fit with the points of two other diamonds, demanded the quilter's most advanced skill, as the color arrangement of the pieces challenged her finest artistry.

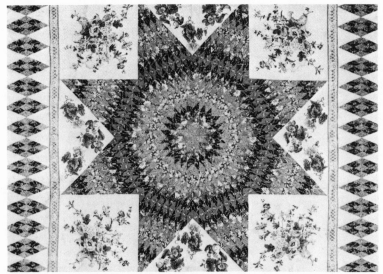

Plate 3. Anonymous. STAR OF BETHLEHEM QUILT. 106 × 110 in. Late 18th cent.

Rose of Sharon Quilt

By Sarah Barker

Like the star, the rose was a popular motif on quilts, as the names of many patterns attest. There is the California Rose, *the* Mexican Rose, *the* Colonial Rose, *and one rose design which became the object of a political dispute in the 1840s when both the Democrats and the Whigs claimed it. The* Rose of Sharon, *pictured here, was frequently the pattern chosen for a woman's bridal quilt, no doubt because of the reference in the Song of Solomon in the Bible, where it occurs in verses celebrating love and marriage. This particular* Rose of Sharon *quilt was made in the mid-nineteenth century by Sarah Barker of Waterville, Vermont, and consists of red and pink calico roses with green leaves and stems. Some of the flower petals were stuffed with cotton to raise the design above the quilt surface and create an interesting texture. The border of the quilt is in red and green. This quilt is said to have won many prizes at county fairs in Vermont.*

Plate 4. Sarah Barker. ROSE OF SHARON QUILT. 85 × 90 in. Mid-19th cent.

Bible Quilt

By Harriet Powers

This appliquéd and pieced quilt was made by Harriet Powers, a Black farm woman of Athens, Georgia, about 1900. Powers identified the scenes, based on Biblical and other episodes, as (reading from left to right): Job Praying for His Enemies; the Dark Day of May 19, 1780; the Serpent Lifted up by Moses; Adam and Eve in Garden; John Baptising Christ; Jonah Casted Overboard; God Created Two of Every Kind, Male and Female; The Falling of the Stars, November 13, 1833; Two of Every Kind of Animals; The Angels of Wrath and the Seven Vials; Cold Thursday, February 10, 1895—A Man Frozen at His Jug of Liquor; The Red Light Night of 1846; Rich People Were Taught Nothing of God; The Creation of Animals Continued; The Crucifixion of Christ Between Two Thieves— The Blood and Water Run from his Right Side. This quilt hangs in the Boston Museum of Fine Arts, and another Bible Quilt by Harriet Powers also survives and hangs in the Smithsonian Museum in Washington, D.C. One of the quilts once was sold for five dollars.

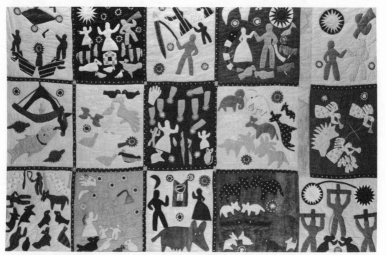

Plate 5. Harriet Powers. BIBLE QUILT. 105 × 69 in. Ca. 1900.

Mariner's Compass Quilt

Anonymous

*Along the Eastern coast, especially in New England and the
Middle States, proximity to the ocean and its importance
as a source of food and trade gave rise to such quilt names as*
Ocean Waves, Ship's Wheel, *and* Mariner's Compass. *This
pieced and appliquéd Mariner's Compass quilt dates from the
second quarter of the nineteenth century and was probably
made in New Jersey, but the name of the maker has been lost.
The nine compass units which compose the design are
made of long thin strips of blue, bronze, yellow and red printed
calico. Each compass contains sixty-four such tapered
strips, and to piece these evenly, with well-defined points and
exact angles, required a high degree of mathematical precision.
The Shelburne Museum catalog explains that each of the
576 strips "was basted to a paper lining; a narrow margin of
calico was folded over the paper, the edges held together
and the two layers whipped with tiny over-and-over stitches."
The pieced work in the compasses is complemented in the
overall design by the appliquéd hickory leaf motif.*

Plate 6. Anonymous MARINER'S COMPASS QUILT. **96 × 100 in. Mid-19th cent.**

Log Cabin Quilt: Barn Raising

By Mary Fish

Log Cabin quilts, especially popular after the Civil War, were a convenient way of using up especially small pieces of material. The basic block was built from the center outward, with strip added to strip. Varying arrangements of light and dark strips, or "logs," created a variety of over-all patterns, each one described by a different name. Thus, the quilt illustrated here is called Barn Raising, *perhaps because the design looks like the parts of a section of barn assembled on the ground prior to being raised. Other popular varieties of the Log Cabin quilt included* Straight Furrow, *in which the lights and darks make long broad diagonals or "furrows" across the quilt surface, and* Courthouse Steps, *in which a progression of small to large strips in each block of the design resembles a set of steps. The quilt pictured here was made in Vermont by Mary Fish. Born in 1828, she began this quilt in 1879. It is said to contain 9792 pieces of material.*

Plate 7. Mary Fish. LOG CABIN QUILT: BARN RAISING. 80 × 80 in. 1879.

Shelburne Museum, Inc., Shelburne, Vt.

Everyday Use

By Alice Walker

Still in her thirties, Alice Walker (1944–) is already among the most highly acclaimed of the contemporary generation of Black women writers. Since 1968 she has published two volumes of poetry, two novels, a biography of Langston Hughes, and the volume of short stories, In Love and Trouble, *from which "Everyday Use" is taken. She has also taught writing and Black literature at several colleges. Her awards include a Merrill Writing fellowship, a grant from the National Endowment for the Arts, and a Radcliffe Institute fellowship. The mother of one daughter, Rebecca Grant, Walker currently lives in San Francisco.*

Alice Walker's fiction is rooted in the Southern life of Black people—in their response to white oppression, their search for self-respect, their survival. Her novel The Third Life of Grange Copeland *traces a poor rural Black family through three generations; and it is often the Black family, as a beleaguered but cohesive unit, about which she writes.* In Love and Trouble *is a group of thirteen stories about Black women. Of various backgrounds, all of them, as Black poet June Jordan has said, are "seekers of dignity and love."*

I will wait for her in the yard that Maggie and I made so clean and wavy yesterday afternoon. A yard like this is more comfortable than most people know. It is not just a yard. It is like an extended living room. When the hard clay is swept clean as a floor and the fine sand around the edges lined with tiny, irregular grooves, anyone can come and sit and look up into the elm tree and wait for the breezes that never come inside the house.

Maggie will be nervous until after her sister goes: she will stand hopelessly in corners, homely and ashamed of the burn scars down her arms and legs, eying her sister with a mixture of envy and awe. She thinks her sister has held life always in the

palm of one hand, that "no" is a word the world never learned
to say to her.

You've no doubt seen those TV shows where the child who has
"made it" is confronted, as a surprise, by her own mother and
father, tottering in weakly from backstage. (A pleasant surprise,
of course: What would they do if parent and child came on the
show only to curse out and insult each other?) On TV mother
and child embrace and smile into each other's faces. Some-
times the mother and father weep, the child wraps them in her
arms and leans across the table to tell how she would not have
made it without their help. I have seen these programs.

Sometimes I dream a dream in which Dee and I are suddenly
brought together on a TV program of this sort. Out of a dark and
soft-seated limousine I am ushered into a bright room filled
with many people. There I meet a smiling, gray, sporty man
like Johnny Carson who shakes my hand and tells me what a
fine girl I have. Then we are on the stage and Dee is embracing
me with tears in her eyes. She pins on my dress a large orchid,
even though she has told me once that she thinks orchids are
tacky flowers.

In real life I am a large, big-boned woman with rough, man-
working hands. In the winter I wear flannel nightgowns to bed
and overalls during the day. I can kill and clean a hog as merci-
lessly as a man. My fat keeps me hot in zero weather. I can
work outside all day, breaking ice to get water for washing; I
can eat pork liver cooked over the open fire minutes after it
comes steaming from the hog. One winter I knocked a bull calf
straight in the brain between the eyes with a sledge hammer
and had the meat hung up to chill before nightfall. But of course
all this does not show on television. I am the way my daughter
would want me to be: a hundred pounds lighter, my skin like an
uncooked barley pancake. My hair glistens in the hot bright
lights. Johnny Carson has much to do to keep up with my quick
and witty tongue.

But that is a mistake. I know even before I wake up. Who
ever knew a Johnson with a quick tongue? Who can even imag-
ine me looking a strange white man in the eye? It seems to me
I have talked to them always with one foot raised in flight, with
my head turned in whichever way is farthest from them. Dee,

though. She would always look anyone in the eye. Heistation
was no part of her nature.

"How do I look, Mama?" Maggie says, showing just enough of
her thin body enveloped in pink skirt and red blouse for me to
know she's there, almost hidden by the door.

"Come out into the yard," I say.

Have you ever seen a lame animal, perhaps a dog run over by
some careless person rich enough to own a car, sidle up to
someone who is ignorant enough to be kind to him? That is the
way my Maggie walks. She has been like this, chin on chest,
eyes on ground, feet in shuffle, ever since the fire that burned
the other house to the ground.

Dee is lighter than Maggie, with nicer hair and a fuller figure.
She's a woman now, though sometimes I forget. How long ago
was it that the other house burned? Ten, twelve years? Some-
times I can still hear the flames and feel Maggie's arms sticking
to me, her hair smoking and her dress falling off her in little
black papery flakes. Her eyes seemed stretched open, blazed
open by the flames reflected in them. And Dee. I see her stand-
ing off under the sweet gum tree she used to dig gum out of; a
look of concentration on her face as she watched the last dingy
gray board of the house fall in toward the red-hot brick chim-
ney. Why don't you do a dance around the ashes? I'd wanted to
ask her. She had hated the house that much.

I used to think she hated Maggie, too. But that was before we
raised the money, the church and me, to send her to Augusta to
school. She used to read to us without pity; forcing words, lies,
other folks' habits, whole lives upon us two, sitting trapped and
ignorant underneath her voice. She washed us in a river of
make-believe, burned us with a lot of knowledge we didn't nec-
essarily need to know. Pressed us to her with the serious way
she read, to shove us away at just the moment, like dimwits, we
seemed about to understand.

Dee wanted nice things. A yellow organdy dress to wear to
her graduation from high school; black pumps to match a green
suit she'd made from an old suit somebody gave me. She was
determined to stare down any disaster in her efforts. Her eyelids
would not flicker for minutes at a time. Often I fought off the

temptation to shake her. At sixteen she had a style of her own: and knew what style was.

I never had an education myself. After second grade the school was closed down. Don't ask me why: in 1927 colored asked fewer questions than they do now. Sometimes Maggie reads to me. She stumbles along good-naturedly but can't see well. She knows she is not bright. Like good looks and money, quickness passed her by. She will marry John Thomas (who has mossy teeth in an earnest face) and then I'll be free to sit here and I guess just sing church songs to myself. Although I never was a good singer. Never could carry a tune. I was always better at a man's job. I used to love to milk till I was hooked in the side in '49. Cows are soothing and slow and don't bother you, unless you try to milk them the wrong way.

I have deliberately turned my back on the house. It is three rooms, just like the one that burned, except the roof is tin; they don't make shingle roofs any more. There are no real windows, just some holes cut in the sides, like the portholes in a ship, but not round and not square, with rawhide holding the shutters up on the outside. This house is in a pasture, too, like the other one. No doubt when Dee sees it she will want to tear it down. She wrote to me once that no matter where we "choose" to live, she will manage to come see us. But she will never bring her friends. Maggie and I thought about this and Maggie asked me, "Mama, when did Dee ever *have* any friends?"

She had a few. Furtive boys in pink shirts hanging about on washday after school. Nervous girls who never laughed. Impressed with her they worshiped the well-turned phrase, the cute shape, the scalding humor that erupted like bubbles in lye. She read to them.

When she was courting Jimmy T she didn't have much time to pay to us, but turned all her faultfinding power on him. He *flew* to marry a cheap city girl from a family of ignorant flashy people. She hardly had time to recompose herself.

When she comes I will meet—but there they are!

Maggie attempts to make a dash for the house, in her shuf-

fling way, but I stay her with my hand. "Come back here," I say. And she stops and tries to dig a well in the sand with her toe.

It is hard to see them clearly through the strong sun. But even the first glimpse of leg out of the car tells me it is Dee. Her feet were always neat-looking, as if God himself had shaped them with a certain style. From the other side of the car comes a short, stocky man. Hair is all over his head a foot long and hanging from his chin like a kinky mule tail. I hear Maggie suck in her breach. "Uhnnnh," is what it sounds like. Like when you see the wriggling end of a snake just in front of your foot on the road. "Uhnnnh."

Dee next. A dress down to the ground, in this hot weather. A dress so loud it hurts my eyes. There are yellows and oranges enough to throw back the light of the sun. I feel my whole face warming from the heat waves it throws out. Earrings gold, too, and hanging down to her shoulders. Bracelets dangling and making noises when she moves her arm up to shake the folds of the dress out of her armpits. The dress is loose and flows, and as she walks closer, I like it. I hear Maggie go "Uhnnnh" again. It is her sister's hair. It stands straight up like the wool on a sheep. It is black as night and around the edges are two long pigtails that rope about like small lizards disappearing behind her ears.

"Wa-su-zo-Tean-o!" she says, coming on in that gliding way the dress makes her move. The short stocky fellow with the hair to his navel is all grinning and he follows up with "Asa-lamalakim, my mother and sister!" He moves to hug Maggie but she falls back, right up against the back of my chair. I feel her trembling there and when I look up I see the perspiration falling off her chin.

"Don't get up," says Dee. Since I am stout it takes something of a push. You can see me trying to move a second or two before I make it. She turns, showing white heels through her sandals, and goes back to the car. Out she peeks next with a Polaroid. She stoops down quickly and lines up picture after picture of me sitting there in front of the house with Maggie cowering behind me. She never takes a shot without making sure the house is included. When a cow comes nibbling around the edge of the

yard she snaps it and me and Maggie *and* the house. Then she puts the Polaroid in the back seat of the car, and comes up and kisses me on the forehead.

Meanwhile Asalamalakim is going through motions with Maggie's hand. Maggie's hand is as limp as a fish, and probably as cold, despite the sweat, and she keeps trying to pull it back. It looks like Asalamalakim wants to shake hands but wants to do it fancy. Or maybe he don't know how people shake hands. Anyhow, he soon gives up on Maggie.

"Well," I say. "Dee."

"No, Mama," she says. "Not 'Dee,' Wangero Leewanika Kemanjo!"

"What happened to 'Dee'?" I wanted to know.

"She's dead," Wangero said. "I couldn't bear it any longer, being named after the people who oppress me."

"You know as well as me you was named after your aunt Dicie," I said. Dicie is my sister. She named Dee. We called her "Big Dee" after Dee was born.

"But who was *she* named after?" asked Wangero.

"I guess after Grandma Dee," I said.

"And who was she named after?" asked Wangero.

"Her mother," I said, and saw Wangero was getting tired. "That's about as far back as I can trace it," I said. Though, in fact, I probably could have carried it back beyond the Civil War through the branches.

"Well," said Asalamalakim, "there you are."

"Uhnnnh," I heard Maggie say.

"There I was not," I said, "before 'Dicie' cropped up in our family, so why should I try to trace it that far back?"

He just stood there grinning, looking down on me like somebody inspecting a Model A car. Every once in a while he and Wangero sent eye signals over my head.

"How do you pronounce this name?" I asked.

"You don't have to call me by it if you don't want to," said Wangero.

"Why shouldn't I?" I asked. "If that's what you want us to call you, we'll call you."

"I know it might sound awkward at first," said Wangero.

"I'll get used to it," I said. "Ream it out again."

Well, soon we got the name out of the way. Asalamalakim had a name twice as long and three times as hard. After I tripped over it two or three times he told me to just call him Hakim-a-barber. I wanted to ask him was he a barber, but I didn't really think he was, so I didn't ask.

"You must belong to those beef-cattle peoples down the road," I said. They said "Asalamalakim" when they met you, too, but they didn't shake hands. Always too busy: feeding the cattle, fixing the fences, putting up salt-lick shelters, throwing down hay. When the white folks poisoned some of the herd the men stayed up all night with rifles in their hands. I walked a mile and a half just to see the sight.

Hakim-a-barber said, "I accept some of their doctrines, but farming and raising cattle is not my style." (They didn't tell me, and I didn't ask, whether Wangero (Dee) had really gone and married him.)

We sat down to eat and right away he said he didn't eat collards and pork was unclean. Wangero, though, went on through the chitlins and corn bread, the greens and everything else. She talked a blue streak over the sweet potatoes. Everything delighted her. Even the fact that we still used the benches her daddy made for the table when we couldn't afford to buy chairs.

"Oh, Mama!" she cried. Then turned to Hakim-a-barber. "I never knew how lovely these benches are. You can feel the rump prints," she said, running her hands underneath her and along the bench. Then she gave a sigh and her hand closed over Grandma Dee's butter dish. "That's it!" she said. "I knew there was something I wanted to ask you if I could have." She jumped up from the table and went over in the corner where the churn stood, the milk in it clabber by now. She looked at the churn and looked at it.

"This churn top is what I need," she said. "Didn't Uncle Buddy whittle it out of a tree you all used to have?"

"Yes," I said.

"Uh huh," she said happily. "And I want the dasher, too."

"Uncle Buddy whittle that, too?" asked the barber.

Dee (Wangero) looked up at me.

"Aunt Dee's first husband whittled the dash," said Maggie so low you almost couldn't hear her. "His name was Henry, but they called him Stash."

"Maggie's brain is like an elephant's," Wangero said, laughing. "I can use the churn top as a centerpiece for the alcove table," she said, sliding a plate over the churn, "and I'll think of something artistic to do with the dasher."

When she finished wrapping the dasher the handle stuck out. I took it for a moment in my hands. You didn't even have to look close to see where hands pushing the dasher up and down to make butter had left a kind of sink in the wood. In fact, there were a lot of small sinks; you could see where thumbs and fingers had sunk into the wood. It was beautiful light yellow wood, from a tree that grew in the yard where Big Dee and Stash had lived.

After dinner Dee (Wangero) went to the trunk at the foot of my bed and started rifling through it. Maggie hung back in the kitchen over the dishpan. Out came Wangero with two quilts. They had been pieced by Grandma Dee and then Big Dee and me had hung them on the quilt frames on the front porch and quilted them. One was in the Lone Star pattern. The other was Walk Around the Mountain. In both of them were scraps of dresses Grandma Dee had worn fifty and more years ago. Bits and pieces of Grandpa Jarrell's Paisley shirts. And one teeny faded blue piece, about the size of a penny matchbox, that was from Great Grandpa Ezra's uniform that he wore in the Civil War.

"Mama," Wangero said sweet as a bird. "Can I have these old quilts?"

I heard something fall in the kitchen, and a minute later the kitchen door slammed.

"Why don't you take one or two of the others?" I asked. "These old things was just done by me and Big Dee from some tops your grandma pieced before she died."

"No," said Wangero. "I don't want those. They are stitched around the borders by machine."

"That'll make them last better," I said.

"That's not the point," said Wangero. "These are all pieces of

dresses Grandma used to wear. She did all this stitching by hand. Imagine!" She held the quilts securely in her arms, stroking them.

"Some of the pieces, like those lavender ones, come from old clothes her mother handed down to her," I said, moving up to touch the quilts. Dee (Wangero) moved back just enough so that I couldn't reach the quilts. They already belonged to her.

"Imagine!" she breathed again, clutching them closely to her bosom.

"The truth is," I said, "I promised to give them quilts to Maggie, for when she marries John Thomas."

She gasped like a bee had stung her.

"Maggie can't appreciate these quilts!" she said. "She'd probably be backward enough to put them to everyday use."

"I reckon she would," I said. "God knows I been saving 'em for long enough with nobody using 'em. I hope she will!" I didn't want to bring up how I had offered Dee (Wangero) a quilt when she went away to college. Then she had told me they were old-fashioned, out of style.

"But they're *priceless!*" she was saying now, furiously; for she has a temper. "Maggie would put them on the bed and in five years they'd be in rags. Less than that!"

"She can always make some more," I said. "Maggie knows how to quilt."

Dee (Wangero) looked at me with hatred. "You just will not understand. The point is these quilts, *these* quilts!"

"Well," I said, stumped. "What would *you* do with them?"

"Hang them," she said. As if that was the only thing you *could* do with quilts.

Maggie by now was standing in the door. I could almost hear the sound her feet made as they scraped over each other.

"She can have them, Mama," she said, like somebody used to never winning anything, or having anything reserved for her. "I can 'member Grandma Dee without the quilts."

I looked at her hard. She had filled her bottom lip with checkerberry snuff and it gave her face a kind of dopey, hangdog look. It was Grandma Dee and Big Dee who taught her how to quilt herself. She stood there with her scarred hands hidden in

the folds of her skirt. She looked at her sister with something like fear but she wasn't mad at her. This was Maggie's portion. This was the way she knew God to work.

When I looked at her like that something hit me in the top of my head and ran down to the soles of my feet. Just like when I'm in church and the spirit of God touches me and I get happy and shout. I did something I never had done before: hugged Maggie to me, then dragged her on into the room, snatched the quilts out of Miss Wangero's hands and dumped them into Maggie's lap. Maggie just sat there on my bed with her mouth open.

"Take one or two of the others," I said to Dee.

But she turned without a word and went out to Hakim-a-barber.

"You just don't understand," she said, as Maggie and I came out to the car.

"What don't I understand?" I wanted to know.

"Your heritage," she said. And then she turned to Maggie, kissed her, and said, "You ought to try to make something of yourself, too, Maggie. It's really a new day for us. But from the way you and Mama still live you'd never know it."

She put on some sunglasses that hid everything above the tip of her nose and her chin.

Maggie smiled; maybe at the sunglasses. But a real smile, not scared. After we watched the car dust settle I asked Maggie to bring me a dip of snuff. And then the two of us sat there just enjoying, until it was time to go in the house and go to bed.

Looking at Quilts

By Marge Piercy

*Born in a working-class, Detroit, Michigan neighborhood,
Marge Piercy (1936–) was the first person in her family to
attend a university. While an undergraduate, she was
active in the radical student movement of the 1960s as a
member of the Students for a Democratic Society, and
she has since been an active member of the women's
movement. She has published a total of nine volumes of
poetry and fiction, whose subject matter is frequently
women as they deal with some of the pressures—of war, of
race, of sex discrimination—of contemporary American
society. Her poems have been described by one critic as
"about love, trust, comradeship; celebrations of animals,
objects as parts of the real world she inhabits; they are in
short and long lines, free and regular meters, using internal
rhymes, or no rhymes at all. Where others seem intolerant,
she is compassionate. Where others give way to fashionable
despair, she hopes by doing and observing." Many of
these qualities can be observed in "Looking at Quilts."*

Who decided what is useful in its beauty
means less than what has no function besides beauty
(except its weight in money)?
Art without frames: it held parched corn,
it covered the table where soup misted savor,
it covered the bed where the body knit
to self and other and the
dark wool of dreams

The love of the ordinary blazes out: the backyard
miracle: Ohio Sunflower,
 Snail's Track,
 Sweet Gum Leaf,
 Moon over the Mountain.

In the pattern Tulip and Peony the sense
of design masters the essence of what sprawled
in the afternoon: called conventionalized
to render out the intelligence, the graphic wit.

Some have a wistful faded posy yearning:
 Star of the Four Winds,
 Star of the West,
 Queen Charlotte's Crown.
In a crabbed humor as far from pompous
as a rolling pin, you can trace wrinkles
from smiling under a scorching grasshopper sun:
 Monkey Wrench,
 The Drunkard's Path,
 Fool's Puzzle,
 Puss in the Corner,
 Robbing Peter to Pay Paul,
and the deflating
 Hearts and Gizzards.

Pieced quilts, patchwork from best gowns,
winter woolens, linens, blankets, worked jigsaw
of the memories of braided lives, precious
scraps: women were buried but their clothing wore on.

Out of death from childbirth at sixteen, hard
work at forty, out of love for the trumpet vine
and the melon, they issue to us:
 Rocky Road to Kansas,
 Job's Troubles,
 Crazy Ann,
 The Double Irish Chain,
 The Tree of Life:
 this quilt might be
the only perfect artifact a woman
would ever see, yet she did not doubt
what we had forgotten, that out of her
potatoes and colic, sawdust and blood
she could create; together, alone,
she seized her time and made new.

Medieval Tapestry and Questions

By Diane Wakoski

*Born in Whittier, California, Diane Wakoski (1937–) was
graduated from the University of California, Berkeley,
and has worked as a clerk in a bookstore and as a junior
high school English teacher. She is a prolific poet, who has
published to date over a dozen volumes of poems,
including* Discrepancies and Apparitions *(1966), from which
"Medieval Tapestry and Questions" is taken;* Inside the
Blood Factory *(1968);* The Motorcycle Betrayal Poems *(1971);
and* Smudging *(1972). Her themes include those of
betrayal and loss, and, in the words of one critic, "female
vulnerability in the male-dominated world." Of her
poetry Wakoski herself has said, "I am a woman, but I do
not write for either men or women. I write for both the man
and the woman in all of us. For me, literature is a means
of communicating and not separating."*

Each age brings its questions of reality:
A woman sitting alone in her tower, embroidering
all the scenes from a jousting tournament,
the red of one knight's plumes spilling over into a skein of
unused thread on her lap,
and her arms in their own grey velvet sleeves, moving swiftly,
—reflecting, as velvet will,
the shimmer of embroidered violets and coriander,
on her muslin bodice.
The hard wood of the spinning wheel in the corner.
The white sheets on her bed.
And the gallows outside her window
that cast such long shadows at twilight.
Can we question the beauty of the shadows? Their patterns
on the cobbled stones?

Perhaps there is also a question of authenticity,
looking back,
—her loneliness coming as too much of a convention,

while the maids bustle about in the great kitchen
several flights below—setting kettles over the fire,
silently pursing their pretty lips,
remembering she was once one of them,
remembering her elevation,
after the king took her to bed
and gave her fine cloths for gowns and linen,
jewels for her fingers.
And there are frowns at remembering the child in its coffin
after it died suddenly
one day.
And the reality of death is one of the questions.

Can we question the death outside the window?
How still she is all day,
her needle flashing in and out of the white cloth,
carrying all the purples and reds, greens,
violets, and yellows into stories,
finger stories,
the mind has nothing to do with.
The mind is out in the forest
—the last flick of the wolf's tail as it disappears in a thicket.
The wolf is panting as it stops running,
scenting a rabbit.
It changes its course so
as to meet
the rabbit.

But her fingers are absorbed in their own story of death
—making the thrust from the running horse
so that the red knight unhorses the yellow
and the audience applauds,
while yellow's lady fans herself,
though one would never know she feels any concern
but for her hands,
like two wild birds in their yellow gloves.
One cannot lose concern as
the colors ask the questions,
in this remote,
in this not—so—remote situation.

Weaving

By Lucy Larcom

*Of Puritan stock, Lucy Larcom (1824–1893) was born in
the small town of Beverly, Massachusetts. The death of her
father, while Lucy was still a small child, left her mother
and ten children with insufficient income. The family
therefore moved to Lowell, Massachusetts, the model
factory town built in 1823, where Mrs. Larcom supervised
a mill-owned boarding house and Lucy, at the age of
eleven, went to work in the mills. For the next ten years,
she continued to do mill work. In those early days of
industrialization, before new immigrants provided an
abundant work force, mill owners created working conditions
that might attract the daughters of rural New England
farmers. As early as 1834, however, Lowell Mill women
organized a strike to protest a wage cut.*

*In her later life Lucy Larcom became a school teacher
and a magazine editor. She continued to write poetry
throughout her life, and published four volumes. She
recorded her factory experiences in an autobiography,*
A New England Girlhood *(1889), and in a long verse
narrative,* An Idyl of Work *(1875).*

All day she stands before her loom;
 The flying shuttles come and go:
By grassy fields, and trees in bloom,
 She sees the winding river flow:
And fancy's shuttle flieth wide,
And faster than the waters glide.

Is she entangled in her dreams,
 Like that fair weaver of Shalott,
Who left her mystic mirror's gleams,
 To gaze on light Sir Lancelot?[1]

[1] *Fair weaver of Shalott:* In Alfred, Lord Tennyson's poem "The Lady of
Shalott" (1832) the lady Elaine sits weaving in her room. Later she dies of her
love for Sir Lancelot, one of Arthur's Knights of the Round Table.

Her heart, a mirror sadly true,
Brings gloomier visions into view.

"I weave, and weave, the livelong day:
 The woof is strong, the warp is good:
I weave, to be my mother's stay;
 I weave, to win my daily food:
But ever as I weave," saith she,
"The world of women haunteth me.

"The river glides along, one thread
 In nature's mesh, so beautiful!
The stars are woven in; the red
 Of sunrise; and the rain-cloud dull.
Each seems a separate wonder wrought;
Each blends with some more wondrous thought.

"So, at the loom of life, we weave
 Our separate shreds, that varying fall,
Some stained, some fair; and, passing, leave
 To God the gathering up of all,
In that full pattern, wherein man
Works blindly out the eternal plan.

"In his vast work, for good or ill,
 The undone and the done he blends:
With whatsoever woof we fill,
 To our weak hands His might He lends,
And gives the threads beneath His eye
The texture of eternity.

"Wind on, by willow and by pine,
 Thou blue, untroubled Merrimack![2]
Afar, by sunnier streams than thine,
 My sisters toil, with foreheads black;
And water with their blood this root,
Whereof we gather bounteous fruit.

"I think of women sad and poor;
 Women who walk in garments soiled:

[2] *Untroubled Merrimack:* The Merrimack River in New Hampshire and Massachusetts on whose banks many 19th-century textile factories were built.

Their shame, their sorrow, I endure;
　By their defect my hope is foiled:
The blot they bear is on my name;
　Who sins, and I am not to blame?

"And how much of your wrong is mine,
　Dark women slaving at the South?
Of your stolen grapes I quaff the wine;
　The bread you starve for fills my mouth:
The beam unwinds, but every thread
With blood of strangled souls is red.

"If this be so, we win and wear
　A Nessus-robe of poisoned cloth;[3]
Or weave them shrouds they may not wear—
　Fathers and brothers falling both
On ghastly, death-sown fields, that lie
Beneath the tearless Southern sky.

"Alas! the weft has lost its white.
　It grows a hideous tapestry,
That pictures war's abhorrent sight:
　Unroll not, web of destiny!
Be the dark volume left unread,
The tale untold, the curse unsaid!"

So up and down before her loom
　She paces on, and to and fro,
Till sunset fills the dusty room,
　And makes the water redly glow,
As if the Merrimack's calm flood
Were changed into a stream of blood.

Too soon fulfilled, and all too true
　The words she murmured as she wrought:
But, weary weaver, not to you
　Alone was war's stern message brought:
"Woman!" it knelled from heart to heart,
"Thy sister's keeper know thou art!"

[3] Nessus-robe: In Greek legend, a garment stained with the blood of the centaur, Nessus, which fatally poisoned Hercules when he wore it.

Virginia Howard, Appalachian Weaver

By Doris Ulmann

Doris Ulmann (1884–1934) was born in New York City. Educated in New York, she also travelled abroad extensively in her youth. After studying for two years at the Clarence White School of Photography, she embarked on a career as a free-lance photographer, which, in the late 1920s and early 1930s, took her for several months each year, into the Southern Appalachian mountains to photograph the mountain people. Some of her portraits appeared in 1937 as illustrations for the book Handicrafts of the Southern Highlands, *with text by Allen H. Eaton. Additional works in this series of portraits were reproduced in 1971, in a collection titled* The Appalachian Photographs of Doris Ulmann. *Although somewhat frail, and forced by a stomach ulcer to watch her diet and to rest often, Ulmann endured bad weather, poor food, and long hours in order to penetrate remote regions of Appalachia and find the subjects for her photographs. Until her early death at the age of fifty, she devoted much of her private fortune to the pursuit of her photography.*

Working in Appalachia with the famous ballad collector and composer John Jacob Niles, Ulmann travelled with him also to Philadelphia and Boston to do photography. She excelled in character-study portraits and still photography, meeting the demands of her art through the great deliberation with which she worked. Among her major published works is Roll, Jordan, Roll *(1933), with text by Julia Peterkin, which contains seventy portraits of Black people of South Carolina.* Virginia Howard, Brasstown, North Carolina, *showing a young Appalachian weaver at her household loom, is one example of Ulmann's numerous portraits of mountain working women.*

Plate 8. Doris Ulmann. VIRGINIA HOWARD, BRASSTOWN, NORTH CAROLINA. Photograph. Ca. 1930.

Three Weavings

By Glen Corbett Povey

*Of her work, weaver Glen Corbett Povey (1942–) writes:
"So much of weaving is craft: the pursuit of anonymous
patterns handed down. Beautiful material, shawls, rugs,
tapestries, ponchos, place mats, blankets are made on a
loom and mostly by women. For me the 'art' happens when
a person, having learned a craft, reaches inside herself
and finds her passions, her interests, what most fascinates
her about life and then expresses it. In my weaving I use
double weave tapestry technique to talk about that wild
quiet that exists before civilization, what the world feels
like from the side of a mountain, the color of twilight
between my children and me. In being most personal,
most myself in the expressions of my craft, the warp and
weft of my life and work are joined."*

*Born in Portland, Oregon, Povey has been weaving since
1966, when she began making place mats and scarves on
an old family loom, sent by her father-in-law. Although she
had attended Sarah Lawrence College and studied life
drawing and painting at the Corcoran Museum Art School
and the Portland Museum Art School (where she had
supported herself by working part time as a secertary in an
electronics firm), her work as a painter had been interrupted
by marriage, two years with the Peace Corps in the
Philippines, and the births of her three children. Weaving,
she discovered, was something she could teach herself to
do at home. Although Povey says she never intended to
become a weaver—thinking that weaving lacked the
dynamic force of painting—her opinions changed when,
in Hawaii in 1971, she apprenticed herself to the renowned
weaver Ruthadelle Anderson, under whose direction Povey
worked with twenty other artists on two-ton tapestries for
the State Senate and House buildings.*

*At the present time Povey works twelve to fourteen hours
a day, seven days a week, in her own studio (which she*

converted from a garage) in Eugene, Oregon. She has won
wide recognition for her sculptured tapestries and larger-
than-life woven portraits, which hang in galleries and
private collections around the country. In 1977—beginning
with an eight- by- eleven-foot weaving—she started on a
new series of abstract landscapes such as those pictured
in this book. Preparing for each of her weavings with
carefully drawn sketches (called cartoons), Povey recreates
in linen, wool, and silk, her various sense impressions of
"spaces"— those inside herself and in literal geographic
locations—in which she feels at home. In flowing, repetitive,
and alternating rhythms of line and color, Povey captures
subtle balances of warmth and cold, of silence and sound,
of water reflections, and, as she says, "of what happens in
that sort of mysterious space (inside)." One such inner
space can be seen in Atabet's Moment—Povey's vision of
the biological energy she once read was found to be similar
in saints, long-distance runners, and artists. Out of the Blue,
she says, visualizes the act of breaking apart all inner
surfaces, "trying to find out where the spirit really is."
Columbia, on the other hand, owes its title to the geographic
space surrounding the Bridge of the Gods on the Columbia
River gorge, outside of Portland, Oregon.

Whereas Povey once felt limited by the medium of
weaving, she has turned this limitation into meaningful
challenge. "Weavers," she says, "aren't like painters. You
have a painting up there and you can change it just a little,
step back and make a few more changes. Weavers are
almost blind. You weave and you weave and you weave.
You can't see the whole piece. You might be able to see
six inches of it that you've woven, but your mind has to
place the whole weaving out there for you."

Comparing her artistic development to the running she
makes time for each morning before work, Povey says,
"I believe in creative growth, and I can't do that standing
still. It's like running. You get used to running a couple of
miles, then it doesn't do anything for you. You need to
run three. That's part of that addiction in my work. I have
to keep pushing myself."

Plate 9. Glen Corbett Povey. WEAVING: PRELIMINARY SKETCH. 1978.

Plate 10. Glen Corbett Povey. ATABET'S MOMENT. Linen and wool, 57½×60½ in. 1978.

Plate 11. Glen Corbett Povey.
OUT OF THE BLUE. Linen and wool,
30 × 30 in. 1978.

Plate 12. Glen Corbett Povey. COLUMBIA.
Linen, silk, and wool, 30 × 40 in. 1978.

Four String Compositions

By Sue Fuller

*Sue Fuller (1914–) grew up in Pittsburgh, where she
graduated from the Carnegie Institute of Technology in 1936.
The evolution of Fuller's unique art of string composition
suggests one way in which women's household work may
have helped to inspire a wholly new art form. Her earliest
childhood memories are of glass and thread: a sun porch in her
house with windows of leaded glass, and her mother
knitting, sewing, and crocheting. She has said that the
abundant threads available to her from her mother's work
"were so wonderful, I couldn't let them go to waste." She was
influenced also by her engineer father, who made model
bridges of string. Fuller studied painting with the artist
Hans Hoffman and graphic design with Arthur Young. Her
pursuit of her own artistic vision was dedicated and rigorous;*

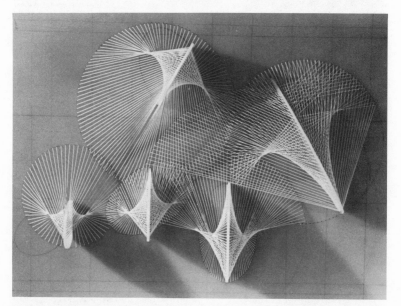

Plate 13. Sue Fuller. STRING COMPOSITION #702, DEMI-STRUCTURE. Plexiglass and cotton
thread, 16 × 20 in. 1977.

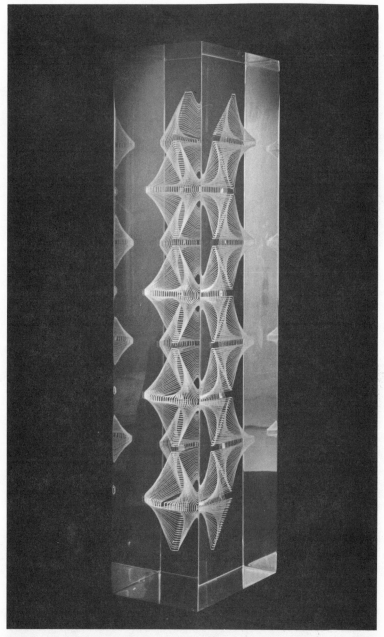

Plate 14. Sue Fuller. STRING COMPOSITION PRISM #810. Lucite embedment, 3⅝ × 5⅝ × 26 in. 1977.

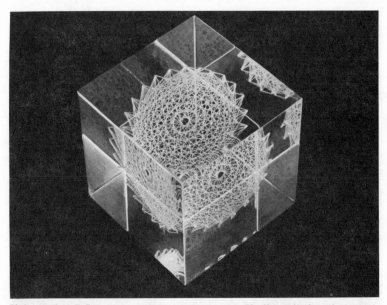

Plate 15. Sue Fuller. STRING COMPOSITION CUBE #401. Plastic embedment, approx. 6 × 6 × 6 in. 1965.

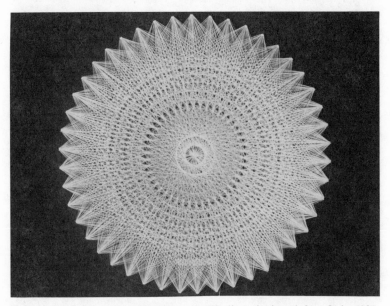

Plate 16. Sue Fuller. STRING COMPOSITION #531. Plastic embedment, 21 × 21 in. 1965.

*she worked in painting, soft ground etching, and collage;
she studied lace making, glass making in Italy and England,
calligraphy in Japan—all the while moving, over a twenty-year
period, toward her own original discoveries in string
composition.*

*Fuller's string compositions are networks of complexly
arranged threads, many of them embedded in panels or blocks
of plastic for purposes both of preservation and of artistic
effect. The plastic material traps the light, which is reflected or
refracted on to the strings, making them appear to shine,
shimmer, move in and out of themselves, and change shapes.
Fuller herself describes her compositions as transparencies,
"like spider webs or looking through grasses or the pendant
streamers of willow trees or rain." Others see in the abstract
arrangements cats' cradles, prisms, suspended snow-
flakes, fancy crystals, and crisscrossed cables or telephone
wires. Geometrically the shapes are circles or ellipses or cones,
spirals or triangles or parallelograms; but like the similar
geometric shapes used by women quilters, the resulting
patterns are dazzling and various.*

*Fuller has taught at the Museum of Modern Art, and at
the Universities of Georgia and Minnesota. The recipient
of many fellowships and grants, she is a renowned con-
temporary artist whose work has been exhibited both
throughout the United States and abroad and is part of the
permanent collections of such museums as the Whitney
Museum of American Art and the Metropolitan Museum of
Art in New York.*

Plucking the Fruits
of Knowledge and Science

By Mary Cassatt

Mary Cassatt (1844–1926) was born in Allegheny City, near Pittsburgh, into a well-to-do family. At seventeen she decided to study art. When she had exhausted the opportunities offered by the Pennsylvania Academy of the Fine Arts, she persuaded her father of the need for further study in Europe, and from the late 1860s on it was in Europe, and especially in Paris, that Cassatt pursued her career. By the 1870s she had identified her artistic methods and goals with those of a group of radical young artists, including Edgar Degas, Claude Monet, and Berthe Morisot, who would later became famous as the "Impressionists."

Cassatt's own art kept evolving throughout her long career, a career which brought her prompt and sustained recognition in Europe but not in her native land. When she returned, an established artist, for a visit to the United States in 1898–1899, the Philadelphia Ledger *reported that "Mary Cassatt, sister of Mr. Cassatt, president of the Pennsylvania Railroad, returned from Europe yesterday. She had been studying painting in France and owns the smallest Pekingese dog in the world."*

Never married, Cassatt is perhaps best known for her many mother and child portraits, a subject she treated both in the Impressionist manner of concentration on a fleeting glimpse of the moment and, later, in a style conveying monumentality and timelessness. In 1892 she created a mural for the Woman's Building at the World's Columbian Exposition of 1893, held in Chicago. She described the mural, composed of three panels, as depicting "modern woman": the two side panels depicted "Young Girls Pursuing Fame" and "the Arts, Music, and Dancing," and the central and largest panel, reproduced here, had as its subject "Young Women Plucking the Fruits of Knowledge and

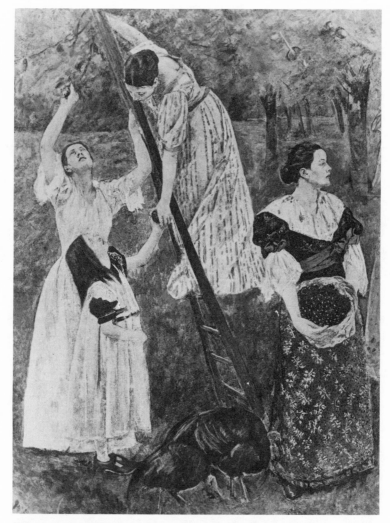

Plate 17. Mary Cassatt. YOUNG WOMEN PLUCKING THE FRUITS OF KNOWLEDGE AND SCIENCE. Facsimile-typogravure from "Modern Women." 1892.

Science." Cassatt reported that, "An American friend asked me in rather a huffy tone the other day, 'Then this is woman apart from her relations to man?' I told him it was. Men I have no doubt are painted in all their vigor on the walls of the other buildings. . . ."

Basket of Peaches

By Fede Galizia

*In the Middle Ages, women in the visual arts were likely to be
engaged in work that was an extension of their traditional
work of spinning and weaving: they wove, designed, and
embroidered tapestries and hangings, both for the churches
and for private dwellings, and vestments for the clergy. Some
of their products in these forms, such as the enormous
Bayeux Tapestry, are treasured masterpieces of both
workmanship and artistic design, for both embroidery and
weaving were not only highly developed but also highly
regarded art forms at this time. Women—nuns in convents, for
example—also participated, in this period before the invention
of printing, in the important work of transcribing and
illuminating manuscripts, and the names of many church
abbesses have come down to us as either the artists or the
patrons of such art work.*

*It was not until the sixteenth century, toward the end of
the period known as the Renaissance, that women began
to emerge as professional painters. Fede Galizia (1578–1630),
an Italian, was one of the earliest of these, and two bio-
graphical facts are especially worth noting, since they occur
also in the life stories of many other women in the visual
arts and help us to understand the limited conditions under
which success was likely to be achieved. These are the
presence and aid of a father or other close male relative who
was an artist, and the presence in the woman herself of superior
talent at an early age. Women, that is to say, often needed
to be prodigies, and to have special connections, in order to
enter what had become a male field. Galizia's father was
a painter, and her own talent was recognized when she
was only twelve years old.*

*Before she was twenty, Galizia had an international
reputation as a portrait painter; she also did religious
paintings. It is her still life painting, however—a new genre at
the time, and one in which she pioneered—that has estab-*

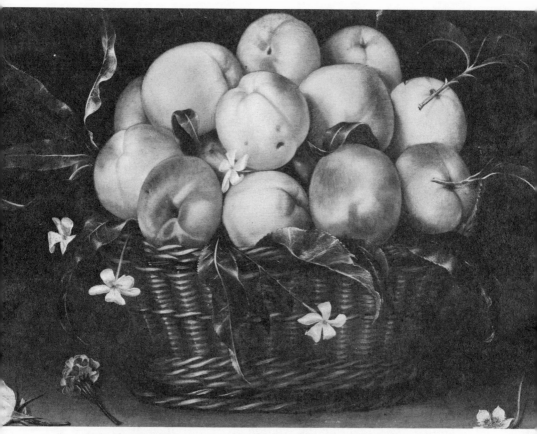

Plate 18. Fede Galizia. BASKET OF PEACHES. Oil on panel, 11 × 16½ in. 16th cent.

lished her lasting reputation. In the example pictured here her plump fruits with their clearly, crisply-edged leaves, convey both the sensuousness of the edible fruit and a symmetry of pleasing formal shapes. Galizia's still lifes are among our earliest examples of paintings in a genre in which women, partly because they would later be excluded from other kinds of painting, would excel.

Exhibition of Women Artists (1790–1900)

By Joan Aleshire

Joan Aleshire (1938–) was born in Baltimore, Maryland, and graduated from Radcliffe College. She has worked as a reporter, a TV production assistant, a book reviewer, and a newsletter editor. She has also lectured on women and literature, and has made an experimental film on the poetry of Emily Dickinson. She currently lives with her photographer husband and their child in rural Vermont, where she writes, works in the town library which she established, and studies for a master's degree in fine arts at Goddard College.

The genesis of Aleshire's poem "Exhibition of Women Artists (1790–1900)" suggests one of the ways in which women artists create a tradition of their own. The poem was inspired both by an exhibit of the work of four centuries of European and American women artists at the Brooklyn Museum in 1977, and by a still life of oranges owned by Aleshire's mother and painted by Sarah Miriam Peale (1800–1885), who was one of her ancestors and who is often described as the first professional woman artist in the United States. Unlike the woman artist described in Aleshire's poem, Sarah Peale remained unmarried, supporting herself entirely from the sale of her work over a career of sixty years.

Of her own work Aleshire says: "I've written all my life in different forms; poetry is my deepest means of expression. I write to say the things I can't say in ordinary conversation, or even in intimate conversation. I keep a notebook of lines, words, and ideas for poems; when an idea becomes enormously compelling, I begin to write. I have a strong belief that the experience of women is waiting to be expressed in all its various individual ways, and that when I write, I am filling in part of the picture."

She could paint with one hand
Studying grapes and peaches
A bowl of pears she would later
Cut, peel and stew for dinner.
And these oranges:
A friend from the South has brought them;
The blossoms have survived the trip
And she has painted them, oranges on black velvet—
The velvet would become a daughter's dress
She'd spend the night sewing for Christmas.

Everything glows against the black
The orange of oranges, white wax of blossoms
The painting glows on this museum wall:
It has come a long way from the easel
Set up in the kitchen so that she
Might paint with one hand, cook with the other
Turn up her sleeve to test warm milk
Against her skin, add sugar to taste
Soothe the colicky child tossing its cradle.

Onions, eggs, peppers, beans
She studied shapes before she quartered them
Stopping to paint
With one hand and both eyes.

The Search for the Perfect Rye Bread

By Bethami Auerbach

*Bethami Auerbach (1949–) was born in Los Angeles and
graduated from Pomona College and Stanford University Law
School. She is a lawyer, currently working for the United
States Environmental Protection Agency in Washington, D.C.,
where she has done litigation and counselling on air and
water pollution problems. Of her writing she says, "I have
always seen myself as a prose (fiction) writer; I came to poetry
not only to try the medium for its own sake, but because
I began to be staggered by the prospect of keeping up with a
demanding job and writing a novel at the same time.
(I would still like to try.) Poetry, as my college writing teacher
pointed out, has the advantage of being something small.
Sometimes I can finish a poem on a weekend, while I'm
waiting for my bread to come out of the oven."*

*"The Search for the Perfect Rye Bread" inspired the title
of the anthology in which it first appeared,* Rye Bread:
Women Poets Rising *(1977). "The making of perfect rye bread
is usually associated with women and the ultimate in
housewifery," the editors explained, "but the association
begins to expand. Since rye bread is a yeast mixture it also
connotes the potential for richness, rising, expanding, growing
and becoming" which they hoped the poems in the anthology
would suggest.*

The perfect rye bread
is a light-colored rye,
missing the molasses and bran
of the pumpernickel
(I've already found the perfect pumpernickel);
it hasn't the orange scent of the limpa,
its character is caraway and cornmeal.
It's a cosmopolitan Jewish rye,

immigrating constantly,
its fragrance making me feel welcome
in my own home.

The search is for something
I know does not exist
at the start, cannot exist
until I create it
and which then
—by that creation—
is guaranteed
found.
In this search the quarry
is the creature of the detective
so it's helpful
in the experience column
to have been a poet.

How much
(if any)
 flour
 (white/wheat/rye/cornmeal)
 liquid
 (water/milk/potato water/buttermilk)
 shortening
 (oil/butter/vegetable)
 etc
 (yeast/sugar/honey/salt/caraway)
and in what combination?
Breadmaking
affirms with every bite
the infiniteness
 (butter/cream cheese/preserves)
of possibility.

The perfect rye bread
has not been found
but every near-miss
every changeling
emerging from my oven

is savored;
nothing I make
with my own hands
can be all bad.

It's a long time to be housebound
 researching
 organizing
 measuring
 mixing
 kneading
 rising
 baking
 cooling
 tasting
4 hours at least,
sometimes 6.
But these are hours
when something is going on in my life,
hours when I might be home
staring at my hands
in terror that nothing is going on in my life.

These are hours of ferment
when, after washing my spoon,
I might grab my pen;
hours of waiting
for a sign
that I can make something
out of nothing.

The Vase

By Jessamyn West

Born in Indiana, Jessamyn West (1902–) was thirty-seven when she wrote her first story and almost forty-three before she published her first book. She had married soon after graduating from Whittier College, and for a time taught school—all six grades in a one-room schoolhouse. Returning to school herself to work on her doctoral degree, she was stricken with tuberculosis. The illness meant lengthy hospitalization and lengthy bed rest at home, but it allowed her both time and, she has said, "permission" for writing: that is to say, since she could do little else, she need not feel guilty about writing.

West achieved wide fame with her first published book, The Friendly Persuasion, *in 1945, a group of short stories about a Quaker couple, Eliza and Jess Birdwell. The collection was later translated into many languages for publication abroad, and also made into a movie. Many of the stories are based on the family memories of Jessamyn West's own mother, Grace, who had always wanted to write but never did. And Eliza (who in the stories is a Quaker minister as well as a wife), is based on West's Quaker grandmother, a book-loving and poetry-reciting woman who was an important influence on the young Jessamyn.*

West's many works include novels, autobiographies, short stories, poetry, essays, movie scripts, and an opera libretto. She has received many honorary degrees and literary awards. Her interests, she says, include "family, words on paper (this means books and writing), the world of nature (weeds, wind buzzards, clouds) and privacy." She prefers housework to cooking: "When you finish [housework], you have painted a picture: the still life. . . ."

Jess, who had planned the day for work, tried to turn it to some use by regarding the rain which had spoiled it. He walked

restlessly from the sitting-room window on the left of the front
door to the sitting-room window on the right; but there was
no difference in the rain. From either place he saw it fall in a
great sheet which, the house splitting, set himself, he figured,
in the center of a cavern of water, set him like the clapper in
the middle of a sounding bell. He silent, the bell itself resound-
ing with the clatter which water, dropped from a great height,
makes on a shell of almost empty clapboard (beds, stoves,
carpets, a human being or two in no wise filling it).

He sent his hearing out beyond the house, testing his belief
that the ear alone can tell winter rain from summer, and had
his belief bolstered, for rain falling upon trees in full leaf has a
gentle huskiness which the bare and rigid limbs of winter
cannot duplicate.

Jess, who was no great hand at hiding the light of his knowl-
edge beneath a bushel of silence, called out to Eliza, and she,
her bread set, came in from the kitchen.

"Thee call me, Jess?" she asked, wiping her hands, rosy from
the kneading, on her apron.

"Eliza," Jess said, "blindfolded, thee could tell the sound of
rain in winter from rain in summer."

"I couldn't," Eliza said flatly.

Jess regarded his wife morosely. Among women Eliza was,
he knew, peerless; but all women he sometimes feared were
flawed, whether in their making or by a throwing away of their
natural heritage, he couldn't say.

"Ain't thee interested in knowing how?" he asked. "Ain't
thy curiosity pricked? Don't natural phenomena mean any-
thing to thee?"

Some did, some didn't. The sound rain made was one that
didn't. Bread rising, house shining, fire dozing on the hearth,
these were phenomena, and natural, too, Eliza supposed, and
for the time being quite enough for her. "Jess," she said,
"I don't see any point being blindfolded and trying to tell
winter rain from summer. Leave it off," she advised with great
practicality, "and save the guesswork."

Jess turned away from the windows and the rain. Women
were too much for him. Still, never despairing of lightening
their dark, he said, "Rain on leaves makes a different sound

from rain on bare limbs."

"In a stand of pine," Eliza objected, "thee'd have to take thy blindfold off."

Jess sighed. He walked to the secretary which filled a great part of the wall on the south side of the door to the kitchen. "I wasn't speaking of evergreens," he said.

There on the middle shelf of the secretary, in a small clearing between books, stood other reminders of woman's strangeness. A queer race, Jess thought, gazing at the set-out, related to us by marriage but mighty odd in spite of it. What were these objects Eliza had saved, set forth like rarities in a museum, preserved, while articles of greater use were lost and broken? A fragment of stone from the chimney of the old log house, a circle of shining wood stamped "Holy Land," but having, to Jess, the look of a piece of local butternut, well polished; a dried orange fetched home from New Orleans, a thimble which Eliza believed had been used in sewing a rent in William Penn's breeches, six feathers small and much faded, plucked long ago from some California bird and lodged now in a squat red cup; a thing of glass, which Jess in twenty years of seeing had never been able to fathom, and which he now took from the secretary and turned about in his hands.

"What's thee call this thing, Eliza?"

"A vase," Eliza said.

"It couldn't very well be a vase," Jess told her reasonably. "It's open at both ends."

"A vase," Eliza said, "is what I've come to call it."

Jess held it off. He peered through it. He ran his thumb over the putty swans, set above the surface of the glass, he traced the fluting at the top which putty had enlarged. "Looks like it started life as a lamp chimney," he said.

"It did," said Eliza.

"A broken one at that."

"Yes," said Eliza, "it was broken."

She took the vase from Jess and curved her white, plump fingers about it, the fingers which at the time of the vase's making had been neither white nor plump, but pink and thin like bird's legs, and as quick in their movements as bird's legs, too.

"Thee's made a neat thing of it," Jess admitted. "Orna-
mental." But he had, in all truth, to add, "Useless though.
Painted over so's it won't do for a chimney. Open at both ends
so's it won't serve as a vase. When'd thee make it?"

"Thee saw it the morning I started it."

"I took no notice."

"No," Eliza said, remembering, "thee didn't."

"What'd thee aim," Jess asked, "making it?" Knowledge of
his suppleness, turning in two minutes and with good grace
from a scientific contemplation of rain's varying sounds to an
examination of a misnamed dido, filled him with content.

Eliza, who had been facing the fire, which lay on the hearth
like a red eye, angry with the sight of so much water falling,
turned to face her husband. She touched the vase, scalloped
top and swelling sides. What was her aim? There were more
aims in it, maybe, then she knew, and even if she knew them
all, could name and number them for Jess, would he under-
stand? He, who had seen her when the first swan, buoyant
upon its painted ripples, was still wet from her brush—and
not noted—would he understand now, so many years later?
When the colors on the vase were beginning to fade?

There was one purpose clear enough for her to see and say
certainly.

"I aimed to make a pretty thing, Jess."

Yes, that was true. That in the beginning had been her whole
aim. A spattering of water dashed against the hot lamp chimney
had snapped a circle from it, but she had not thrown it away;
she had set the chimney on the pantry shelf, remembering a
neighbor's saying that such a broken thing could be so painted
and decorated as to be an ornament to any parlor. It had stayed
there a long time, waiting an hour when, work slackening, she
could set a picture onto its glassy bareness. And as the days
passed it gave her pleasure, stepping in and out of the pantry to
see it waiting. Between all the necessary thoughts of cooking
a design to set upon the chimney began to work itself out in
her mind, a plan which in the midst of the kitchen traffic
opened a place of quiet and aloneness for her.

Jess, watching her turn the vase about in her hands, said

nothing, so she repeated her words. "I planned it to be an ornament, Jess. A pretty thing for our parlor."

Could Jess understand that? Prettiness outside, Jess understood, she knew. Many a time he'd roused her, just fallen asleep, to look at the stars, had carried many a flower inside to her, had called out to her to look at a cloud, a sky at sundown, a bird, a curious stone, even. But prettiness inside? Did pillow shams thick with satin stitch and French knots given him a smidgin more pleasure than unbleached muslin bare as when it came from the looms? Did it matter to him whether there were peacock feathers over the grate and gilded cat-tails in the corner? She thought not.

But a woman lived in a house, not outdoors. A sunset didn't come inside, light the wall behind the kitchen range so's she could see it while cooking supper; clouds taking this shape or that didn't settle down on the mantlepiece to keep her company while mending. The prettiness a woman saw, she had to make, she had to build it up from odds and ends. Did Jess ever note her handiwork? The articles embroidered, painted, stenciled, gilded, dyed? The combcases, footstools, doilies, tidies, fire screens, rugs, penwipers, lambrequins? Did he see how the bareness of timber and stone had been hidden and softened, until the room, to her eye, showed itself as prettier than any cloud, and not to be outdone, even by a rose.

Jess thrust out a finger, touched one of the swans. "An ornament for our sitting room," he said. "Time on end."

Eliza noted he didn't say pretty. Well, that didn't matter. It had come to mean more to her than prettiness, anyway.

"Jess," she said, "I don't know but what in case of fire this'd be the first thing I'd save."

Jess looked anew at the object she held. "Before the family Bible?" he asked. "The letters? The deeds?"

"For those," Eliza said, "I could count on thee."

"But for some things, not?"

Eliza said nothing.

Jess' big nose wrinkled at the bridge. The lines that ran downward from cheekbone to jaw deepened. His large, well-

muscled mouth moved a little as if he were savoring beforehand the words he was about to say.

"There are those," he said, "who say I carry thee around on a chip, Eliza. Figger me a poor apron-tied old fellow, married to a female preacher and not able to call his soul his own."

Eliza knew this to be true; still, for all they said, there were things Jess was not to be counted on for. Or maybe, not Jess. Maybe man, any man.

Jess remembered temperatures: ten below or 102° in the shade. He remembered the dimensions of snow-drifts and the number of inches that had fallen in a single cloudburst. Eliza remembered how she had felt and from this determined season and weather.

She had started her vase on a summer morning, she knew, for she could remember how warm she had felt standing in her nightdress by the bed. In the half-light Jess was only a shadowy mound beneath the covers, stirring a little as he settled toward deeper sleep. It was before sunup and outside, birds, rousing, sang their short easy songs, the ones which could be performed while half awake.

It was earlier than rising time, but she had no sleep left in her and was too happy to lie still any longer. In a moment's musing, she then seventeen, there had come to her such bliss in a sudden picturing of what her life and Jess' might be, that she felt she must be out of bed, and advancing toward it; moving forward into the opening years, toward the children, toward the May mornings and snowy evenings, toward the fine housewifery and lovingkindness, toward the old age when she and Jess, sleepless through the long nights as old people are, would say, Remember, remember, as they lay listening to wind or rain. It all came to her that summer morning on waking and she had to be up out of bed and hastening to meet it.

She carried her clothes downstairs, walking silently with bare feet across floor-boards still warm with yesterday's heat. She washed in soft cistern-water and dressed in the kitchen. She wished that Jess might have been hungry for seven breakfasts in one so that she could have cooked every dish she'd ever heard him say he fancied: buckwheat cakes, soda biscuits,

sausage gravy, tenderloin, ham with its taste of salt and hickory smoke.

The fire caught and blazed. The fruity, summer air had to take the column of autumn smelling smoke with what grace it could. Biscuits cut and dolloped with cream waited the oven. Her nightdress was folded as precisely as if measured. The best cups were on the table. Psalm 101 had been read and meditated. But it was not enough. Bliss was not yet served. It was then she remembered her vase.

She brought chimney, putty and paints from the pantry and sitting at the kitchen table, the design, known to her mind a long time, became now a separate thing, began now to live outside herself, and there, seemed able in its expression of her happiness to hasten her advance into the life she had imagined.

Her fingers, remembering flowers, enlarged with putty the meager crimping at the chimney's top to petal-sized scallops. Over the break, mended with putty, she molded a plumed swan, a great bird with arched breast and flaunting tail. About the swan she painted blue water and green reeds and the swan itself she made a dazzling white. Overhead was the sky of summer across which long thin clouds like frayed pencils drifted, and the frayings, all raveling out toward the same direction, made it seem as if a wind, light but persistent, blew across the picture.

There were to be two swans, finally, but now Eliza rested. She rose and walked from the table, set the biscuits to baking and moved the skillets to the front of the stove. Still, it was not they, not the laid table, nor cooking food, which seemed nearest to what she had seen, or dreamed, lying upstairs by Jess' side: it was the vase, the swan, the reeds, the summer sky.

"Thee looked it over," Eliza told Jess, "the morning I started it. Came downstairs and rocked on thy toes in front of it."

"What'd I say," Jess asked, "rocking there? I reckon I wasn't speechless."

"No, Jess," said Eliza, "thee wasn't speechless."

"What'd I say?" he persisted.

"Thee said," Eliza told him, "and well I remember, 'What's for breakfast? I'm hungry enough to eat a biled owl.' "

Jess rocked a little on his toes now. "Well," he said, "that was something. Better'n saying I could eat a biled swan, I reckon."

That was something and she had not been unhappy, setting the praised breakfast on the table, speaking with Jess of what fruits he would bring in for canning, saying the day would be another scorcher, lifting the pretty cup, which in itself set their eating apart from ordinary meals. But when breakfast was over the vase had taken on a paltry look and some of her happiness had ebbed away: it was nothing, she saw, but a mended lamp chimney; the great swan, putty and paint. The wind didn't really blow—that was only a trick of her painting, a thing any-body'd see through. She set the vase away in the pantry again. She looked up at it there on the top shelf and wondered how it could have been for a half-hour, not only a place of stillness for her, beautiful and far away, but a setting forth somehow of all the bliss and eagerness she had felt before sunup, listening to the beginning bird songs and seeing the children's faces.

It was a long time before she touched it again. The children's faces she had seen upstairs were real faces, and their voices and needs were real, not only May mornings and winter evenings, but all the hours between. The house, she trimmed and soft-ened as she had planned that morning, so that now she would rise from her chair, open a door, and surprise herself anew with a room which waited her, as far from bareness as a grafted tree in full bearing is from a seedling.

She often thought of the vase, but there had never come another moment like that of the first summer morning—and time, for her, was always short. Still, she planned to finish it, set the second swan in place beside the first. There were days when its incompletion troubled her mind, gave her the feeling that she had turned away from something more than a painted lamp chimney . . . that all the children, Jess, the house, her church even, were not reason enough for having neglected it . . . that it was more to her than she understood.

In spite of this, the vase waited, unfinished for years. Then in November, after little Sarah's death, she had taken it from its shelf late one afternoon and with chair pushed close to the

sitting-room fire had set about painting the second swan, a companion for the first. It was a miserable day; there had been rain in the morning, but after dinner the air had sharpened and snow had begun to fall, not briskly, so that her thoughts were of sleigh rides or the boys fighting snow battles, but listlessly so that her mind turned toward the year's end and little Sarah's grave. She had passed from the first period of grief when her arms had known the loss of her child as sharply as if a portion of her own flesh had been cut away, and she was able to say God's will be done; still she was left with a great heaviness and it was strange, even to her, that this had seemed the hour to finish the vase.

If little Sarah had been alive she would have stood by her side, watching her brush strokes, saying, "Is thee making a bird, mother?", and outlining the curving breast of the second swan she thought, I can never lose her. She remembered the morning she had started her work, all that joy and vision of joy, as if the whole of life would be nothing but delight, nothing but smoothness with never a setback. How different this was, no vision, never misdoubting that there were sorrows ahead, but somehow a tranquil satisfaction in seeing the second swan, the companion for which the first had waited so many years, take shape, and in believing, once again, that it was a real wind which moved the frayed clouds across the summer sky.

The second swan was never finished, though. It remained a shadow, an outline. As she had begun to touch it with whiteness, Jess, bareheaded, hands and hair wet with melting snow, came in.

"Eliza," he cried, "it is more than I can bear."

She had set her brush aside and said, "What is it, Jess?", though she knew.

"Sarah's grave," Jess said. "Under the snow. She loved the snow, so. Thee knows how she loved it, Eliza."

Then he did a thing he had never done—before or since—he dropped on his knees and laying his head, the red hair darkened with melting snow, on to her lap, had cried, not quietly, for Jess was not a quiet man.

"Eliza," he asked, "had thee forgotten that the first words Sarah ever spoke were about the snow?" He lifted his head from

her lap and looked toward the windows. "There she stood," he said, "clapping her little hands and crying. 'Pretty flowers, pretty flowers.' "

Eliza had not forgotten. The words had been in her mind all afternoon. "No, Jess," she said. "I haven't forgotten."

"How can thee be playing then?" Jess cried. "Playing with thy paints? And Sarah's grave there under the snow?"

Eliza smoothed the damp hair. "I haven't forgotten God either, Jess," she said.

After a time Jess had grown calm, had warmed himself at the fire and gone out to finish his evening's feeding. Then Eliza had set the vase, unfinished as it was, one swan but the dream of a swan, gray and shadowy, and without plumage, on the shelf of the secretary. Let it stand there, she thought. It was, perhaps, the best she would ever be able to do, and she was content that it should have its place among the other things she treasured—reminding her of so much, the dream before sunup, and much beside, that, never dreamed of, had come since that morning.

The rain was still pelting down and Jess had forgotten the vase. "Eliza," he said, going back to his old idea, "not only seasons, but places, I'll venture, could be told from the sound of the rain. The jungle," he said, fired with the thought of so much rain and so much geography, "how'd it sound there? Or on a mountain peak, how'd it sound falling on bare rocks? Or on the sea? Water spanking down on water? Well, here we are," he subsided. "Stuck. We'll never know."

Eliza didn't feel stuck. She felt at home.

Jess peered out the window. He reconciled himself to rain in Indiana. "Got to make a run for it," he said. "Cows bawling their heads off."

He clasped Eliza to him before he went out, as warmly as if bound, as in his mind no doubt he was, on a journey, and Eliza felt between his clasping arms and herself, the vase, which she still held, separating them. And yet, she supposed, seen in another way, it was a link. After he left she set it back in the secretary, but she could still feel the pressure of its fluted rim against her breast as she moved about the kitchen busy with her evening work.

Two Collages

By Miriam Schapiro

*Miriam Schapiro (1923–) has moved from working in
a largely male-defined style—the Abstract Expressionism
prevalent in New York in the 1950s—to the creation of
works more deeply rooted in her life and experiences as a
woman. Born in Toronto, Canada, Schapiro studied
at the State University of Iowa, where she received the
bachelor of arts, master of arts, and master of fine arts
degrees. After her marriage to Paul Brach, a fellow art
student, she moved to New York, where she began
to exhibit her paintings. In her early thirties, she had a
child. She soon discovered that combining marriage,
motherhood, and her career left her with feelings of "enor-
mous guilt." To clarify her feelings, she began to create
a new kind of painting, narrow, vertical, and built up of
separate compartments, suggesting a sense both of aspira-
tion and limits.*

*By 1970 Schapiro had moved to California, where
she met Judy Chicago (see section 2) and helped establish
the Feminist Art Program at the California Institute of the
Arts in Valencia. Here she participated in the creation
of an unusual art exhibit, Womanhouse. Womanhouse was
a wrecked, abandoned house in Hollywood which twenty-
one students and their teachers cleaned, repaired, and
redecorated, creating rooms that would express their
experiences and fantasies. Schapiro and another woman
constructed a dollhouse. When it was finished, Schapiro has
said, she "realized that it was a pivotal expression in my
life."*

*She began to produce a completely new kind of work:
collages that made extensive use of fabrics. "I wanted
to explore and express a part of my life which I had always
dismissed—my homemaking, my nesting. I wanted to
validate the traditional activities of women, to connect
myself to the unknown women artists who made quilts,
who had done the invisible 'woman's work' of civilization.*

*. . . The collagists who came before me were men, who . . .
often roamed the streets at night scavenging, collecting
material, their junk, from urban spaces. My world, my
mother's and grandmother's world, was a different
one. The fabrics I used would be beautiful if sewed into
clothes or draped against windows, made into pillows, or
slipped over chairs. My 'junk,' my fabrics, allude to a
particular universe, which I wished to make real, to
represent."*

That particular universe is represented here by two
Schapiro collages. Souvenirs (1977) combines handkerchiefs,
a grid format, and drip paint in an organization of squares

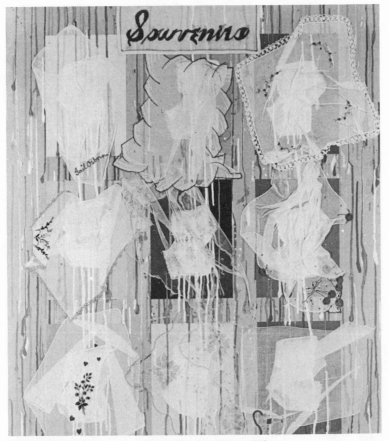

Plate 19. Miriam Schapiro. SOUVENIRS. Acrylic/collage. 1976.

reminiscent of a patchwork quilt. My Nosegays Are
for Captives *(1975) uses an apron and handkerchiefs. The
handkerchiefs are gifts from friends and acquaintances, and
thus represent the community of women with whom
Schapiro sees herself as collaborating.*

*Schapiro has taught at Parsons School of Design, the
University of California, San Diego, the Tyler School
of Art, and Bryn Mawr College. She is the recipient of many
awards and fellowships, and her paintings hang in the
permanent collections of over two dozen museums, includ-
ing the Hirshhorn Museum in Washington, D.C., and the
Museum of Modern Art in New York.*

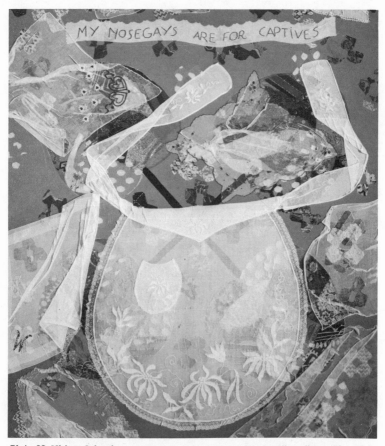

Plate 20. Miriam Schapiro. MY NOSEGAYS ARE FOR CAPTIVES. **Acrylic/collage, 40 × 32 in.
1975.**

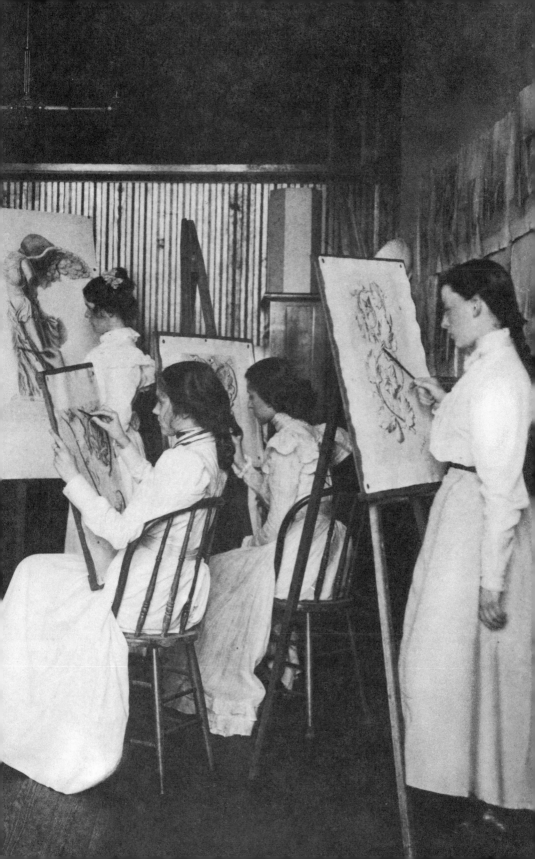

2: Becoming an Artist

Obstacles and Challenges

LIKE ELIZA in Jessamyn West's story "The Vase," women of all times, in the midst of their household work, have experienced the universal human need for creative expression. For most of these women—the homebound makers of home-used articles— art was an extension of functional tasks, integrated into their daily lives. We have seen that contemporary women artists like Glen Corbett Povey and Miriam Schapiro have drawn upon those traditional household arts for the materials of their professional work. That work, however, like the work of most of the artists represented in the remainder of this book, differs from household art in several important ways. Intended to be neither functional nor decorative, the art we turn to now is primarily a personal, direct expression of each artist's specific values, feelings and/or ideas about herself and the world beyond her home, as well as within it. Further, for these women, each completed piece is but one addition to an ongoing pursuit of creative expression. For them, art is a primary occupation which has assumed equality with household work, and often priority over it.

As the selections in section 2 attest, becoming an artist may take a great deal of time: time to experiment, to gain technical knowledge, to arrive at an intimate understanding of one's world—be it the family, the community, or a larger social order. Moreover, becoming an independent artist, like becoming a

mature adult, requires that one know oneself: know the differ-
ence between what others see and what the self sees, and act on
that knowledge.

For the act of creation is, first of all, action. It is making some-
thing that never existed before in just that way. It is putting to-
gether materials that others have used (and perhaps some they
haven't) into new patterns. It is standing behind one's creation
despite the fact it may not be accepted or understood. It is be-
lieving that one has the right to do these things, and persisting
in doing them—action that requires both discipline and
strength.

Although the phrase "becoming an artist" suggests youthful
activity, we include in section 2 work by and about women of
all ages. For inner growth and self-development are processes
which do not end with becoming an adult. With each new per-
sonal experience, each new challenge or opportunity, all of us
learn more about ourselves and become better able to translate
this knowledge into action. What joins each of the artists in this
section—indeed, throughout this book—is that in pursuing
their separate careers, they often have faced obstacles and chal-
lenges common to all women. In the words and visual images
of these artists we experience the searching, sometimes des-
perate yearning, of many women, whether young or old, to be
themselves, sometimes against overwhelming social or eco-
nomic odds. We can also see, in the recent work of some of the
artists presented here, an expression of increasing confidence—
in themselves as artists, as well as in their right to the personal
freedom being claimed by many women today.

In many ways, the challenges to becoming an artist are the
same for both men and women. All artists, indeed all people,
need financial security; yet works of art have rarely produced
sufficient income for an artist to live by. Artists in every period
of history have, for the most part, needed to take time away
from their art in order to earn their bread. For the male artist
(without a patron) the necessary choice often has been to seek
employment outside the home, or to produce income through
some self-employed means. But in times more culturally rigid
than ours, women (who almost never had patrons) have had lit-
tle opportunity to support themselves except through marriage.

We are all familiar with the stereotype of the (usually, male) writer or sculptor or painter who is struggling alone in some garret room, oblivious of daily routine. We have less often seen images of artists who have been also wives and mothers, or women living alone, or in the hub of a full social environment. Before and during the time of Shakespeare, until the Industrial Revolution, women worked in the home—most of them from the time they rose each day until the time they went to sleep, every day of the year. When women did begin to enter the paid labor force, their hours of work were long: twelve, fourteen, sixteen hours a day. Although working conditions for laboring men were similar, many of these same women returned after their jobs to homes, husbands, and children—representing an additional drain on whatever creative energy they possessed. For all artists, no matter what their economic situation, work continually interrupted often becomes work incompleted. The male artist of a social class that permitted him to earn a decent living, could, at the end of a day at his job, at least be assured of a few hours of concentrated creative work, free of household demands. But for most women throughout history, the means of independent financial security, the private time to create, have simply not existed.

In addition to financial security and time to create, an artist needs educational opportunities, as well as first-hand experience of the world beyond the home. Society, however, has for hundreds of years stereotyped women as less intelligent than men, less worthy of education, and too weak to venture out alone to seek their fortunes. "Respectable" young women, during those many years, did not sally forth for adventure or for education, but were trained to acquire skills suitable to home and marriage. General schooling for females lagged behind that for males; and it was not until the 1870s that women gained access to a higher education equivalent to that which had been available to men in the United States since the seventeenth century. The private tutoring and reading of a fortunate few was still subject to parental censorship. Educated at home, Ellen Glasgow, the famous American novelist of the early 1900s, has said in her autobiography that she dared not read Darwin and other "radical" writers of the time except in secret, or in open

rebellion against her father. Glasgow, a white woman, could at least read; in her native South, Black women of her era, along with Black men, were still largely deprived even of literacy. If a gifted woman did, on occasion, possess sufficient education and social knowledge for literary expression, she was advised to write on topics "acceptable" for female minds, such as love and religion. Faced with these and other restrictions, a number of resourceful women writers adopted male pseudonyms. Thus the work of nineteenth-century writers George Eliot (Mary Ann Evans) and Currer Bell (Charlotte Brontë) got into print, and was highly regarded by the public of their time.

Historically, educational opportunities for women visual artists have not been much better than for women writers. Although women were sometimes allowed to take art classes, or to study art privately with a tutor, their training was different, less thorough, and often less professional than that of male artists. Rarely were women encouraged or allowed to work competitively in genres (such as historical painting) which brought fame to and displayed the great talents of their male contemporaries. Indeed, many women (with the notable exceptions of the daughters of painters) were through the eighteenth century prevented even from pursuing the art of portraiture. Such pursuit, according to the renowned Dr. Samuel Johnson, was deemed "indelicate in a female." Until less than one hundred years ago women could not participate in co-educational art classes or study human anatomy from live, nude models. One famous photograph by Thomas Eakins shows women in 1883 studying the anatomy of a cow, which was their only studio model.

Thus, it is hardly surprising that a woman in Shakespeare's time, of Shakespeare's talent, should have failed to make so much as a beginning as a poet and a dramatist in a society which did not educate or encourage women to be independent artists, which regarded them as created to serve the needs of men, and which was openly hostile to any woman who dared to be different. Facing the obstacles of parental disapproval, "Shakespeare's sister," Virginia Woolf's hypothetical heroine, ventured into the outside world of the theater to learn the arts of playwriting and acting. Yet because she was a woman, and

uneducated, her work was not taken seriously. Also, because she was a woman, she had no financial means of support outside of marriage, and thus was forced into emotional and financial dependence on those who valued her body more than her artistic genius: a dependence which stifled her creative aspirations and spirit. Her genius never got into print.

"Yet genius of a sort," says Virginia Woolf, "must have existed among women [in all historical periods]. Now and again an Emily Brontë . . . blazes out and proves its presence. But it certainly never got itself on to paper." (Or, we might add, on to canvas, or into wood or stone.) Even in Shakespeare's time, however, women did occasionally achieve success and fame in their art, although their celebrity seldom survived succeeding centuries. Anne Bradstreet (1612–1672), the wife of a well-to-do American colonist, was America's first and most widely-published poet. For that distinction, Bradstreet's name, if not always her work, has remained known. Recently the work of other women writers of Bradstreet's era has been "discovered" and reprinted, and is now receiving the serious critical attention it deserves.

Even with the assurance that her poems had been accepted for publication, Anne Bradstreet was aware of the precariousness of her achievement. In the "Prologue" to her collected poems, she defended herself against the charge of plagiarism in advance, as well as against the opinion that her success was the result of luck, rather than of hard work. Although she reminds her readers that the ancient Greeks set great store by the creative spirits of the nine female Muses, she observes that even this fact will not much influence public opinion in her behalf; rather than admit of excellence in women's work, her society will conclude that the Greeks were generally fools and liars. She ends by pleading "some small acknowledgement" of her talent, despite the fact of her gender.

Two centuries after Bradstreet, the works of Charlotte Brontë and Emily Dickinson present further refrains in a long, historical chorus of frustration: education denied; the needs of caregiver conflicting with needs for private time to create; the needs to explore conflicting with society's limits; the disapproval of

parents; the lack of sufficient income. Like Charlotte Brontë herself, her fictional heroine Jane Eyre earns her keep by working as a governess—a time-consuming and selfless occupation. Jane leads the same "sequestered" life experienced by Brontë, who, as a writer, longed for a broader experience of the world. In the closely autobiographical passages reproduced here, Jane Eyre inwardly rebels against the obstacles oppressing her creative imagination, but is forced to succumb to the limitations imposed upon her as a female.

Poet Emily Dickinson, on the other hand, knowing clearly who she is and what she must do, at the same time expresses the frustration of realizing that her ideas and her work will not be appreciated or understood. Choosing a life of solitude in which— by remaining at home—she retained financial security without having to marry, Dickinson devoted her life to her writing. Like many artistically independent women before and after her time, Dickinson's private achievements did not guarantee public acceptance; and even her private success was often at great emotional expense, as we can see in both her letters and poems. No longer the child who thought like her parents, or who believed what society expected her to believe, Dickinson reveals in her writing the pain of going against convention, but also the pride she felt in meeting—in her own religious terms—her "calling" as a poet.

Still, despite external obstacles and challenges, what continues to obsess each of the artists who appear in section 2 is their intense need to create: to turn their personal energies, talents, and imaginations into new forms of expression. In Gertrude Käsebier's *The Sketch*, the photographer underlines the central importance of the creative act, in which the young woman artist's entire being is absorbed and concentrated. Frances Johnston's photograph of young women artists at their easels also captures the inner intensity of these determined students. In May Swenson's poem "The Centaur," we encounter the stubborn creative spirit of the artist who, as a child (despite her mother's disapproval), turned a willow branch into a horse, herself into the rider, and then both into her fantasy of a centaur, half-horse, half-human.

Swenson's poem also suggests—especially since many chil-

dren engage in similar make-believe—the playful side of the
artist's activity. Seldom the gloomy, moody creatures portrayed
through stereotypes, many artists throughout their lives enjoy
a "childlike" pleasure in imaginative play such as that de-
scribed by Swenson. All of us, artists or not, have enjoyed some
form of the play of movement (skipping a stone), of color and
shape (finding pictures in the clouds), of sound (tapping out
rhythm with a stick). All of these contain elements of the arts;
all represent the playfulness in which art often begins, and the
play in the arts to which we respond. The artist learns to trans-
late and incorporate these playful elements into a particular
medium. The pleasureable activity, at a certain point, becomes
the artist's work—when discipline, technical training, the im-
position of form and order, all assume major importance. In
this sense, the artist is one who works at play, turning fantasies
and dreams into responsibilities.

The speaker in Michele Murray's poem "At Sixteen" ex-
presses her own strong sense of responsibility to her art: art
which she once imagined (metaphorically) as a rainstorm which
would quench her creative "thirst," but which instead has
generated new dreams and creative desires needing expression.
Carmen Lomas Garza, a contemporary visual artist, presents
an example in her interview of someone who knew at an early
age that she must actively work, as well as play, at her art—
teaching herself to draw, filling school notebooks and every
spare moment with sketches until, at last, she could have proper
materials and instruction. Art classes were for her the main
reason for attending school; through her art she could create
images which expressed her own sense of herself—a self unseen
and disregarded by her peers, because she was a Chicana.

Moving beyond the themes of external obstacles and chal-
lenges—economic, social and technical—Erica Jong's essay in-
troduces other themes: the internalized challenges and conflicts
faced by the woman artist. Becoming an artist, suggests Jong,
requires that one first become a "self." Even with educational
opportunities, time and the energy to create, all artists need
self-confidence; for the act of creation is also the bold act of
"naming," of defining in new shapes and forms ideas and feel-
ings common to many, but given new depth and meaning

through art. Art does not ever repeat in exactly the same way anything that has been created before, nor can an artist who lacks the confidence to do something different and new hope for the originality art requires. Yet, as Jong tells us, women have always been taught that they are not men's artistic or intellectual equals; women have always been encouraged to take their opinions from others, to depend on others' approval for their own sense of self-worth. Thus, while all artists have had to take risks, women artists in particular have been socially burdened with a strange double-bind: to become artists and thus risk losing their female identities; or to be the women society expects, thus losing their identities as artists. Doubting their own abilities, their own opinions, indeed themselves as women— yet wishing to create—women artists have for centuries expressed through their work varying degrees of frustration and despair. Some artists, like Jong herself when she was younger, have tried to resolve their inner conflicts by ignoring them: by writing or painting "like a man," which has often been considered the highest compliment that can be paid to women artists, yet which denies them an authentic voice of their own.

In excerpts from a journal she kept during one year of living entirely alone, May Sarton presents yet another kind of inner conflict the woman artist may confront: of having to choose between a life of solitude, for the sake of art, and a life with others—which for most women also means to assume the role of caregiver, often at the expense of art. Being alone, Sarton sometimes faces "failures of nerve" and longs to feel connected with the lives of others. Yet, having seen in the lives of other women artists the demands a family makes, Sarton concludes that for her, solitude is the better (although imperfect) alternative; she is grateful for the luxury of "time to be." Included in Sarton's journal, however, is a letter from a married former student, "K," which poses questions similar to those posed by Jong. Becoming aware that for years she has unconsciously borrowed in her writing a "voice" not her own, K wonders how she will find the means of expressing the person she really is—whom she has only begun to discover.

K's letter also raises problems concerning the distractions and influences of living with a family. Today, not only do more

women who are married pursue artistic careers; they also, more than in the past, continue their careers when they have children. Sometimes they raise their children alone, depending financially and emotionally on no one but themselves. Susan Griffin's poem reflects the conflicts experienced by an independent woman whose life combines the demands of motherhood and art. The speaker in the poem struggles to support herself and her child through her writing and poetry readings— aware that the readings she gives will probably not so much as pay for the baby-sitter, aware as well of the needs of her child which must come before her own. As fiction writer Tillie Olsen has said in a much-quoted essay, "Silences: When Writers Don't Write":

> . . . women are traditionally trained to place others' needs first, to feel these needs as their own. . . . their sphere, their satisfaction to be in making it possible for others to use their abilities. . . .
>
> More than in any human relationship, overwhelmingly more, motherhood means being instantly interruptible, responsive, responsible. Children need one *now* (and, remember, in our society, the family must often be the center for love and health the outside world is not). The very fact that these are needs of love, not duty, that one feels them as one's self; that there is no one else to be responsible for these needs, gives them primacy. It is distraction, not meditation, that becomes habitual; interruption, not continuity; spasmodic, not constant toil. . . . Unused capacities atrophy, cease to be.[1]

Even in situations where women can count on themselves or others for adequate financial support, the demands of motherhood and the monotonous, daily chores of housework are psychological, as well as physical, burdens: consuming creative energy when they are performed, causing inhibiting guilt when a woman neglects them or turns their performance over to someone else (assuming she has that choice). Furthermore, the demands of her art may alienate the artist from other women who are wives and mothers, thus depriving her of a needed source of support. The speaker in Ingrid Wendt's poem "Dust," however, asserts her connection with traditional women, recognizing in her encounters with the daily dust, the unspoken experience of her mother's daily life. In endowing that experience

[1] *Harper's,* October, 1965.

with her own meaning, rather than choosing to deny or ignore it, Wendt also asserts the importance of subject matter that by conventional male literary standards would be beneath notice.

Hortense Calisher's "The Rabbi's Daughter" also presents the conflicts between the demands of art and the demands of domestic life. In this story a young woman pianist, rather than be separated from her husband, follows him to the city in which he works, far removed from her own world of music and from the father and mother who encouraged and supported her career. Her piano is crowded into the one small space available in her new home, yet she is afraid to practice for fear of disturbing the neighbors. She must wash dishes, although this makes her knuckles swell. She fears not only alienation from her art, but the consequent resentment that may alienate her from the husband whom she loves.

If the outcome of the conflict between art and love is only foreshadowed in the ending of Calisher's story, Patti Warashina's ceramic sculpture *You Captured My Heart* suggests one highly possible conclusion. Warashina's piece presents us with a woman who has entirely sacrificed herself to the ideal of romantic love. Her spiritual independence is symbolically killed as she serves up on a platter her heart, pierced with arrows. Warashina's deliberate, witty exaggeration offers both a comment and a warning by a self-aware woman artist.

Ruth Whitman's essay "The Divided Heart," on the other hand, offers an example of an artist's heart surviving even the combined, conflicting responsibilities of poet, wife and mother. It is true, she tells us: the pull of her traditional duties as a woman has often led her away from her work. But her art, in the long run, has been enriched. The work of the artist and the activity of mothering, sharing, and building a homelife, she declares, have actually strengthened one another. "Both together were the real total of my life."

Yet becoming a mother is a step, once taken, that is irrevocable. Despite the very real joys that motherhood can hold, in becoming a mother an artist faces new challenges that she is often unprepared to handle. Especially if she does not have the example and support of other women who are both artists and

mothers, she may feel herself alone in an alien land. Having come through one door, the woman in Dorothea Tanning's painting *Maternity* sees the fantasies of her own creative imagination waiting beyond another, distant door, toward which she cannot move.

The image of the door recurs in a different context in the poem "Prospective Immigrants Please Note" by Adrienne Rich. The act of immigration here is a metaphor for the act of discovering, or "naming," one's inner self—a self which others may not understand. Returning us to the theme of self-definition discussed by Erica Jong—a theme central to the work of becoming an artist, and which will be developed in section 3 of this book—Rich's poem also suggests the risks involved in each artist's discovering who she is. Passing through the door, she will be changed; life will not be the same. And, as Rich tells us, no one *needs* to pass through the door; no one *needs* to make herself vulnerable to new emotional experience in order "to live worthily." Yet, "how much will evade you,/ at what cost no one knows." How much art by women will be lost to us, as the audience, if women artists do not pass through the door and become truly themselves?

We conclude this section with works by Ellen Bass and Judy Chicago, women who represent a new generation of women artists today. These artists are in the process of affirming their identities, of going through and beyond the "door" and discovering—in addition to unavoidable uncertainties—a joyful sense of their creative power. With fewer social and economic obstacles than had women in the past, with greater freedom to learn, to explore, and to pursue a career in the world outside the home, many women artists are also more free to sort out and to reconcile within themselves often-conflicting attitudes and beliefs: to determine for themselves the difference between who they really are and what society would have them be. And, by breaking through "stone" or "the flower," sometimes too intent on their work to know "the breaking through/ as it happens," Bass, Chicago, and countless women artists today are at the same time clearing openings through which future women artists, in their own ways, will follow.

Shakespeare's Sister

By Virginia Woolf

*Virginia Woolf (1882–1941) was born in London to Julia
Princep Jackson Stephen and Sir Leslie Stephen. Her father
was a noted scholar and agnostic philosopher of his
day. Despite the family's comfortable income, provision was
made only for the higher education of Woolf's brothers.
Neither she nor her sister, Vanessa, was enabled to attend a
university. Woolf was educated at home in her father's
extensive library and in the upper-class literary society of
her parents' many friends (among them authors Thomas
Hardy, R. L. Stevenson, and John Ruskin). After her
mother's death in 1895, Woolf, always rather shy and frail,
spent most of her time studying, learning Greek, and
developing "an independent literary taste." At an early age
she was writing front-page critical articles for the* Times
Literary Supplement. *By age twenty-four she had written
her first novel,* The Voyage Out, *which was published
in 1915. At age thirty she married her devoted and
supportive admirer Leonard Woolf, who later became a
leader in the British Labour Party and a writer on economic
affairs. Their London home was a literary gathering
place, and together the Woolfs founded the Hogarth Press
(doing the printing themselves), with the purpose of
publishing "the best and most original" work of obscure
young authors, who at that time included Katharine
Mansfield and T. S. Eliot.*

*Before her death Virginia Woolf had written more than
twenty volumes of both fiction and non-fiction. An eloquent
defender of women's rights in England, she carried this
concern into novels such as* Orlando, Mrs. Dalloway, *and*
To the Lighthouse—*exploring the inner lives of women,
their female identities, and their relationships with other
women as well as with men. Of* A Room of One's Own
*(1929) it has been said, "It surpasses any feminist writing
since Mary Wollstonecraft in artistry and profundity*

of emotion." In this book-length essay, combining two
public addresses, Virginia Woolf challenges the common
assumption, current even in this century, that women are
intellectually and artistically incapable of producing great
literature. Women of genius have always existed, Woolf
says; but, unlike their male contemporaries, few women
have been granted the basic material and spiritual
conditions (an independent income and the privacy of a
room of one's own) to develop their talents. Since Virginia
Woolf's time, literary and historical research has restored
to us the poetry and prose of a surprisingly large number
of women who wrote during Shakespeare's day;[1] *however,*
these generally were women of a more privileged class
than Shakespeare's, nor, so far as has been discovered, did
they write for the theater. The following excerpts from
A Room of One's Own *indicate what might well have*
befallen a gifted young woman of Elizabethan times—
Shakespeare's sister—had she attempted a career like that
of her brother.

It would be better to draw the curtains; to shut out distractions;
to light the lamp . . . and to ask . . . under what conditions
women lived, not throughout the ages, but in England, say in
the time of Elizabeth.

For it is a perennial puzzle why no woman wrote a word of
that extraordinary literature when every other man, it seemed,
was capable of song or sonnet. What were the conditions in
which women lived, I asked myself; for fiction, imaginative
work that is, is not dropped like a pebble upon the ground, as
science may be; fiction is like a spider's web, attached ever so
lightly perhaps, but still attached to life at all four corners.
Often the attachment is scarcely perceptible; Shakespeare's
plays, for instance, seem to hang there complete by themselves.
But when the web is pulled askew, hooked up at the edge, torn
in the middle, one remembers that these webs are not spun in

[1] See, for example, writers of the period included in Mary R. Mahl and Helene
Koon, *The Female Spectator: English Women Writers before 1880* (Blooming-
ton, Ind., Old Westbury, N.Y., 1977).

midair by incorporeal creatures, but are the work of suffering human beings, and are attached to grossly material things, like health and money and the houses we live in

Here am I asking why women did not write poetry in the Elizabethan age, and I am not sure how they were educated; whether they were taught to write; whether they had sitting-rooms to themselves; how many women had children before they were twenty-one; what, in short, they did from eight in the morning till eight at night. They had no money evidently; according to [the historian] Professor Trevelyan they were married whether they liked it or not before they were out of the nursery, at fifteen or sixteen very likely. It would have been extremely odd, even upon this showing, had one of them suddenly written the plays of Shakespeare, I concluded, and I thought of that old gentleman, who is dead now, but was a bishop, I think, who declared that it was impossible for any woman, past, present, or to come, to have the genius of Shakespeare. He wrote to the papers about it. He also told a lady who applied to him for information that cats do not as a matter of fact go to heaven, though they have, he added, souls of a sort. How much thinking those old gentlemen used to save one! How the borders of ignorance shrank back at their approach! Cats do not go to heaven. Women cannot write the plays of Shakespeare.

Be that as it may, I could not help thinking, as I looked at the works of Shakespeare on the shelf, that the bishop was right at least in this; it would have been impossible, completely and entirely, for any woman to have written the plays of Shakespeare in the age of Shakespeare. Let me imagine, since facts are so hard to come by, what would have happened had Shakespeare had a wonderfully gifted sister, called Judith, let us say. Shakespeare himself went, very probably—his mother was an heiress—to the grammar school, where he may have learnt Latin—Ovid, Virgil and Horace—and the elements of grammar and logic. He was, it is well known, a wild boy who poached rabbits, perhaps shot a deer, and had, rather sooner than he should have done, to marry a woman in the neighborhood, who bore him a child rather quicker than was right. That escapade

sent him to seek his fortune in London. He had, it seemed, a
taste for the theatre; he began by holding horses at the stage
door. Very soon he got work in the theatre, became a successful
actor, and lived at the hub of the universe, meeting everybody,
knowing everybody, practising his art on the boards, exercising
his wits in the streets, and even getting access to the palace of
the queen. Meanwhile his extraordinarily gifted sister, let us
suppose, remained at home. She was as adventurous, as imagi-
native, as agog to see the world as he was. But she was not
sent to school. She had no chance of learning grammar and
logic, let alone of reading Horace and Virgil. She picked up a
book now and then, one of her brother's perhaps, and read a few
pages. But then her parents came in and told her to mend the
stockings or mind the stew and not moon about with books and
papers. They would have spoken sharply but kindly, for they
were substantial people who knew the conditions of life for a
woman and loved their daughter—indeed, more likely than not
she was the apple of her father's eye. Perhaps she scribbled
some pages up in an apple loft on the sly, but was careful to hide
them or set fire to them. Soon, however, before she was out of
her teens, she was to be betrothed to the son of a neighboring
wool-stapler. She cried out that marriage was hateful to her,
and for that she was severely beaten by her father. Then he
ceased to scold her. He begged her instead not to hurt him, not
to shame him in this matter of her marriage. He would give her
a chain of beads or a fine petticoat, he said; and there were tears
in his eyes. How could she disobey him? How could she break
his heart? The force of her own gift alone drove her to it. She
made up a small parcel of her belongings, let herself down by a
rope one summer's night and took the road to London. She was
not seventeen. The birds that sang in the hedge were not more
musical than she was. She had the quickest fancy, a gift like her
brother's, for the tune of words. Like him, she had a taste for the
theatre. She stood at the stage door; she wanted to act, she said.
Men laughed in her face. The manager—a fat, loose-lipped man
—guffawed. He bellowed something about poodles dancing and
women acting—no woman, he said, could possibly be an
actress. He hinted—you can imagine what. She could get no

training in her craft. Could she even seek her dinner in a tavern
or roam the streets at midnight? Yet her genius was for fiction
and lusted to feed abundantly upon the lives of men and women
and the study of their ways. At last—for she was very young,
oddly like Shakespeare the poet in her face, with the same grey
eyes and rounded brows—at last Nick Greene the actor-
manager took pity on her; she found herself with child by that
gentleman and so—who shall measure the heat and violence of
the poet's heart when caught and tangled in a woman's body?—
killed herself one winter's night and lies buried at some cross-
roads where the omnibuses now stop outside the Elephant and
Castle.

That, more or less, is how the story would run, I think, if a
woman in Shakespeare's day had had Shakespeare's genius. But
for my part, I agree with the deceased bishop, if such he was—it
is unthinkable that any woman in Shakespeare's day should
have had Shakespeare's genius. For genius like Shakespeare's is
not born among labouring, uneducated, servile people. It was
not born in England among the Saxons and the Britons. It is not
born today among the working classes. How, then, could it
have been born among women whose work began, according to
Professor Trevelyan, almost before they were out of the nur-
sery, who were forced to it by their parents and held to it by all
the power of law and custom? Yet genius of a sort must have
existed among women as it must have existed among the work-
ing classes. Now and again an Emily Brontë or a Robert Burns
blazes out and proves its presence. But certainly it never got
itself on to paper. When, however, one reads of a witch being
ducked, of a woman possessed by devils, of a wise woman sell-
ing herbs, or even of a very remarkable man who had a mother,
then I think we are on the track of a lost novelist, a suppressed
poet, of some mute and inglorious Jane Austen, some Emily
Brontë who dashed her brains out on the moor or mopped and
mowed about the highways crazed with the torture that her gift
had put her to. Indeed, I would venture to guess that Anon, who
wrote so many poems without signing them, was often a
woman. It was a woman Edward Fitzgerald, I think, suggested
who made the ballads and the folk-songs, crooning them to her

children, beguiling her spinning with them, or the length of the winter's night. . . .

Next I think that you may object that in all this I have made too much of the importance of material things. Even allowing a generous margin for symbolism, that five hundred a year stands for the power to contemplate, that a lock on the door means the power to think for oneself, still you may say that the mind should rise above such things; and that great poets have often been poor men. Let me then quote to you the words of your own Professor of Literature, who knows better than I do what goes to the making of a poet. Sir Arthur Quiller-Couch writes: "The poor poet has not in these days, nor has had for two hundred years, a dog's chance . . . a poor child in England has little more hope than had the son of an Athenian slave to be emancipated into that intellectual freedom of which great writings are born." That is it. Intellectual freedom depends upon material things. Poetry depends upon intellectual freedom. And women have always been poor, not for two hundred years, merely, but from the beginning of time. Women have had less intellectual freedom than the sons of Athenian slaves. Women, then, have not had a dog's chance of writing poetry. That is why I have laid so much stress on money and a room of one's own. . . .

I told you in the course of this paper that Shakespeare had a sister; but do not look for her in Sir Sidney Lee's life of the poet. She died young—alas, she never wrote a word. She lies buried where the omnibuses now stop, opposite the Elephant and Castle. Now my belief is that this poet who never wrote a word and was buried at the crossroads still lives. She lives in you and me, and in many other women who are not here tonight, for they are washing up the dishes and putting the children to bed. But she lives; for great poets do not die; they are continuing presences; they need only the opportunity to walk among us in the flesh. This opportunity, as I think, it is now coming within your power to give her. For my belief is that if we live another century or so—I am talking of the common life which is the real life and not of the little separate lives which we live as individuals—and have five hundred a year each of us and rooms of our own; if we have the habit of freedom and the courage to

write exactly what we think; if we escape a little from the common sitting-room and see human beings not always in their relation to each other but in relation to reality, . . . if we face the fact, for it is a fact, that there is no arm to cling to, but that we go alone and that our relation is to the world of reality and not only to the world of men and women, then the opportunity will come and the dead poet who was Shakespeare's sister will put on the body which she has so often laid down. Drawing her life from the lives of the unknown who were her fore-runners, as her brother did before her, she will be born. As for her coming without that preparation, without that effort on our part, without that determination that when she is born again she shall find it possible to live and write her poetry, that we cannot expect, for that would be impossible. But I maintain that she would come if we worked for her, and that so to work, even in poverty and obscurity, is worth while.

Prologue

By Anne Bradstreet

Born in England, Anne Bradstreet (1612–1672) is America's
first published poet. As a young bride she emigrated in 1630
to the Massachusetts Bay Colony, where her father
and her husband became prominent leaders. Her girlhood
education had been unusually nonconformist and thorough:
her father had been steward to the estates of the Earl
of Lincoln in Lincolnshire, England, and Anne Bradstreet
had been given private tutors and access to the Earl's
own library. In the New World, Anne Bradstreet raised eight
children while writing the poems which her brother-in-law
took, probably without her knowledge or consent, to
London. There, in 1650, they were published under the title,
The Tenth Muse Lately Sprung Up in America. Or Severall
Poems, Compiled with Great Variety of Wit and Learning,
Full of Delight . . . By a Gentlewoman of Those Parts.
The eight-stanza "Prologue" to the volume, part of which
follows, shows Bradstreet's need to defend the act of
writing against the criticism, indifference, or open hostility
of a society that believed a woman could not and should
not write poems. (The Governor of the Massachusetts
Bay Colony, John Winthrop, had demonstrated such
hostility just five years earlier, in blaming the "loss of her
understanding and reason" of a Connecticut woman on her
"giving herself wholly to reading and writing, and
[having] written many books.") A second, authorized edition
of Bradstreet's poems, including many additional later
poems, was published in 1678, six years after her death.

I am obnoxious to each carping tongue
Who says my hand a needle better fits,
A Poets pen all scorn I should thus wrong,
For such despite they cast on Female wits:
If what I do prove well, it won't advance,
They'l say it's stoln, or else it was by chance.

But sure the Antique Greeks were far more mild
Else of our Sexe, why feigned they those Nine[1]
And poesy made, *Calliope's* own Child;[2]
So 'mongst the rest they placed the Arts Divine,
But this weak knot, they will soon untie,
The Greeks did nought, but play the fools and lye.

Let Greeks be Greeks, and women what they are
Men have precedency and still excell,
It is but vain unjustly to wage warre;
Men can do best, and women know it well
Preheminence in all and each is yours;
Yet grant some small acknowledgement of ours.

[1] *Those Nine:* the nine Muses, daughters of Mnemosyne (Memory) and Zeus, who in Greek mythology preside over the arts and sciences.
[2] *Calliope:* the Muse of eloquence and epic poetry, whose name means "the beautiful-voiced."

Jane Eyre

British [handwritten]

By Charlotte Brontë

*Born in England, Charlotte Brontë (1816–1855) was five
years old when her mother died of cancer, leaving six
children, three of them (including Anne and Emily, who
also became writers) younger than Charlotte herself.
Although an aunt came to live with the family, Charlotte's
father, a rector in the small Yorkshire village of Haworth,
later enrolled Charlotte and three of her sisters in a
boarding school for clergyman's daughters, where the two
eldest died as the result of malnutrition and lack of
sanitation. In 1831 Charlotte attended a different school,
where she later returned to teach—the first of many
short-term positions as school teacher or private family
governess, the only respectable professions for a "lady" of
her time. In 1846, she, Emily, and Anne collaborated on
a book of poems, which was published under the
pseudonyms Currer, Ellis, and Acton Bell—names chosen
mainly to disguise the fact that they were women, and
thus to gain the serious critical attention ordinarily reserved
for men. The next year Charlotte Brontë, as Currer Bell,
published* Jane Eyre, *the first and most famed of her several
novels, and one which continues to attract a large audience
today. With the deaths of Emily, Anne, her father, and her
only brother, Charlotte at thirty-eight was the last living
member of her original family. In 1854, after having refused
three other proposals of marriage, she married her father's
curate, Arthur Bell Nichols. She died the following year.
By then she had written, in addition to* Jane Eyre, *such
novels as* Shirley *and* Villette, *which contain further shrewd
portrayals of the situation of women in the nineteenth
century.*

assistant clergyman [handwritten margin note]

The following selection from Jane Eyre *takes place shortly
after Jane, the novel's main character, has arrived as a
governess at Thornfield Manor, an English country estate.
Jane, who in many ways is similar to Brontë herself, has*

been orphaned at an early age and has spent the past
eight years at a boarding school, where she was cruelly
treated and suffered the death of her best friend. She has
learned to paint and has filled a portfolio with strange,
dream-like images, yet she despairs at the imperfection of
her work, which she has neither the knowledge of
technique nor the time to improve.

On the other hand, she feels that she cannot express
herself through other media available to her, in the forms of
traditional household art—forms which in her day were
considered as trivial as were women themselves. Trained,
as a woman, to suppress her strongest feelings, she has
no socially acceptable means of expressing them, and is
isolated from others who might share them.

Anybody may blame me who likes when I add further that now
and then, when I took a walk by myself in the grounds, when
I went down to the gates and looked through them along the
road, or when, while Adèle played with her nurse, and Mrs.
Fairfax made jellies in the store-room, I climbed the three stair-
cases, raised the trap-door of the attic, and having reached the
leads, looked out afar over sequestered field and hill, and along
dim sky-line—that then I longed for a power of vision
which might overpass that limit; which might reach the busy
world, towns, regions full of life I had heard of but never seen:
that then I desired more of practical experience than I
possessed; more of intercourse with my kind, of acquaintance
with variety of character, than was here within my reach.
I valued what was good in Mrs. Fairfax, and what was good in
Adèle; but I believed in the existence of other and more vivid
kinds of goodness, and what I believed in I wished to behold.

Who blames me? Many, no doubt; and I shall be called dis-
contented. I could not help it: the restlessness was in my
nature; it agitated me to pain sometimes. Then my sole relief
was to walk along the corridor of the third story, backwards
and forwards, safe in the silence and solitude of the spot and
allow my mind's eye to dwell on whatever bright visions rose
before it—and, certainly, they were many and glowing; to let

my heart be heaved by the exultant movement, which, while it swelled it in trouble, expanded it with life; and, best of all, to open my inward ear to a tale that was never ended—a tale my imagination created, and narrated continuously; quickened with all of incident, life, fire, feeling, that I desired and had not in my actual existence.

It is in vain to say human beings ought to be satisfied with tranquility: they must have action; and they will make it if they cannot find it. Millions are condemned to a stiller doom than mine, and millions are in silent revolt against their lot. Nobody knows how many rebellions besides political rebellions ferment in the masses of life which people earth. Women are supposed to be very calm generally: but women feel just as men feel; they need exercise for their faculties and a field for their efforts as much as their brothers do; they suffer from too rigid a restraint, too absolute a stagnation, precisely as men would suffer; and it is narrow-minded in their more privileged fellow-creatures to say that they ought to confine themselves to making puddings and knitting stockings, to playing on the piano and embroidering bags. It is thoughtless to condemn them, or laugh at them, if they seek to do more or learn more than custom has pronounced necessary for their sex.

My Business Is to Sing

By Emily Dickinson

*Born in Amherst, Massachusetts into a prominent family—
her father was a leading lawyer and legislator—Emily
Dickinson (1830–1886) lived a life of outer decorousness
and inner defiance. She attended Amherst Academy and
spent one year at the female seminary in South Hadley,
Massachusetts (later Mount Holyoke College). From then
on, Dickinson increasingly withdrew into the privacy and
seclusion of her family home, which she rarely left.
Outwardly—with the important exceptions of refusing to
join the church and remaining unmarried—she tried to
conform to the expectations of her family and polite society.
In the privacy of her bedroom, however, she wrote her
fiercely independent poems: 1775 of them were found in her
dresser drawer after her death. Only seven of these were
published in her lifetime. Of the existence of the rest, few
people had been aware: her brother and his wife, who
lived nearby; and several friends and correspondents,
including the writer Helen Hunt Jackson, and Thomas
Wentworth Higginson, editor of the* Atlantic Monthly. *In
her letters to these friends, collected and edited by Thomas
H. Johnson in* The Letters of Emily Dickinson, *we are
allowed a glimpse into her feelings about daily experiences,
into some of the sources for her poetic imagery, and into
the strong belief in herself that is the basis for many of
her poems. In the following poems, as in the letters, we
see Dickinson's active refusal to accept what her family
and society termed "correct" feminine attitudes and
behavior: unquestioning passivity, religious piety, and
exclusive service to domestic affairs. Unlike the more
conventional woman she described in poem 732, Dickinson
chose to serve her art, which to her was like a religion—
knowing that in so doing, she would not be understood by
those around her, and that her poems (like the songs of
a bird no one hears) would not be appreciated. Ironically,*

she was right; for many years after her death, publishers insisted on altering these poems to suit prevailing literary standards of content and style. The numbering and the text of the poems as given here follow the 1955, definitive edition of Dickinson's poems edited by Thomas H. Johnson, in which the original content and punctuation of all 1775 poems have been restored. Excerpts from Dickinson's correspondence also appear here as in the original letters.

From Dickinson's Letters

To her friend Abiah Root, 7 May 1845: How do you enjoy your school this term? Are the teachers as pleasant as our old school-teachers? I expect you have a great many prim, starched up young ladies there, who, I doubt not, are perfect models of propriety and good behavior. If they are, don't let your free spirit be chained by them.

To Abiah Root, late 1850: The shore is safer, Abiah, but I love to buffet the sea—I can count the bitter wrecks here in these pleasant waters, and hear the murmuring winds, but oh, I love the danger!

To her brother Austin, 15 December 1851: We don't *have* many jokes tho' *now*, it is pretty much all sobriety, and we do not have much poetry, father having made up his mind that its pretty much all *real life*. Fathers real life and *mine* sometimes come into collision, but as yet, escape unhurt!

To the literary critic Thomas Wentworth Higginson, 25 April 1862: I have a Brother and Sister—My Mother does not care for thought—and Father, too busy with his Briefs—to notice what we do—He buys me many Books—but begs me not to read them—because he fears they joggle the Mind. They are religious—except me—and address an Eclipse, every morning—whom they call their "Father."

To Higginson, July 1862: Perhaps you smile at me. I could not stop for that—My Business is Circumference. . . .

To Mr. and Mrs. Josiah Gilbert Holland, Ca. Summer 1862: Perhaps you laugh at me! Perhaps the whole United States are laughing at me too! *I* can't stop for that! *My* business is to love. I found a bird, this morning, down—down—on a little bush at

the foot of the garden, and wherefore sing, I said, since nobody
hears?

One sob in the throat, one flutter of bosom—*"My* business
is to *sing"*—and away she rose! How do I know but cherubim,
once, themselves, as patient, listened, and applauded her un-
noticed hymn?

*To her cousins, Louise and Frances Norcross, 7 October
1863:* Nothing has happened but loneliness, perhaps too daily
to relate.

*After visiting Emily Dickinson in Amherst in 1870, the
critic Higginson wrote a letter to his wife describing the visit
and quoting some of Dickinson's remarks to him:* "I find
ecstasy in living—the mere sense of living is joy enough." I
asked if she never felt want of employment, never going off
the place & never seeing any visitor. "I never thought of con-
ceiving that I could ever have the slightest approach to such a
want in all future time" (& added) "I feel that I have not ex-
pressed myself strongly enough."

*In his next letter to his wife, 16 August 1870, Higginson
commented,* "I never was with any one who drained my nerve
power so much."

Five Poems

324
Some keep the Sabbath going to Church— *explanation, why she's*
I keep it, staying at Home— *opposed to organized religion*
With a Bobolink for Chorister—
And an Orchard, for a Dome—

Some keep the Sabbath in Surplice—
I just wear my Wings—
And instead of tolling the Bell, for Church,
Our little Sexton—sings.

God preaches, a noted Clergyman—
And the sermon is never long,
So instead of getting to Heaven, at last—
I'm going, all along.

508
I'm ceded—I've stopped being Theirs—
The name They dropped upon my face
With water, in the country church
Is finished using, now,
And They can put it with my Dolls,
My childhood, and the string of spools,
I've finished threading—too—

Baptized, before, without the choice,
But this time, consciously, of Grace—
Unto supremest name—
Called to my Full—The Crescent dropped—
Existence's whole Arc, filled up,
With one small Diadem.

My second Rank—too small the first—
Crowned—Crowing—on my Father's breast—
A half unconscious Queen—
But this time—Adequate—Erect,
With Will to choose, or to reject,
And I choose, just a Crown—

613
They shut me up in Prose—
As when a little Girl
They put me in the Closet—
Because they liked me "still"—

Still! Could themself have peeped—
And seen my Brain—go round—
They might as wise have lodged a Bird
For Treason—in the Pound—

Himself has but to will
And easy as a Star
Abolish his Captivity—
And laugh—No more have I—

657

I dwell in Possibility—
A fairer House than Prose—
More numerous of Windows—
Superior—for Doors—

Of Chambers as the Cedars—
Impregnable of Eye—
And for an Everlasting Roof
The Gambrels of the Sky—

Of Visitors—the fairest—
For Occupation—This—
The spreading wide my narrow Hands
To gather Paradise—

732

She rose to His Requirement—dropt
The Playthings of Her Life
To take the honorable Work
Of Woman, and of Wife—

If ought She missed in Her new Day,
Of Amplitude, or Awe—
Or first Prospective—Or the Gold
In using, wear away,

It lay unmentioned—as the Sea
Develop Pearl, and Weed,
But only to Himself—be known
The Fathoms they abide—

The Centaur

By May Swenson

*May Swenson (1919–) was born in Logan, Utah, and
graduated from Utah State University; but, as poet William
Stafford has commented, "she has made New York
City into her place." For many years her poems have
appeared in magazines and literary journals such as*
Harper's, Atlantic Monthly, *and the* New Yorker, *and have
been collected into several books—*To Mix with Time, Half
Sun Half Sleep, Iconographs, More Poems to Solve, *and others.
She has also written several children's books and an
experimental play, has translated from the Swedish a book
of poems by Tomas Tranströmer, and has authored* The
Contemporary Poet as Artist and Critic. *The recipient of
many literary awards, in 1970 she was made a member of
the National Institute of Arts and Letters. Her poems,
as she says, are taken from "the organic, the inorganic, and
the psychological world" in which she lives. In "The
Centaur," we see a highly rhythmical fusion of these
worlds, as Swenson remembers one way—not "ladylike,"
but secretly defiant—she was able to express her own
creative energies.*

The summer that I was ten—
Can it be there was only one
summer that I was ten? It must

have been a long one then—
each day I'd go out to choose
a fresh horse from my stable

which was a willow grove
down by the old canal.
I'd go on my two bare feet.

But when, with my brother's jack-knife,
I had cut me a long limber horse
with a good thick knob for a head,

and peeled him slick and clean
except a few leaves for the tail,
and cinched my brother's belt

around his head for a rein,
I'd straddle and canter him fast
up the grass bank to the path,

trot along in the lovely dust
that talcumed over his hoofs,
hiding my toes, and turning

his feet to swift half-moons.
The willow knob with the strap
jouncing between my thighs

was the pommel and yet the poll
of my nickering pony's head.
My head and my neck were mine,

yet they were shaped like a horse.
My hair flopped to the side
like the mane of a horse in the wind.

My forelock swung in my eyes,
my neck arched and I snorted.
I shied and skittered and reared,

stopped and raised my knees,
pawed at the ground and quivered.
My teeth bared as we wheeled

and swished through the dust again.
I was the horse and the rider,
and the leather I slapped to his rump

spanked my own behind.
Doubled, my two hoofs beat
a gallop along the bank,

the wind twanged in my mane,
my mouth squared to the bit.
And yet I sat on my steed

quiet, negligent riding,
my toes standing the stirrups,
my thighs hugging his ribs.

At a walk we drew up to the porch.
I tethered him to a paling.
Dismounting, I smoothed my skirt

and entered the dusky hall.
My feet on the clean linoleum
left ghostly toes in the hall.

Where have you been? said my mother
Been riding, I said from the sink,
and filled me a glass of water.

What's that in your pocket? she said.
Just my knife. It weighted my pocket
and stretched my dress awry.

Go tie back your hair, said my mother,
and *Why is your mouth all green?*
Rob Roy, he pulled some clover
as we crossed the field, I told her.

The Sketch

By Gertrude Käsebier

International Museum of Photography at George Eastman House, Rochester, N.Y.

Pioneer in the field of portrait photography, Gertrude Käsebier (1852–1934) is known for portraying the internal realities of her subjects in a time when most photography was factually informative. Born in Iowa, she lived, until her father died, in the rough mining town of Leadville, Colorado. Sent to live with her maternal grandmother, she attended Moravian Seminary for Girls in Bethlehem, Pennsylvania, and later moved to her mother's boarding house in New York. In 1873 she married Edward Käsebier, a German salesman.

Until her three children were almost grown, Käsebier postponed her desire to become an artist. In 1888, at age thirty-six, she began to study painting and portraiture at Pratt Institute. Although she had already won a fifty-dollar prize in a photography contest, she devoted her time to painting, persuaded by professors and colleagues that photography lacked the artistic potential of other media. In 1893, however, on a European trip, she discovered her true vocation as a photographer. Without the customary conveniences of darkroom work, she would wait until after ten o'clock at night (when it was entirely dark) to carry wet plates down to a river to be washed. Often she worked until almost dawn—returning wet, exhausted, and triumphant. Within several years she had opened a portrait studio in New York, apprenticing herself to well-known photographers in order to learn the more practical aspects of business and her art.

Best known for her provocative portraits of mothers and children, she gained wide recognition, and encouraged other women to enter the field of photography; in a magazine article she wrote in 1898, she suggested the particular adaptability of her field to women's lives. In 1899 she served, with her friend Frances Benjamin Johnston, as juror for the influential Philadelphia Salon of pictorial photographers.

Plate 21. Gertrude Käsebier. THE SKETCH. Photograph. Ca. 1902.

 *Published in leading journals of photography and shown
in various exhibitions, her photographs—which often
obliterated detail in favor of impressionistic lighting—were
a radical departure from the norm. In* The Sketch *a young
artist gazes wistfully at a landscape she is sketching on paper.
Different, however, from any factual report, this carefully
composed photograph—with its central focus on the artist's
paper, the brightest detail in the scene—draws our attention
to Käsebier's own feeling that the act of creation is a
source of wonder and of endless possibilities.*

Female Students Drawing

By Frances Benjamin Johnston

*Frances Benjamin Johnston (1864–1952), like her colleague
Gertrude Käsebier, came to photography through the
study of painting. Born in Grafton, West Virginia, raised also
in Rochester, New York, and Washington, D.C., Johnston
studied painting and drawing for two years in Paris at
the Académie Julien and later at the Art Students League in
Washington, D.C. Working as a correspondent with a
popular New York magazine, she began learning the art of
photography (studying at the Smithsonian Institution)
in order to illustrate her articles on industry, government
agencies, and the homes of Washington officials. Within a
short time she opened her own Washington studio and
became the unofficial White House photographer for every
president from Cleveland to Taft.*

*Regarded by the public of her day as somewhat eccentric
(she smoked, drank beer, and never married), Johnston
nevertheless commanded high respect for her work, at home
and abroad. At the Paris Exposition of 1900, she was
awarded a gold medal (one of three given to women) for
her large exhibit on the Washington, D.C. school system.
She addressed the International Photographic Congress in
Paris that year on the subject of women photographers in
America, a topic she later covered in a series of articles
for the* Ladies' Home Journal. *Also in 1900, with a letter of
introduction from New York's Governor Theodore Roosevelt,
she went to Naples, Italy, to record Admiral Dewey's
triumphant return from Manila.*

*In her later life, Johnston specialized in architectural
and garden photography—an interest which led her, at the
age of sixty-three, to study and make a photographic record
of early American architecture in the South. This work
resulted in a book,* Colonial Churches in Virginia, *which she
published with Henry Irving Brock. In 1933, when she was
sixty-nine, she began work on a seven-year project—*

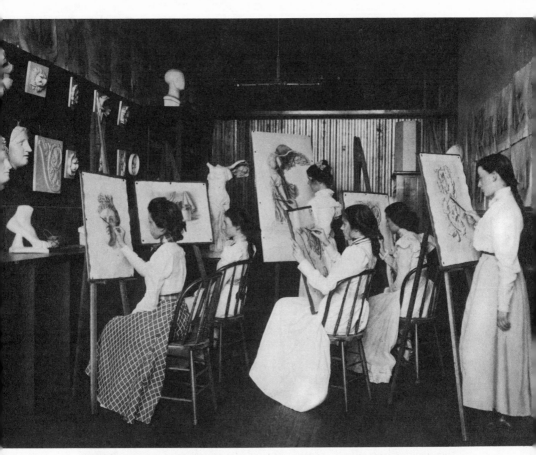

Plate 22. Frances Benjamin Johnston. CLASS OF FEMALE STUDENTS DRAWING FROM THE
ANTIQUE. **Photograph. 1899.**

*funded with four Carnegie Foundation grants—of making
7,658 negatives of Southern buildings and homes,
which she later gave to the Library of Congress.*

*The Johnston photograph reproduced here shows women
sketching classical models, a familiar practice for art
students. As the photograph suggests, Johnston's interest
in women working in the arts was not confined to
photographers. Perhaps we may also see in this picture
Johnston's continuing allegiance to the medium through
which her own career as an artist began.*

At Sixteen

By Michele Murray

Judith Michele Freedman Murray (1934–1974) was born in Brooklyn of Jewish parents. In 1953, she converted to Catholicism. She attended the New School for Social Research, and received a master's degree in 1956 from the University of Connecticut. Married, and the mother of four children, she wrote two novels for young readers (Nellie Cameron and The Crystal Nights), edited a literary anthology of stories and poems about women's lives (A House of Good Proportion), and taught at five colleges. Her poems appeared in many journals until her death, at age forty, of cancer—several months before the publication of her first volume of poems, The Great Mother, and Other Poems. In this intensely personal book, she has traced a nearly chronological record of her life's most important experiences—as a young woman, a wife, a mother, and, finally, as a woman who knows she is dying. "At Sixteen" is from this volume of poems.

singing a prolonged hymn of expectation
 it seemed to me
the great force of art would come into my life
like a pregnant wind carrying water from the sea
above the forested mountains to drop its load
upon hitherto unwatered desert

and I would stand
looking up
and open my mouth to drink the first rains
 I did not think
the thirst would grow
the more I drank.

Getting a Start: Interview with Carmen Lomas Garza

By Olivia Evey Chapa

*A lifelong Texas resident, Olivia Evey Chapa (1947–)
has travelled widely as a lecturer on the subject of the
Chicana woman. She taught the first courses on the
Mexican American woman to be presented in the state at
the University of Texas at Austin and at Texas University of
Arts and Industries (A & I), Kingsville, where she
currently teaches. She has published articles dealing with
racism and sexism, as well as on the Chicana woman, and
was contributing editor for the issue of* Tejidos *(Winter,
1976) which published the interview excerpted below.
Chapa holds a Ph.D. in education, her areas of specialization
including bilingual education, Chicana studies, and
community education. The mother of a three-year-old
daughter named Valentina, Chapa makes her home in Alice,
Texas.*

*Carmen Lomas Garza (1948–) has also spent much of
her life in Texas. She studied art at Texas University
of Arts and Industries, where she became active in the
Chicano movement, organizing in 1969 a show of Chicano
art for the first national conference of the Mexican American
Youth Organization (MAYO). Graduating from A & I
in 1972, she earned a master's degree in education the
following year at the Antioch Graduate School, Austin,
meanwhile continuing to experiment in media including
silk screen and print making. She has worked as an art
teacher and has illustrated books, including* The Gypsy
Wagon *(1974) and* Chicano Voices *(1975). In addition to
one-woman shows in Texas and California, her work has
appeared in numerous group exhibitions, including the
Tucson Museum of Modern Art, the Instituto Cultural
Mexicano, San Antonio, the Houston Museum of*

*Contemporary Art, and the Smithsonian Institute, and in
1977 travelled the U.S. and Canada in the World Print
Competition of the San Francisco Museum of Modern Art.
Currently studying for a master's degree in fine arts at
San Francisco State University, Garza is employed on the
curator's staff at the Galeria De La Raza/Studio 24.*

Olivia Evey Chapa: How did you get started as an artist? Who
gave you encouragement and inspiration?
Carmen Lomas Garza: I did have a little bit of art in elementary.
But it really goes back to junior high. I really needed art the
most in junior high. In the first place it was a very traumatic
time, especially since I went from an all-Chicano elementary
school to a junior high with a mixture of Anglos and Chicanos.
I was having a very hard time with the classes so I spent a lot of
time doodling. I would sit in back of the class and doodle. It was
the only salvation. If it hadn't been for my doodling I would
have quit! I would have dropped out. It became especially
important in high school because by that time I knew I wanted
to be an artist. The art classes were the most important and art
was my main interest in high school. Everything else was
something I just had to do; I absolutely had to do. I got "A's" in
my art classes and "C's" in everything else.

When I was doodling in junior high I used to use loose-leaf
paper, the backs of my old note paper. I started copying illustra-
tions in newspapers, something, anything. I didn't have any art
classes. At that time I thought: if only I could find an artist to
help me who would teach me a little bit—what are art supplies
and where to get them. I was using clean loose-leaf paper and
my parents freaked out. My answer to that was that at the end
of every school year I'd collect all the old notebook paper from
my brothers and sisters and I'd save it up and have paper for the
rest of the year. It got to the point that I had a lot of drawings on
loose-leaf paper so I thought: I am going to have to find some-
thing better. So I went to the five-and-ten. I'd saved up my
money, and I got a cheap sketch pad and some good number two
pencils and got going. That was the first time my parents took
notice. When they realized I was serious, then they started sup-

porting me. I was thirteen or fourteen and in the eighth grade. They started giving me more money to buy my art supplies—sketch books, india ink, pencils. They've been invaluable, my first and best teachers. They encouraged me and they were fantastic models, my first models. Especially my father—I would always get him and my brothers and sisters to pose for me.

When I was in the ninth grade I heard there were art classes in high school and I found a reason to go to school. I had to wait a whole year to take art since the class was only offered to eleventh and twelfth graders. Anyway, I finally took an art class and it was my best class. I spent a lot of time in the art classroom and in any activity involving art. When I was a senior, we went on a field trip and I found out that Texas A & I University (A & I) existed and that it had an art department. It was good because it was located where I lived. So as soon as I graduated from high school, I registered for the first summer semester. I took principles of art and a biology class. That's where the fetus came into the development of my art work; the Biology Department had a whole collection of embryos and fetuses. I was really amazed. It was the first time I'd ever seen a whole collection of fetuses. To me it was a very powerful symbol of tranquility—peace without any kind of worry, a very innocent peace. A peace with no realization of all the troubles and hassles of life. The hard times of junior high and high school had brought these realizations to me. I was an introvert; I was depressed and the peace in the fetus was overwhelming. I felt I had to capture it; I had to see it; I had to memorize it. I did many drawings of the fetus. (I've gotten to the point where I can draw a fetus from memory.)

When I use the fetus I'm trying to project the fetus still in the womb, still very well protected, totally unaware and totally tranquil. The fetus symbolizes to me peace and tranquility. When I did *Lo que nos espera*,[1] which is a print depicting a fetus surrounded by insects, symbols of the evils that await the child, I really didn't see any kind of life beyond college. I felt that once I was through with my undergraduate work, I just didn't see any point in anything for my life. I was feeling very negative. I drew

[1] *Lo que nos espera:* That which awaits us.

that fetus with all those insects surrounding the womb as sym-
bols of the hassles it's going to go through—all that criticism
and rejection from society. I was feeling a lot of rejection, I
didn't feel in place. It had a lot to do with the fact that I was
Chicana and the things I had gone through, but I didn't realize
this. I took it very personally—the traumatic things I'd gone
through in high school. Like the fact that I didn't have fantastic
new clothing and a lot of gringas flaunted it. They made me feel
inferior and it all went toward destroying my self-image. By the
time I got to college I didn't know what was wrong, but I felt
very bad. So all of this came out in my drawings and prints.

The Artist as Housewife

By Erica Jong

*Erica Jong (1942–) has written two novels, four volumes
of poems, many articles, and a book of essays on women
writers and the current literary scene. She has taught at
several colleges and universities, and has received numerous
literary grants and awards. Raised in New York City,
she studied writing and literature at Barnard College and
Columbia School of the Arts. Her studies at Barnard led her,
she says, to an "abiding interest in Satire." Later, reading
poets Pablo Neruda and Alberti, she realized "that poetry
can be serious and comic at the same time." Strongly
influenced as well by the work of women writers (she
mentions Virginia Woolf, Anne Sexton, Sylvia Plath,
Carolyn Kizer and Adrienne Rich), Jong suggests that her
first three books have certain themes in common: "the
search for honesty within oneself, the difficulty of resolving
the conflicting needs for security and adventure, the
necessity of seeing the world both sensuously and
intelligently at the same time." Because these books—*
Fruits and Vegetables, Half-Lives, *and* Fear of Flying—*are
indeed frank in Jong's acceptance of female sexuality, and
because of their immense popularity as "best-sellers,"
Erica Jong has herself become a figure of much controversy.
In the following selection, excerpted from her essay "The
Artist as Housewife," Jong discusses some of the
psychological demands placed on all writers, and suggests
why women, because of society's conditioning, have
difficulty meeting these demands. The way society sees
women is still often different from the way they see
themselves, and, as Jong says, "Many women writers have
yet to win the freedom to be honest."*

Being an artist of any sex is such a difficult business that
it seems almost ungenerous and naive to speak of the special
problems of the woman artist. The problems of becoming an

artist are the problems of selfhood. The reason a woman has greater problems becoming an artist is because she has greater problems becoming a self. She can't believe in her existence past thirty. She can't believe her own voice. She can't see herself as a grown-up human being. She can't leave the room without a big wooden pass.

This is crucial in life but even more crucial in art. A woman can go on thinking of herself as a dependent little girl and still get by, if she sticks to the stereotyped roles a woman is supposed to play in our society. Frau Doktor. Frau Architect. Mrs. George Blank. Mrs. Harry Blank. Harold's mother. Mother of charge plates, blank checks, bankbooks; insurance beneficiary, fund raiser, den mother, graduate student, researcher, secretary. . . . As long as she goes on taking orders, as long as she doesn't have to tell herself what to do, and be accountable to herself for finishing things. . . . But an artist takes orders only from her inner voice and is accountable only to herself for finishing things. Well, what if you have no inner voice, or none you can distinguish? Or what if you have three inner voices and all three of them are saying conflicting things? Or what if the only inner voice which you can conjure up is male because you can't really conceive of authority as soprano?

Just about the most common complaint of talented women, artists manqué, women who aspire to be artists, is that they *can't finish things.* Partly because finishing implies being judged—but also because finishing things means being grown up. More important, it means possibly succeeding at something. And success, for women, is always partly failure.

Don't get a doctorate because then you'll never find a husband.

Don't be too successful or men will be scared of you.

The implication is always that . . . success at one end brings failure at the other. . . .

No wonder women are ambivalent about success. Most of them are so ambivalent, in fact, that when success seems imminent they go through the most complex machinations to ward it off. Very often they succeed, too.

The main problem of a poet is to raise a voice. We can suffer all kinds of kinks and flaws in a poet's work except lack of

authenticity. Authenticity is a difficult thing to define, but roughly it has to do with our sense of the poet as a *mensch*, a human being, an *author* (with the accent on authority). Poets arrive at authenticity in very different ways. Each poet finds her own road by walking it—sometimes backward, sometimes at a trot. To achieve authenticity you have to know who you are and approximately why. You have to know yourself not only as defined by the roles you play but also as a creature with an inner life, a creature built around an inner darkness. Because women are always encouraged to see themselves as role players and helpers ("helpmate" as a synonym for "wife" is illuminating here), rather than as separate beings, they find it hard to grasp this authentic sense of self. They have too many easy cop-outs.

Probably men are just as lazy and would cop out if they could. Surely men have similar and very crushing problems of selfhood and identity. The only difference is that men haven't got the built-in escape from identity that women have. They can't take refuge in being Arnold's father or Mr. Betty Jones. . . .

Of course, it's also a question of trust. Katherine Anne Porter said that becoming a writer was all a question of learning to trust yourself, to trust your own voice. . . .

Naming is the crucial activity of the poet; and naming is a form of self-creation. In theory, there's nothing wrong with the woman's changing names for each new husband, except that often she will come to feel that she has no name at all. (All men are mirrors. Which one will she look into today?) So her first name, her little girl name is the only one which winds up sounding real to her. . . . If women artists often elect to use their maiden (or even maternal) names, it's in a sort of last-ditch attempt to assert an unchanging identity in the face of the constant shifts of identity which are thought in our society to constitute femininity. Changing names all the time is only symbolic of this. It's only disturbing because it mirrors the inner uncertainty. . . .

And what about "writing like a man" and the word "poetess" (which has come to be used like the word "nigrah")? I know

of no woman writer who hasn't confessed the occasional
temptation to send her work out under a masculine nom de
plume, or under initials, or under the "protection" of some
male friend or lover. . . .

I knew I wanted to be a writer from the time I was ten or
eleven and, starting then, I attempted to write stories. The
most notable thing about these otherwise not very memorable
stories was that the main character was always male. I never
tried to write about women and I never thought anyone would
be interested in a woman's point of view. I assumed that what
people wanted to hear was how men thought women were, not
what women themselves thought they were. None of this was
quite conscious, though. I wrote about boys in the same way a
black child draws blond hair (like mine) on the faces in her
sketchbook. . . .

This only proves that one's own experience is less convinc-
ing than the cultural norm. In fact, one has to be strong indeed
to trust one's own experience. Children characteristically lack
this strength. And most women, in our culture, are encouraged
to remain children. I know two little girls whose mother is a
full-time practicing physician who works a very long day and
works at home. The children see the patients come and go.
They know their mother is a doctor, and yet one of them re-
turned from nursery school with the news that men were
doctors and women had to be nurses. All her mother's reason-
ing and all the child's own experience could not dissuade her.

So, too, with my feelings about writers. I spent my whole
bookish life identifying with writers and nearly all the writers
who mattered were men. Even though there were women
writers, and even though I read them and loved them, they did
not seem to *matter.* If they were good, they were good *in spite
of* being women. If they were bad, it was *because* they were
women. I had, in short, internalized all the dominant cultural
stereotypes. And the result was that I could scarcely even
imagine a woman as an author. Even when I read Boswell, it
was with him that I identified and not with the women he
knew. Their lives seemed so constricted and dull compared
with dashing around London. I, too, loved wordplay and clever

conversation. I, too, was a clown. I, too, was clever and a bit ridiculous. I was Boswell. The differences in our sexes honestly never occurred to me.

So, naturally, when I sat down to write, I chose a male narrator. Not because I was deluded that I was a man—but because I was very much a woman, and being a woman means, unfortunately, believing a lot of male definitions (even when they cause you to give up significant parts of your own identity). . . .

I didn't really become an avid reader of poetry until college. The modern poets I loved best then were Yeats and Eliot, Auden and Dylan Thomas. Diverse as they were, they had in common the assumption of a male viewpoint and a masculine voice, and when I imitated them, I tried to sound either male or neuter. Despite Emily Dickinson, poetry, for me, was a masculine noun. It came as a revelation to discover contemporary women poets like Anne Sexton, Sylvia Plath, and Denise Levertov, and to realize that strong poetry could be written out of the self that I had systematically (though perhaps unconsciously) repressed. And it was not until I allowed the femaleness of my personality to surface in my work that I began to write anything halfway honest.

I remember the year when I began to write seriously, when I threw out all my college poems and began again. What I noticed most persistently about my earliest poems was the fact that they did not engage my individuality very deeply. I had written clever poems about Italian ruins and villas, nightingales, and the graves of poets—but I had tried always to avoid revealing myself in any way. I had assumed a stock poetic voice and a public manner. It was as though I disdained myself, felt I had no *right* to have a self. Obviously an impossible situation for a poet. . . .

Once I confessed to my vulnerability, I was able to explore it, and from that everything followed. I stopped writing about ruins and nightingales. I was able to make poetry out of the everyday activities of my life: peeling onions, a trip to the gynecologist, a student demonstration, my own midnight terrors and dreams—all the things I would have previously dismissed as trivial.

Because of my own history, I think women poets have to insist on their right to write like women. Where their experience of the world is different, women writers ought to reflect that difference. They ought to feel a complete freedom about subject matter. But most important, our definition of femininity has to change. . . .

Unfortunately, the terms male and female have become so loaded and polarized, so laden with old prejudices, that they are almost useless for purposes of communication. We don't know what masculine really means, nor what feminine really means. We assume them to be opposites and we may not even be right about that. Yet we are stuck with these words. They are deeply embedded in language and in our minds (which language in part helped to shape). What shall we do with masculine and feminine? Does it do anyone any good just to pretend that they don't exist?

Gradually, we will redefine them. Gradually, society will change its false notions of male and female, and perhaps they will cease to be antitheses. Gradually, male experience and female experience will cease to be so disparate, and then maybe we will not have to worry about women understanding their own self-hatred as a prerequisite to authentic creative work.

Journal of a Solitude

By May Sarton

*May Sarton (1912–) was born in Belgium and emigrated
with her family to the United States in 1916. She attended
schools in Cambridge, Massachusetts, and worked for
some years in repertory theaters on the East Coast, some
of which she founded and/or directed. Since 1937 she has
taught in many colleges and universities, won numerous
prizes for her writing, and published more than thirty
volumes of fiction, poetry, autobiography and drama. While
her subject matter varies greatly, from love poems to
descriptions of paintings, her themes often deal with the
personal responsibilities of the artist—to herself, to others,
and to her art—and with the effects of gender on the life
of the woman artist. In her novel* Mrs. Stevens Hears the
Mermaids Singing, *May Sarton explores the question of the
muse, traditionally the source of support and inspiration
for the male artist. Since the days of the ancient Greeks—
as Anne Bradstreet also recognized, in her "Prologue"—this
support has come from women. Who then, Sarton questions,
supports the woman artist; who is her inspirational muse?*
Journal of a Solitude *(1973), from which the following
excerpts are taken, is a record of one year in her life as
a writer living alone in her New England home. Here,
without denying her own need for a muse, Sarton takes up
another aspect of the sources of the woman artist's support—
the value of solitude for the creative spirit. A remark of
Sarton's character Mrs. Stevens applies well to the insights
found in* Journal of a Solitude: *"Loneliness is the poverty
of self; solitude is the richness of self."*

October 11th. I can hardly believe that relief from the anguish
of these past months is here to stay, but so far it does feel like
a true change of mood—or rather, a change of *being* where
I can stand alone. So much of my life here is precarious. I can-
not always believe even in my work. But I have come in these

last days to feel again the validity of my struggle here, that it is meaningful whether I ever "succeed" as a writer or not, and that even its failures, failures of nerve, failures due to a difficult temperament, can be meaningful. It is an age where more and more human beings are caught up in lives where fewer and fewer inward decisions can be made, where fewer and fewer real choices exist. The fact that a middle-aged, single woman, without any vestige of family left, lives in this house in a silent village and is responsible only to her own soul means something. The fact that she is a writer and can tell where she is and what is it like on the pilgrimage inward can be of comfort. It is comforting to know there are lighthouse keepers on rocky islands along the coast. Sometimes, when I have been for a walk after dark and see my house lighted up, looking so alive, I feel that my presence here is worth all the Hell.

I have time to think. That is the great, the greatest luxury. I have time to be. Therefore my responsibility is huge. To use time well and to be all that I can in whatever years are left to me. This does not dismay. The dismay comes when I lose the sense of my life as connected (as if by an aerial) to many, many other lives whom I do not even know and cannot ever know. The signals go out and come in all the time. . . .

My father was theoretically a feminist, but when it came down to the nitty gritty of life he expected everything to be done for him, of course, by his wife. It was taken for granted that "his work" must come before anything else. He was both a European bourgeois in upbringing and a man of the nineteenth century, so my mother didn't have a prayer. My father didn't like her to work and never gave her credit for it, even in some years when she was designing embroidered dresses for Belgart in Washington, D.C., and made more money than he did. Her conflict—and it was acute—came from her deep belief in what he wanted to do and at the same time resentment of his attitude toward her and his total lack of understanding of what he asked of her. They simply could not discuss such matters. Here we have surely made enormous strides in my lifetime. Few young women today would not at least make a try at "having it out"

before marrying. Women are at last becoming persons first and wives second, and that is as it should be.

Later on in the night I reached a quite different level of being. I was thinking about solitude, its supreme value. Here in Nelson I have been close to suicide more than once, and more than once have been close to a mystical experience of unity with the universe. The two states resemble each other: one has no wall, one is absolutely naked and diminished to essence. Then death would be the rejection of life because we cannot let go what we wish so hard to keep, but have to let go if we are to continue to grow.

When I talk about solitude I am really talking also about making space for that intense, hungry face at the window, starved cat, starved person. It is making space to *be there.* Lately a small tabby cat has come every day and stared at me with a strange, intense look. Of course I put food out, night and morning. She is so terrified that she runs away at once when I open the door, but she comes back to eat ravenously as soon as I disappear. Yet her hunger is clearly not only for food. I long to take her in my arms and hear her purr with relief at finding shelter. Will she ever become tame enough for that, to give in to what she longs to have? It is such an intense look with which she scans my face at the door before she runs away. It is not a pleading look, simply a huge question: "Can I trust?" Our two gazes hang on its taut thread. I find it painful.

For a long time, for years, I have carried in my mind the excruciating image of plants, bulbs, in a cellar, trying to grow without light, putting out *white* shoots that will inevitably wither. It is time I examined this image. Until now it has simply made me wince and turn away, bury it, as really too terrible to contemplate. . . .

This December I have been more aware than ever before of the meaning of a festival of light coming as it does when the days are so short, and we live in darkness for the greater part of the afternoon. Candlelight, tree lights—ours, tiny ones—are reflected in all the windows from four o'clock on.

Then there are the great presents of long letters from former

students and friends from whom I hear only once a year. They
bring me a tapestry of lives, a little overwhelming, but interest-
ing in their conjunctions. Two of my best poets at Wellesley,
two girls who had something like genius, each married and
each stopped writing altogether. Now this year each is moving
toward poetry again. That news made me happy. It also made
me aware once more of how rarely a woman is able to continue
to create after she marries and has children.

Whatever college does not do, it does create a climate where
work is demanded and where nearly every student finds him-
or herself meeting the demand with powers he did not know he
had. Then quite suddenly a young woman, if she marries, has
to diverge completely from this way of life, while her husband
simply goes on toward the goals set in college. She is expected
to cope not with ideas, but with cooking food, washing dishes,
doing laundry, and if she insists on keeping at a job, she needs
both a lot of energy and the ability to organize her time. If she
has an infant to care for, the jump from the intellectual life
to that of being a nurse must be immense. "The work" she
may long to do has been replaced by various kinds of labor for
which she has been totally unprepared. She has longed for
children, let us say, she is deeply in love, she has what she
thought she wanted, so she suffers guilt and dismay to feel so
disoriented. Young husbands these days can and do help with
the chores and, far more important, are aware of the problem
and will talk anxiously about it—anxiously because a wife's
conflict affects their peace of mind. But the fact remains that, in
marrying, the wife has suffered an earthquake and the husband
has not. His goals have not been radically changed; his mode
of being has not been radically changed.

I shall copy parts of one of these letters, as it gave me much
to ponder on and I shall refer to it again in the weeks to come,
no doubt. K says,

It has been a year of unusual branching out, and I feel quite young.
You will laugh at that, but many of our friends now are pathetically
worried about aging and full of envy for young people and regrets
about wasting their own youth—and these are parents of small chil-
dren, under thirty! I think it is a very destructive system indeed that

worships youth the way we Americans do and gives young people no ideals of maturity to reach for, nothing to look forward to. (Adolescence is often so miserable that one needs an incentive to get through it!)

Well, I'd better stop, because I feel a harangue coming on; I'm so hopelessly out of tune with these times and it's a temptation to join the haranguers. . . .

As for the writing of poems, I'm beginning to see that *the* obstruction is being female, a fact I have never accepted or known how to live with. I wish that I could talk to you about it; I know that you are into insights that I'm only beginning to realize *exist*. (And that's why Sylvia Plath interests me; Robert Lowell describes her as "feminine rather than female," whatever that means; but she strikes me as breaking through the feminine to something natural that, while I suppose it still has a sex, can't be called feminine even.) At least I can see the inadequacy of that male and very Freudian psychiatrist, trying to help me accept or do something with this burden of femininity that marriage had seemed to finalize. I am grateful to all the crazies out there in the Women's Liberation; we *need* them as outrageous mythical characters to make our hostilities and dilemmas really visible. As shallow as my contact with the Women's Liberation has been, I have really seen something new about myself this year; the old stalemated internal conflict has been thrown off balance and I am surprised to understand how much of my savage hostility is against men. I have always been rejecting language because it *is* a male invention. My voice in my own poems, though coming out of myself, became a masculine voice on the page, and I felt the need to destroy that voice, that role, in making room for D in my life. It is not just my equation but a whole family tradition, which decrees a deep and painful timidity for the women; and for me this was always especially intolerable, since the personality I was born with was the very opposite of passive! It is very fortunate for me that, of all my friends, excepting you, D is the only one who seems to understand, or at least to sympathize with this—a fact which violates the principles of psychiatry since he is the one most threatened by any sexual crisis I may undergo, the target most at hand for hostilities against men, and the most disturbed by the instability that comes with my trying to readjust the balance of my mind.

This letter goes to the heart of the matter. I found it deeply disturbing. For what is really at stake is unbelief in the woman as artist, as creator. K no longer sees her talent as relevant or

valid, language itself as a masculine invention. That certainly closes the door with a bang! But I believe it will open because the thrust of a talent as real as hers must finally break through an intellectual formula and assert what she now denies. What she writes eventually will be in her own voice. Every now and then I meet a person whose speaking voice appears to be placed artifically, to come not from the center of the person, but from an unnatural register. I am thinking especially of women with high, strained voices. I know nothing about voice placement in a technical sense, but I have longed to say, "For God's sake, get down to earth and speak in your own voice!" This is not so much a matter of honesty, perhaps (K is excruciatingly honest), as of self-assurance: I am who I am.

This Is the Story
of the Day in the Life
of a Woman Trying

By Susan Griffin

*Susan Griffin (1943–) was born in California and received
her B.A. from the University of California at Berkeley and her
M.A. from San Francisco State University. The mother of
one daughter, Becky, Griffin has published four books of
poems, a collection of short stories, and a television play,*
Voices, *which won an Emmy award in 1975. She has taught
literature and women's studies at Berkeley and at San
Francisco State University, and was awarded a National
Endowment for the Arts grant in 1976. She is a founding
member of the Feminist Writers' Guild.*

*Griffin's subject matter, often drawn from her personal life,
expresses a strong commitment to feminist concerns, as do
her many articles and a recent work of nonfiction titled*
Women and Nature: The Roaring Inside Her. *She is currently
preparing for publication two additional books of prose,*
Rape: The Power of Consciousness, *and* Pornography and
Silence. *The prose poem that follows, from her collection*
Like the Iris of an Eye *(1976), describes the avalanche of details
a writing mother must often contend with during the
course of an ordinary day, revealing the conflicts between her
responsibilities to her art and to her life.*

This is the story of the day in the life of a woman trying
to be a writer and her child got sick. And in the midst of
writing this story someone called her on the telephone.
And, of course, despite her original hostile reaction to the
ring of the telephone, she got interested in the conversation
which was about teaching writing in a women's prison,
for no pay of course, and she would have done it if it
weren't for the babysitting and the lack of money for the
plane fare, and then she hung up the phone and looked

at her typewriter, and for an instant swore her original
sentence was not there. But after a while she found it. Then
she began again, but in the midst of the second sentence,
a man telephoned wanting to speak to the woman she
shares her house with, who was not available to speak on
the telephone, and by the time she got back to her type-
writer she began to worry about her sick daughter down
stairs. And why hadn't the agency for babysitters called back
and why hadn't the department for health called back
because she was looking for a day sitter and a night sitter,
one so she could teach the next day and one so she could
read her poetry. And she was hoping that the people who
had asked her to read poetry would pay for the babysitter
since the next evening after that would be a meeting of
teachers whom she wanted to meet and she could not afford
two nights of babysitters let alone one, actually. This was
the second day her child was sick and the second day she
tried to write (she had been trying to be a writer for years)
but she failed entirely the first day because of going to the
market to buy Vitamin C and to the toy store to buy cutouts
and crayons, and making soup from the chicken carcass that
had been picked nearly clean to make sandwiches for
lunch, and watering the plants, sending in the mortgage
check and other checks to cover that check to the bank,
and feeling tired, wishing she had a job, talking on the tele-
phone, and putting out newspaper and glue and scissors
on the kitchen table for her tired, bored child and squint-
ing her eyes at the clock waiting for *Sesame Street* to begin
again. Suddenly, after she went upstairs to her bedroom
with a book, having given up writing as impossible, it was
time to cook dinner. But she woke up on the second day
with the day before as a lesson in her mind. Then an old
friend called who had come to town whom she was eager
to see and she said, "Yes, I'm home with a sick child," and
they spent the morning talking. She was writing poetry and
teaching she said. He had written four books he
said. Her daughter showed him her red and blue and
orange colored pictures. She wished he didn't have to leave

so early, she thought but didn't say, and went back to pick
up tissue paper off the floor and fix lunch for her and her
child and begin telephoning for babysitters because she
knew she had to teach the next day. And the truth was,
if she did not have a sick child to care for, she was
not sure she could write anyway because the kitchen was
still there needing cleaning, the garden there needing
weeding and watering, the living room needing curtains,
the couch needing pillows, a stack of mail needing answers
(for instance if she didn't call the woman who had lived
in her house the month before about the phone bill soon,
she would lose a lot of money). All besides, she had
nothing to write. She had had fine thoughts for writing the
night before but in the morning they took on a sickly
complexion. And anyway, she had begun to think her life
trivial and so it was, and she was tired writing the same
words, or different words about the same situation, the
situation or situations being that she was tired, tired of try-
ing to write, tired of poverty or almost poverty or fear of
poverty, tired of the kitchen being dirty, tired of having
no lover. She was amazed that she had gotten herself
dressed, actually, with thoughts like these, and caught her-
self saying maybe I should take a trip when she realized she
had just come back from a trip and had wanted to be
home so much she came back early. And even in the writ-
ing of this she thought I have written all this before and
went downstairs to find her daughter had still not eaten a
peanut butter sandwich and she wondered to herself what
keeps that child alive?

Dust

By Ingrid Wendt

*Born in Aurora, Illinois, Ingrid Wendt (1944–) attended
Cornell College (Iowa) and the University of Oregon, where
she received the Neuberger Award in poetry and a master of
fine arts degree in writing in 1968. To supplement fellowships,
she worked part-time and summers as a waitress, a church
organist, a pianist, a file clerk, and a teaching assistant.
She has taught creative writing, literature and women's
studies at Fresno State College, California, and at the
University of Oregon, and has been managing editor of*
Northwest Review. *Her poems have appeared in* Poetry Now,
Calyx, Feminist Studies, West Coast Review, San José
Studies, *and many other journals, and in anthologies including*
No More Masks! *and* Intro 1. *Her first book of poems,* Moving
the House, *is in press. She and her husband, writer Ralph
Salisbury, have one daughter, Erin. At the present time
Wendt teaches poetry writing with the Oregon Arts
Foundation, as writer-in-residence in twenty-seven Eugene,
Oregon, public schools. The following poem is part of a series
from* Moving the House, *in which the poet confronts and
attempts to transcend some of the inevitable details of daily
living which conflict with her sense of selfhood; to overcome
monotony and feelings of isolation; to give order and
perspective to her experience; as Erica Jong might put it,
to "name."*

Old houses have the most

It ticks out of the walls
like seconds

•

Arrogant tourists, attracting
only their own
kind

Speaking loudly in corners
under tables, beds

whichever way the wind
happens to blow
 •

It's not the rest of the world we track in

It's us

When the heater is on

When we rub
moving from room to room
this simple air up
against
this simple, worn-out, top layer of wall
 •

The one who cleans, knows:

 it's what
you could order your life
around:

 getting dressed to eat breakfast
for strength to finish the cleaning in time to shop
for clothes to wear to work to earn money
for food to eat
for strength to wash the dishes
to wash the clothes to wear to bed to get enough rest
to get the cleaning done
 •

Ah, to clean and pretend it was nothing

Ah, in their house
to let them pretend it was nothing

Ah, to pretend to each other
you aren't
pretending at all
 •

Facing it:

"What did you do today?"
 Nothing

"What can you show for it?"
 Absence

 •

Days I was in school
Mother cleaning everything we didn't
do Saturdays:

 shelves where clean
dishes went, insides of windows I never
saw anyone touch

light bulbs on ceilings, tops
of doorframes, windowframes, curtain rods
backs of every last picture on the wall

 •

Dust wouldn't be
dust forever

It mixes with something when no one
not even TV is looking

Indiscriminate as sin
it clings
greaselike
to cracks between baseboard
and floor, to bathroom walls, kitchen walls
doors of cupboards, ceilings, cracks
around door knobs, stove knobs, faucets, chrome the length
of the sink, of the stove, of the edge
of anger

The sponge of our knowledge useless against it

Mother, years it took me to guess
you knew all this

Your Saturday helper dusting her
own room, living room, dining room, den

All this she hadn't expected
to notice
to care about

Ever

•

It ticks out of the walls
like lives
before us

The walls won't
hold them
any more.

The Rabbi's Daughter

By Hortense Calisher

*Hortense Calisher (1911–) was born in New York City. After
earning her A.B. from Barnard College, she worked in a
department store, married, had two children, and was a social
worker, a teacher, and an editor of a girls' magazine. The
publication of several of her short stories brought her the award
of a Guggenheim fellowship in 1952, enabling her to spend
a year in England. Her first book of short stories appeared in
1953, when she was forty-two. Since then she has received
other writing awards, including a National Endowment for the
Arts fellowship, and has taught at numerous colleges and
universities. Her articles have appeared in* The Nation,
the New York Times Book Review, *and other periodicals.
Calisher has published more than seven novels, as well as
several additional collections of stories. Among her books are*
False Entry, Eagle Eye, *a memoir titled* Herself, *a farce on
sexual mores titled* Queenie, *and* Journal from Ellipsia,
*a satire on male-female relationships postulating "a planet on
which things are otherwise."*

They all came along with Eleanor and her baby in the cab to
Grand Central, her father and mother on either side of her, her
father holding the wicker bassinet on his carefully creased
trousers. Rosalie and Helene, her cousins, smart in their fall
ensembles, just right for the tingling October dusk, sat in the
two little seats opposite them. Aunt Ruth, Dr. Ruth Brinn, her
father's sister and no kin to the elegant distaff cousins, had in-
sisted on sitting in front with the cabman. Eleanor could see
her now, through the glass, in animated talk, her hat tilted
piratically on her iron-gray braids.

Leaning forward, Eleanor studied the dim, above-eye-level
picture of the driver. A sullen-faced young man, with a lock
of black hair belligerent over his familiar nondescript face:
"Manny Kaufman." What did Manny Kaufman think of Dr.
Brinn? In ten minutes she would drag his life history from him,
answering his unwilling statements with the snapping glance,

the terse nods which showed that she got it all, at once, under-
stood him down to the bone. At the end of her cross-question-
ing she would be quite capable of saying, "Young man, you are
too pale! Get another job!"

"I certainly don't know why you wanted to wear that get-up,"
said Eleanor's mother, as the cab turned off the Drive toward
Broadway. "On a train. And with the baby to handle, all alone."
She brushed imaginary dust from her lap, scattering disap-
proval with it. She had never had to handle her babies alone.

Eleanor bent over the basket before she answered. She was a
thin fair girl whom motherhood had hollowed, rather than en-
hanced. Tucking the bottle-bag further in, feeling the wad of
diapers at the bottom, she envied the baby blinking solemnly
up at her, safe in its surely serviced world.

"Oh, I don't know," she said. "It just felt gala. New Yorkish.
Some people dress down for a trip. Others dress up—like me."
Staring at her own lap, though, at the bronze velveteen which
had been her wedding dress, sensing the fur blob of hat insecure
on her unprofessionally waved hair, shifting the shoes, faintly
scuffed, which had been serving her for best for two years, she
felt the sickening qualm, the frightful inner blush of the inap-
propriately dressed.

In front of her, half-turned toward her, the two cousins swayed
neatly in unison, two high-nostriled gazelles, one in black, one
in brown, both in pearls, wearing their propriety, their utter
rightness, like skin. She had known her own excess when she
had dressed for the trip yesterday morning, in the bare rooms,
after the van had left, but her suits were worn, stretched with
wearing during pregnancy, and nothing went with anything any
more. Tired of house dresses, of the spotted habiliments of ma-
ternity, depressed with her three months' solitude in the coun-
try waiting out the lease after Dan went on to the new job, she
had reached for the wedding clothes, seeing herself cleansed and
queenly once more, mysterious traveler whose appearance
might signify anything, approaching the pyrrhic towers of New
York, its effervescent terminals, with her old brilliance, her old
style.

Her father sighed. "Wish that boy could find a job nearer
New York."

"You know an engineer has to go where the plants are," she said, weary of the old argument. "It's not like you—with your own business and everything. Don't you think I'd like . . .?" She stopped, under Rosalie's bright, tallying stare.

"I know, I know." He leaned over the baby, doting.

"What's your new house like?" said Rosalie.

"You know," she said gaily, "after all Dan's letters, I'm not just sure, except that it's part of a two-family. They divide houses every which way in those towns. He's written about 'Bostons,' and 'flats,' and 'duplexes.' All I really know is it has automatic heat, thank goodness, and room for the piano." She clamped her lips suddenly on the hectic chattering voice. Why had she had to mention the piano, especially since they were just passing Fifty-seventh Street, past Carnegie with all its clustering satellites—the Pharmacy, the Playhouse, the Russian restaurant—and in the distance, the brindled windows of the galleries, the little chiffoned store fronts, spitting garnet and saffron light? All her old life smoked out toward her from these buildings, from this parrot-gay, music-scored street.

"Have you been able to keep up with your piano?" Helene's head cocked, her eyes screened.

"Not—not recently. But I'm planning a schedule. After we're settled." In the baby's nap time, she thought. When I'm not boiling formulas or wash. In the evenings, while Dan reads, if I'm only—just not too tired. With a constriction, almost of fear, she realized that she and Dan had not even discussed whether the family on the other side of the house would mind the practicing. That's how far I've come away from it, she thought, sickened.

"All that time spent." Her father stroked his chin with a scraping sound and shook his head, then moved his hand down to brace the basket as the cab swung forward on the green light.

My time, she thought, my life—your money, knowing her unfairness in the same moment, knowing it was only his devotion, wanting the best for her, which deplored. Or, like her mother, did he mourn too the preening pride in the accomplished daughter, the long build-up, Juilliard, the feverish, relative-ridden Sunday afternoon recitals in Stengel's studio,

the program at Town Hall, finally, with her name, no longer Eleanor Goldman, but Elly Gold, truncated hopefully, euphoniously for the professional life to come, that had already begun to be, thereafter, in the first small jobs, warm notices?

As the cab rounded the corner of Fifth, she saw two ballerinas walking together, unmistakable with their dark Psyche knots over their fichus, their sandaled feet angled outwards, the peculiar compensating tilt of their little strutting behinds. In that moment it was as if she had taken them all in at once, seen deep into their lives. There was a studio of them around the hall from Stengel's, and under the superficial differences the atmosphere in the two studios had been much the same: two tight, concentric worlds whose *aficionados* bickered and endlessly discussed in their separate argots, whose students, glowing with the serious work of creation, were like trajectories meeting at the burning curve of interest.

She looked at the cousins with a dislike close to envy, because they neither burned nor were consumed. They would never throw down the fixed cards. Conformity would protect them. They would marry for love if they could; if not, they would pick, prudently, a candidate who would never remove them from the life to which they were accustomed. Mentally they would never even leave Eighty-sixth Street, and their homes would be like their mothers', like her mother's, *bibelots* suave on the coffee tables, bonbon dishes full, but babies postponed until they could afford to have them born at Doctors Hospital. "After all the money Uncle Harry spent on her, too," they would say later in mutually confirming gossip. For to them she would simply have missed out on the putative glory of the prima donna; that it was the work she missed would be out of their ken.

The cab swung into the line of cars at the side entrance to Grand Central. Eleanor bent over the basket and took out the baby. "You take the basket, Dad." Then, as if forced by the motion of the cab, she reached over and thrust the bundle of baby onto Helene's narrow brown crepe lap, and held it there until Helene grasped it diffidently with her suede gloves.

"She isn't—she won't wet, will she?" said Helene.

A porter opened the door. Eleanor followed her mother and father out and then reached back into the cab. "I'll take her now." She stood there hugging the bundle, feeling it close, a round comforting cyst of love and possession.

Making her way through the snarled mess of traffic on the curb, Aunt Ruth came and stood beside her. "Remember what I told you!" she called to the departing driver, wagging her finger at him.

"What did you tell him?" said Eleanor.

"Huh! What I told him!" Her aunt shrugged, the blunt Russian shrug of inevitability, her shrewd eyes ruminant over the outthrust chin, the spread hands. "Can I fix life? Life in Brooklyn on sixty dollars a week? I'm only a medical doctor!" She pushed her hat forward on her braids. "Here! Give me that baby!" She whipped the baby from Eleanor's grasp and held it with authority, looking speculatively at Eleanor. "Go on! Walk ahead with them!" She grinned. "Don't I make a fine nurse? Expensive, too!"

Down at the train, Eleanor stood at the door of the roomette while the other women, jammed inside, divided their ardor for the miniature between the baby and the telescoped comforts of the cubicle. At the end of the corridor, money and a pantomime of cordiality passed between her father and the car porter. Her father came back down the aisle, solid gray man, refuge of childhood, grown shorter than she. She stared down at his shoulder, rigid, her eyes unfocused, restraining herself from laying her head upon it.

"All taken care of," he said. "He's got the formula in the icebox and he'll take care of getting you off in the morning. Wish you could have stayed longer, darling." He pressed an envelope into hand. "Buy yourself something. Or the baby." He patted her shoulder. "No . . . now never mind now. This is between you and me."

"Guess we better say good-bye, dear," said her mother, emerging from the roomette with the others. Doors slammed, passengers swirled around them. They kissed in a circle, nibbling and diffident.

Aunt Ruth did not kiss her, but took Eleanor's hands and looked at her, holding on to them. She felt her aunt's hands moving softly on her own. The cousins watched brightly.

"What's this, what's this?" said her aunt. She raised Eleanor's hands, first one, then the other, as if weighing them in a scale, rubbed her own strong, diagnostic thumb back and forth over Eleanor's right hand, looking down at it. They all looked down at it. It was noticeably more spatulate, coarser-skinned than the left, and the middle knuckles were thickened.

"So . . .," said her aunt. "So-o . . .," and her enveloping stare had in it that warmth, tinged with resignation, which she offered indiscriminately to cabmen, to nieces, to life. "So . . ., the 'rabbi's daughter' is washing dishes!" And she nodded, in requiem.

"Prescription?" said Eleanor, smiling wryly back.

"No prescription!" said her aunt. "In my office I see hundreds of girls like you. And there is no little pink pill to fit." She shrugged, and then whirled on the others. "Come. Come on." They were gone, in a last-minute flurry of ejaculations. As the train began to wheel past the platform, Eleanor caught a blurred glimpse of their faces, her parents and aunt in anxious trio, the two cousins neatly together.

People were still passing by the door of the roomette, and a woman in one group paused to admire the baby, frilly in the delicately lined basket, "Ah, look!" she cooed. "Sweet! How old is she?"

"Three months."

"It *is* a she?"

Eleanor nodded.

"Sweet!" the woman said again, shaking her head admiringly, and went on down the aisle. Now the picture was madonna-perfect, Eleanor knew—the harsh, tintype lighting centraled down on her and the child, glowing in the viscous paneling that was grained to look like wood, highlighted in the absurd plush-cum-metal fixtures of this sedulously planned manger. She shut the door.

The baby began to whimper. She made it comfortable for the night, diapering it quickly, clipping the pins in the square folds,

raising the joined ankles in a routine that was like a jigging
ballet of the fingers. Only after she had made herself ready for
the night, hanging the dress quickly behind a curtain, after she
had slipped the last prewarmed bottle out of its case and was
holding the baby close as it fed, watching the three-cornered
pulse of the soft spot winking in and out on the downy head—
only then did she let herself look closely at her two hands.

The difference between them was not enough to attract
casual notice, but enough, when once pointed out, for anyone
to see. She remembered Stengel's strictures on practicing with
the less able left once. "Don't think you can gloss over, Miss. It
shows!" But that the scrubbing hand, the working hand, would
really "show" was her first intimation that the daily make-
shift could become cumulative, could leave its imprint on the
flesh with a crude symbolism as dully real, as conventionally
laughable, as the first wrinkle, the first gray hair.

She turned out the light and stared into the rushing dark. The
physical change was nothing, she told herself, was easily re-
paired; what she feared almost to phrase was the death by post-
ponement, the slow uneventful death of impulse. "Hundreds of
girls like you," she thought, fearing for the first time the com-
promises that could arrive upon one unaware, not in the heroic
renunciations, but erosive, gradual, in the slow chip-chipping of
circumstance. Outside the window the hills of the Hudson
Valley loomed and receded, rose up, piled, and slunk again into
foothills. For a long time before she fell asleep she probed the
dark for their withdrawing shapes, as if drama and purpose
receded with them.

In the morning the porter roused her at six, returning an iced
bottle of formula, and one warmed and made ready. She rose
with a granular sense of return to the real, which lightened as
she attended to the baby and dressed. Energized, she saw herself
conquering whatever niche Dan had found for them, revitaliz-
ing the unknown house as she had other houses, with all the
artifices of her New York chic, squeezing ragouts from the tiny
salary spent cagily at the A & P, enjoying the baby instead of
seeing her in the groggy focus of a thousand tasks. She saw her-
self caught up at odd hours in the old exaltation of practice,

even if they had to hire a mute piano, line a room with cork. Nothing was impossible to the young, bogey-dispensing morning.

The station ran past the window, such a long one, sliding through the greasy lemon-colored lights, that she was almost afraid they were not going to stop, or that it was the wrong one, until she saw Dan's instantly known contour, jointed, thin, and his face, raised anxiously to the train windows with the vulnerability of people who do not know they are observed. She saw him for a minute as other passengers, brushing their teeth hastily in the washrooms, might look out and see him, a young man, interesting because he was alone on the platform, a nice young man in a thick jacket and heavy work pants, with a face full of willingness and anticipation. Who would get off for him? As she waited in the jumble of baggage at the car's end, she warned herself that emotion was forever contriving toward moments which, when achieved, were not single and high as they ought to have been, but often splintered slowly—just walked away on the little centrifugal feet of detail. She remembered how she had mulled before their wedding night, how she had been unable to see beyond the single devouring picture of their two figures turning, turning toward one another. It had all happened, it had all been there, but memory could not recall it so, retaining instead, with the pedantic fidelity of some poet whose interminable listings recorded obliquely the face of the beloved but never invoked it, a whole rosary of irrelevancies, in the telling of which the two figures merged and were lost. Again she had the sense of life pushing her on by minute, imperceptible steps whose trend would not be discerned until it was too late, as the tide might encroach upon the late swimmer, making a sea of the sand he left behind.

"Dan!" she called. "Dan!"

He ran toward her. She wanted to run, too, to leap out of the hemming baggage and fall against him, rejoined. Instead, she and the bags and the basket were jockeyed off the platform by the obsequious porter, and she found herself on the gray boards of the station, her feet still rocking with the left-over rhythm of

the train, holding the basket clumsily between her and Dan, while the train washed off hoarsely behind them. He took the basket from her, set it down, and they clung and kissed, but in all that ragged movement, the moment subdivided and dispersed.

"God Lord, how big she is!" he said, poking at the baby with a shy, awkward hand.

"Mmm. Tremendous!" They laughed together, looking down.

"Your shoes—what on earth?" she said. They were huge, laced to the ankle, the square tips inches high, like blocks of wood on the narrow clerkly feet she remembered.

"Safety shoes. You have to wear them around a foundry. Pretty handy if a casting drops on your toe."

"Very swagger." She smiled up at him, her throat full of all there was to tell—how, in the country, she had spoken to no one but the groceryman for so long that she had begun to monologue to the baby; how she had built up the first furnace fire piece by piece, crouching before it in awe and a sort of pride, hoping, as she shifted the damper chains, that she was pulling the right one; how the boy who was to mow the lawn had never come, and how at last she had taken a scythe to the knee-deep, insistent grass and then grimly, jaggedly, had mown. But now, seeing his face dented with fatigue, she saw too his grilling neophyte's day at the foundry, the evenings when he must have dragged hopefully through ads and houses, subjecting his worn wallet and male ingenuousness to the soiled witcheries of how many landlords, of how many narrow-faced householders tipping back in their porch chairs, patting tenderly at their bellies, who would suck at their teeth and look him over. "You permanent here, mister?" Ashamed of her city-bred heroisms, she said nothing.

"You look wonderful," he said. "Wonderful."

"Oh." She looked down. "A far cry from."

"I borrowed a car from one of the men, so we can go over in style." He swung the basket gaily under one arm. "Let's have breakfast first, though."

"Yes, let's." She was not eager to get to the house.

They breakfasted in a quick-lunch place on the pallid,

smudged street where the car was parked, and she waited, drinking a second cup of coffee from a grainy white mug while Dan went back to the station to get the trunk. The mug had an indistinct blue V on it in the middle of a faded blue line running around the rim; it had probably come secondhand from somewhere else. The fork she had used had a faint brassiness showing through its nickel-colored tines and was marked "Hotel Ten Eyck, Albany," although this was not Albany. Even the restaurant, on whose white, baked look the people made gray transient blurs which slid and departed, had the familiar melancholy which pervaded such places because they were composed everywhere, in a hundred towns, of the same elements, but were never lingered in or personally known. This town would be like that too; one would be able to stand in the whirling center of the five-and-dime and fancy oneself in a score of other places where the streets had angled perhaps a little differently and the bank had been not opposite the post office, but a block down. There would not even be a need for fancy because, irretrievably here, one was still in all the resembling towns, and going along these streets one would catch oneself nodding to faces known surely, plumbed at a glance, since these were overtones of faces in all the other towns that had been and were to be.

They drove through the streets, which raised an expectation she knew to be doomed, but cherished until it should be dampened by knowledge. Small houses succeeded one another, gray, coffee-colored, a few white ones, many with two doors and two sets of steps.

"Marlborough Road," she said. "My God."

"Ours is Ravenswood Avenue."

"No!"

"Slicker!" he said. "Ah, darling, I can't believe you're here. His free arm tightened and she slid down on his shoulder. The car made a few more turns, stopped in the middle of a block, and was still.

The house, one of the white ones, had two close-set doors, but the two flights of steps were set at opposite ends of the ledge of porch, as if some craving for a privacy but doubtfully main-

tained within had leaked outside. Hereabouts, in houses with
the cramped deadness of diagrams, was the special ugliness
created by people who would keep themselves a toehold above
the slums by the exercise of a terrible, ardent neatness which
had erupted into the foolish or the grotesque—the two niggling
paths in the common driveway, the large trellis arching pomp-
ously over nothing. On Sundays they would emerge, the fathers
and mothers, dressed soberly, even threadbare, but dragging
children outfitted like angelic visitants from the country of the
rich, in poke bonnets and suitees of pink and mauve, larded tri-
umphantly with fur.

As Dan bent over the lock of one of the doors, he seemed to
her like a man warding off a blow.

"Is the gas on?" she said hurriedly. "I've got one more
bottle."

He nodded. "It heats with gas, you know. That's why I took
it. They have cheap natural gas up here." He pushed the door
open, and the alien, anti-people smell of an empty house came
out toward them.

"I know. You said. Wait till I tell you about me and the
furnace in the other place." Her voice died away as, finally, they
were inside.

He put the basket on the floor beside him. "Well," he said,
"This am it."

"Why, there's the sofa!" she said. "It's so funny to see every-
thing—just two days ago in Erie, and now here." Her hand de-
layed on the familiar pillows, as if on the shoulder of a friend.
Then, although a glance had told her that no festoonings of the
imagination were going to change this place, there was nothing
to do but look.

The door-cluttered box in which they stood predicated a
three-piece "suite" and no more. In the center of its mustard
woodwork and a wallpaper like cold cereal, two contorted
pedestals supported less the ceiling than the status of the room.
Wedged in without hope of rearrangement, her own furniture
had an air of outrage, like social workers who had come to res-
cue a hovel and had been confronted, instead, with the proud
glare of mediocrity.

She returned the room's stare with an enmity of her own. Soon I will get to know you the way a woman gets to know a house—where the baseboards are the roughest, and in which corners the dust drifts—the way a person knows the blemishes of his own skin. But just now I am still free of you—still a visitor.

"Best I could do." The heavy shoes clumped, shifting.

"It'll be all right," she said. "You wait and see." She put her palms on his shoulders. "It just looked queer for a minute, with windows only on one side." She heard her own failing voice with dislike, quirked it up for him. "Half chick. That's what it is. Half-chick house!"

"Crazy!" But some of the strain left his face.

"Uh-huh, *Das Ewig Weibliche*, that's me!" She half pirouetted. "Dan!" she said. "Dan, where's the piano?"

"Back of you. We had to put it in the dinette. I thought we could eat in the living room anyway."

She opened the door. There it was, filling the box room, one corner jutting into the entry to the kitchenette. Tinny light, whitening down from a meager casement, was recorded feebly on its lustrous flanks. Morning and evening she would edge past it, with the gummy dishes and the clean. Immobile, in its cage, it faced her, a great dark harp lying on its side.

"Play something, for luck." Dan came up behind her, the baby bobbing on his shoulder.

She shook her head.

"Ah, come on." His free arm cinched the three of them in a circle, so that the baby participated in their kiss. The baby began to cry.

"See," she said. "We better feed her."

"I'll warm the bottle. Have to brush up on being a father." He nudged his way through the opening. She heard him rummaging in a carton, then the clinking of a pot.

She opened the lid of the piano and struck the A, waiting until the tone had died away inside her, then struck a few more notes. The middle register had flattened first, as it always did. Sitting down on the stool, she looked into her lap as if it belonged to somebody else. What was the piano doing here, this

opulent shape of sound, five hundred miles from where it was
the day before yesterday; what was she doing here, sitting in the
lopped-off house, in the dress that had been her wedding dress,
listening to the tinkle of a bottle against a pan? What was the
mystery of distance—that it was not only geographical but
clove through the map into the heart?

She began to play, barely flexing her fingers, hearing the nails
she had let grow slip and click on the keys. Then, thinking of
the entities on the other side of the wall, she began to play
softly, placating as if she would woo them, the town, provi-
dence. She played a Beethoven andante with variations, then an
adagio, seeing the Von Bülow footnotes before her: ". . . the
ascending diminished fifth may be phrased, as it were, like a
question, to which the succeeding bass figure may be regarded
as the answer."

The movement finished but she did not go on to the scherzo.
Closing the lid, she put her head down on her crossed arms.
Often, on the fringes of concerts, there were little haunting
crones of women who ran up afterward to horn in on the con-
gratulatory shoptalk of the players. She could see one of them
now, batting her stiff claws together among her fluttering drap-
eries, nodding eagerly for notice: "I studied . . . I played too, you
know . . . years ago . . . with De Pachmann!"

So many variants of the same theme, she thought, so many of
them—the shriveled, talented women. Distance has nothing to
do with it; be honest—they are everywhere. Fifty-seventh Street
is full of them. The women who were once "at the League,"
who cannot keep themselves from hanging the paintings, the
promising *juvenilia,* on their walls, but who flinch, deprecat-
ing, when one notices. The quondam writers, chary of ridicule,
who sometimes, over wine, let themselves be persuaded into
bringing out a faded typescript, and to whom there is never any-
thing to say, because it is so surprisingly good, so fragmentary,
and was written—how long ago? She could still hear the light
insistent note of the A, thrumming unresolved, for herself
and for all the other girls. A man, she thought jealously, can be
reasonably certain it was his talent which failed him, but the

women, for whom there are still so many excuses, can never be so sure.

"You're tired." Dan returned, stood behind her.

She shook her head, staring into the shining case of the piano, wishing that she could retreat into it somehow and stay there huddled over its strings, like those recalcitrant nymphs whom legend immured in their native wood or water, but saved.

"I have to be back at the plant at eleven." He was smiling uncertainly, balancing the baby and the bottle.

She put a finger against his cheek, traced the hollows under his eyes. "I'll soon fatten you up," she murmured, and held out her arms to receive the baby and the long, coping day.

"Won't you crush your dress? I can wait till you change."

"No." She heard her own voice, sugared viciously with wistfulness. "Once I change I'll be settled. As long as I keep it on . . . I'm still a visitor."

Silenced, he passed her the baby and the bottle.

This will have to stop, she thought. Or will the denied half of me persist, venomously arranging for the ruin of the other? She wanted to warn him standing there, trusting, in the devious shadow of her resentment.

The baby began to pedal its feet and cry, a long nagging ululation. She sprinkled a few warm drops of milk from the bottle on the back of her own hand. It was just right, the milk, but she sat on, holding the baby in her lap, while the drops cooled. Flexing the hand, she suddenly held it out gracefully, airily, regarding it.

"This one is still 'the rabbi's daughter,' " she said. Dan looked down at her, puzzled. She shook her head, smiling back at him, quizzical and false, and bending, pushed the nipple in the baby's mouth. At once it began to suck greedily, gazing back at her with the intent, agate eyes of satisfaction.

You Captured My Heart

By Patti Warashina

Ceramic sculptor Patti Warashina (1940–) was born in Spokane, Washington. She received her B.F.A. in 1962 and her M.F.A. in 1964 from the University of Washington, Seattle, and by 1961 had already begun to exhibit her ceramic works, which in that year won an award in the Northwest Crafts- men's Exhibition in Seattle. In 1964 she began teaching at Wisconsin State University. She has taught at Eastern Michigan University and at the Cornish School of Allied Arts, and currently is a professor of art at the University of Washington.

The recipient of many grants and awards, including a National Endowment for the Arts grant in 1975, Warashina has traveled extensively in the United States and Asia, showing her work in many invitational exhibits, including two in Japan, lecturing, and teaching in workshops. Funded by the World's Craft Council (UNESCO), she visited the Philippines, and in 1978 she received a Ford Foundation grant. Her work has appeared in more than a dozen one- and two-person shows, in numerous group exhibitions, including the First World Crafts Exhibition in Toronto, Canada, the Whitney Museum of American Art, and the Smithsonian Institution, and is collected in such museums as the Everson Art Museum, Syracuse, and the Detroit Art Institute.

In her ceramic sculptures Warashina often combines straightforward, representational images in unexpected ways. Most of her ideas for her work are subconscious, Warashina says. She begins each piece with a series of sketches, many of them portraying objects which surround her "in the house, objects common to women." Married and the mother of two children, Warashina calls on her own experience for the subject of much of her work—affirming the positive aspects of women's traditional activities, while at the same time satirizing the extremes to which they can be carried.

The ceramic sculpture pictured here is part of a series in

Plate 23. Patti Warashina. YOU CAPTURED MY HEART. Low-fire clay, under-glaze, wood, 25 × 18 × 14 in. 1977.

which various women, each surrounded by a box, offer to their
viewers an object or objects held in their hands on serving
platters or plates. These objects (a cake, a bowl of food, a
bouquet of lilies) are all exaggerated in size—suggesting that
they have become as important as, if not more important
than, the women who serve them. The ambiguity of such
"service" is heightened by Warashina's choice of titles such as
Love It or Leave It, Tiger Lily, Galloping Gourmet. In You
Captured My Heart, the woman, dressed in traditional
Japanese costume, offers her loving heart with a bedazzled
expression which suggests the completeness of her "capture."

The Divided Heart

By Ruth Whitman

*Ruth Whitman (1922–) grew up in Manhattan. Married
at nineteen, she studied at Harvard, worked as a free-lance
writer, and had three children before her first book of poems
was published.* Her books include The Passion of Lizzie
Borden: New and Selected Poems, The Marriage Wig and Other
Poems, Blood and Milk Poems, An Anthology of Yiddish
Poetry *(which she translated and edited), and* The Selected
Poems of Jacob Glatstein. *Recipient of many writing awards,
she has given poetry readings in America and England,
taught poetry at the Radcliffe Institute, and was director of
the Poetry Writing Program in Massachusetts schools,
1971–1973. She is married to Morton Sacks. Her essay shows
how she learned to combine the work of an artist with
being a wife and mother.*

I am writing this riding home to Boston from New York, where
I gave several poetry readings and spent a day at an English
teachers' conference in Philadelphia. I have been away four
days. At home my husband, my daughters of nineteen and
twenty-four and my son of thirteen are running the house.

Five years ago, this would have been impossible, not only be-
cause the children are older now, almost grown, but because
I have changed and my family has changed. It has been a long
apprenticeship learning to reconcile my creative and domestic
lives. Even now, riding homeward on the bus, I feel twinges of
guilt about leaving the family for so many meals; some anxiety
about my young son ranging around Boston on his own, and a
longing to see them, after four days of strangers. I feel these
vestiges of guilt, despite the fact that they have been coopera-
tive and encouraging, on this trip particularly, when so much of
my professional life was involved. They have learned to tolerate
the duality of my life.

I have been leading a double life since I was a child of nine or
ten, living in a crowded apartment in the midst of an emo-

tionally demanding family in mid-Manhattan, having just dis-
covered the secret vice of writing. I remember crawling under
furniture—my bed, or the diningroom table—to read or write in
privacy. Later on, I learned to use the bathroom as a study, since
the door had a lock and no one could say, "What are you doing
under the table?"

Writing for me was and is an assertion of identity. I never feel
so much myself, with a great sense of relief and release, as when
I stop somewhere in the midst of the daily chaos with pencil
and paper. As I grew older I learned to work on top of the dining-
room table, despite radios blaring, telephones ringing, and peo-
ple coming, going, talking loudly. It tremendously sharpened
my powers of concentration, this exercise in shutting out the
world. But it was a great strain on the nervous system.

I had no room of my own until I was forty. At nineteen, when
I eloped to Cambridge with my first husband, a poor Harvard
undergraduate, writing poetry had to be sandwiched into odd
moments of privacy.

Being married was a strange, unexpected experience. We were
both undergraduates and I supported us both with odd jobs. No
one expected me to keep house in the rooming houses and tiny
apartments we camped in, but the nest-building instinct was
beginning to stir in me. I was already committed to life as a poet
and scholar; I thought of myself as a person, not a woman, and
here was this sudden irrelevant interest in the price of ham-
burger, in the signs in grocery stores, in feeding the people I
loved, and the gradual wish for a child. It was a reversal of the
more common experience, when a woman in a domestic setting
feels guilt over wanting a private creative life of her own: I felt
guilty over wanting a domestic life. I remember deliberately
keeping my eyes averted from grocery store windows, believing
that the desire to cook and the desire to write were irrecon-
cilable.

When my first child was born (an event which I postponed for
eight years), the guilt became more evenly distributed. I was
working as a free-lance editor, as well as writing, and I worked
until the day before my daughter was born, and went back to
work two weeks after. I was afraid to lose my independence, my
person-ness. But the whole experience of pregnancy, which I

found marvelously mind-expanding as well as body-expanding,
followed by the experience of viewing this beautiful piece of life
for which I was responsible, gave me a passion for motherhood.
The conflict was complete. I felt guilty no matter what I did.

Perfection of life or perfection of work? Which would you
rather strive for? My answer had to be—both. I began to see that
life was not static. It changed continually. And one could guide
the change: children could be educated to allow for a free parent;
husbands could be educated to see the equality of needs and
responsibilities; I could become less rigid in my view of my
needs; I could trust to my basic commitment and drive, no mat-
ter how painful the frustration I felt when I had something to
write and no place or time in which to write it.

I taught my children to play by themselves for part of every
day from an early age. I learned to wake up at night, after a brief
sleep, and work on my writing at three or four in the morning;
or wake up at six and write until everyone woke up. I still tend
automatically to wake up and write in the middle of the night
when I am working on a poem. I shared the fact that I was writ-
ing with my children and encouraged them to write things of
their own. Poetry is a great leveler.

I don't mean to imply for a moment that there were not tre-
mendous pain and division in my heart. I didn't want to miss
companionship with my children, particularly during the years
of rapid growth and learning. I now see that this period was
relatively short. On the other hand, I felt resentful at having to
delay my own creative development for so long. My third child
was born before my first book came out. But by that time I was
beginning to understand that my libido was strong enough to
make both books and babies and that in fact one strengthened
the other. Both together were the real total of my life. Spirit-
ually, so long as I insisted on my right to a private life, there was
no real division. The division was in the distribution of time.

I spent about twenty years at the hearthstone, in moments of
elation and moments of despair, until there was a soothing of
the conflict in the form of a three-week fellowship at the
MacDowell Colony. My son was two and my mother came to
stay with him.

So much was pent up in me that I began to write even before

I unpacked my suitcase, and I had a book of poems ready when I left. My second lifesaver was a fellowship from the Radcliffe Institute, which provided funds and a place to work away from home, allowing me to juggle the domestic balls in the air together with poetic ones. I began to see that there were other women like me, struggling with the same problems, and I felt part of a community of artists and scholars who each had new roles to define. In the two years that I was a fellow I finished a book of translations of the Yiddish poet, Jacob Glatstein, and wrote most of my third book of poems.

Gradually I began to reach the point when a line of poetry and a menu could be cooking in my head side by side, without interfering with one another. Time and my definition of poetry had both expanded.

Last fall when I received an international poetry prize and an opportunity to go to England, my husband, who is a teacher and a painter, and on whom the greatest burden of responsibility would fall, agreed to take over for six days. There is no question that without a supportive family it would have been much harder to go, perhaps impossible. One of the unexpected bonuses of the trip was the sense of freedom—being in a strange city, sleeping alone, traveling alone. The solitude was heady to a person who had all her life been surrounded by relatives and friends.

It is perhaps significant to mention that I had entered my prizewinning poem under the male pseudonym, "Robert Schumann," partly because I have always felt a strong affinity for the composer, and partly because I wanted to see what would happen. As it turned out, the judges were surprised that I was a woman and kept asking me why I chose a male name. I will never know whether or not I would have won with a female pseudonym. There were no other women among the winners.

The women's movement during the past few years has helped me think more freely and with less guilt about myself. More important, it has helped me to speak openly and without fear about my experience and needs. Most important, it has made possible an emotional community among women, a sis-

terhood of women everywhere, daughters, friends, even the women who have lived before us. It has also become possible to regard men as fragile and needy and still express love and sympathy for them. For me that means a leveling out of dependence, a new and different distribution of roles and support.

Will the two sides of the conflict ever be completely reconciled? I think not. There will always be abrasions in domestic life, burdening demands of job and family. In the artist, it may be these very abrasions which sometimes produce the pearl. I discover that many of my neurotic veils, self-doubts, and obfuscations have fallen away. I find I have more direct access to my sources of creativity. I am not afraid to report conflict. It is a process of continuous education for me and my family. The life and the work are coming closer together.

My original title for this essay was "The Poet as Mother," intending to make the point that the basic conflict of my life was between my function in the family and my function in my individual life. But the problem of fulfilling one's life creatively as well as emotionally, of fulfilling one's responsibility to society as well as to oneself, has been experienced in some form by every man I know. Such a title would be discrimination in reverse, as though only women had these conflicts.

The word "parent" is more inclusive than "mother." It spans all the caretaking, educative, loving, and succoring functions that both sexes perform for the succeeding generation, not only for our biological children, but for our students and friends as well. More and more I see the parental function—not authoritative, but educative—as the responsibility of every human being who has found out anything by living. If civilization means anything, it lies in becoming part of the great chain of learning from those who have gone before us, and of teaching those who come after us.

A private creative person lives inside each of us. It is one's basic identity, with all the symbols, images, and language that each of us has stored up since childhood. It is in these more universal terms that the poet and parent begin to come together, that the conflict begins to subside and the divided heart becomes whole.

Maternity

By Dorothea Tanning

*Vividly portraying "the overwhelming isolation of woman"
and, in particular, the woman artist, the paintings of
Dorothea Tanning (1910–) give few actual clues to the life of
the artist herself. Born in Galesburg, Illinois, Tanning attended
Knox College for two years and, briefly, the Chicago
Academy of Arts. Seeking to learn from first-hand impressions,
rather than formal instruction, she moved to New York in
1936 and later (1939–1941) to Paris and Stockholm, where she
immersed herself in contemporary literature and the art
of the "fantastic," Dada, and Surrealist painters. She began to
exhibit her own work upon her return to New York, and
held her first one-person show in 1944. Before and after her
marriage to the renowned painter Max Ernst, in 1946,
Tanning also worked in stage and costume design, creating
designs for George Balanchine's ballets* Night Shadow *(1945),*
Bayou *(1952), and* Will o' the Wisp *(1953).*

*During the late 1940s Tanning and Ernst lived in Sedona,
Arizona, whose desert landscape is reflected in many of the
paintings she did prior to 1952, when she and Ernst moved to
Paris. There they continued their association with many
of the world's leading Surrealist painters, such as André
Breton, Yves Tanguy and Roberto Matta. Working in the
Surrealist style, married to a painter whose fame was already
established, Tanning struggled to assert her own separate
identity and to win recognition as an individual artist.
Speaking later of her neglect by leading critics of the time,
especially by Breton in his influential writings, Tanning has
said that "for Breton I depended on Max, from every point
of view.... I had noticed with a certain consternation that the
place of women among the Surrealists was no different
from that which they occupied among the population in
general, the bourgeoisie included." Nevertheless, Tanning's
works have continued to be shown in prestigious galleries
in New York, London, and Paris. During the 1960s her*

Plate 24. Dorothea Tanning. MATERNITY. Oil on canvas, 56 × 45 in., signed. 1946.

painting began to be more colorful and abstract, "pulsing" with patterns of heat and "cosmic images." Currently living in Paris, Tanning now works in soft sculpture, using varieties of stuffed fabrics to create abstract shapes that sometimes recall themes from her earlier paintings.

Maternity, *like much of Tanning's earlier Surrealist work,*
presents dreamlike combinations of precise, detailed images
which, she has said, have "nothing to do with anything
in the dictionary." Intensely personal, many of her paintings of
the 1940s–1950s show women in various stages of transi-
tion—symbolized by hallways, tunnels, or rooms with door
upon door opening into the distance. As in Maternity,
many paintings contain some form of Pekingese dog, and the
overall mood is at once tranquil and ominous.

In Maternity, *reproduced here, three characters—mother,*
child and dog, whose faces look very much alike, and
like Tanning herself—are poised in a stance of resigned despair.
Having passed through one door, they stand in a barren,
threatening desert, far from a second doorway, beyond which
looms some strange construction of the mind. Different
from conventional paintings of blissful maternity, Tanning's
Maternity, *with its deadening yellow, white and grey tones,*
visually suggests the artist's feelings of apprehension
and isolation—feelings which are echoed, in their own ways,
by other artists in section 2.

Prospective Immigrants Please Note

By Adrienne Rich

Adrienne Rich (1929–) was born and raised in Baltimore,
Maryland, and began writing poetry as a child under the
supervision and encouragement of her father, through whose
extensive library she was introduced to the major British
poets. In 1951, the year she graduated from Radcliffe
College, her first book of poems, **A Change of World,** *won the*
Yale Younger Poets Award. In 1953, following a Guggenheim
Fellowship and a year of travel in Europe, she married
Alfred H. Conrad, an economist. Between 1955 and 1959 she
bore three sons and published her second book of poems,
The Diamond Cutters and Other Poems *(1955). Like her*
first volume, **The Diamond Cutters** *received critical praise for*
its qualities of "poise and control," "modesty," "crafts-
manship," and "gravity."

Although awards and recognition for her work continued,
there followed a silence of eight years before Rich published her
third volume, **Snapshots of a Daughter-in-Law,** *in 1963.*
The poems in this volume marked a new departure. Moving
away from such earlier influences on her work as William
Butler Yeats and Robert Frost and from the "objective" tone of
many of the poems in the earlier volumes, she began to
write in a longer, looser mode and also to write, as she later
said, "for the first time, directly about experiencing myself
as a woman." The title poem, "jotted in fragments during
children's naps, brief hours in a library, or at 3 A.M. after rising
with a wakeful child," expresses both the obstacles and
the challenges of her life, as she tried to reconnect the frag-
mented parts of herself—as wife, mother, and poet. "Prospec-
tive Immigrants Please Note," one of the final poems in
Snapshots of a Daughter-in-Law, *describes the need for*
redefinition that Rich was experiencing at the time. As
in the Tanning painting, the image of a door figures promi-

nently, but with the important difference that here the "immigrant" directly confronts it. To embrace the inner self that waits on the other side, a self that others may neither recognize nor accept, is an act of self-naming that the poet understands is both risky and necessary.

Either you will
go through this door
or you will not go through.

If you go through
there is always the risk
of remembering your name.

Things look at you doubly
and you must look back
and let them happen.

If you do not go through
it is possible
to live worthily

to maintain your attitudes
to hold your position
to die bravely

but much will blind you,
much will evade you,
at what cost who knows?

The door itself
makes no promises.
It is only a door.

You Do Not Know
the Breaking Through

By Ellen Bass

*Born in Philadelphia, Ellen Bass (1947–) grew up in New
Jersey, living for many years above the liquor store owned and
operated by her parents. She received her B.A. from Goucher
College and an M.A. in creative writing from Boston
University, working meanwhile, among other jobs, as a
waitress, a salesperson, an artist's model, a camp counselor,
and a typist. After college she worked for four years as a
counselor and group facilitator, and was a leader in writing
workshops at the Cambridge and Boston Centers for Adult
Education. She has published two books of poems—*I'm Not
Your Laughing Daughter *and* Of Separateness & Merging—*and
has co-edited, with Florence Howe, an anthology of poems
by women,* No More Masks! *In 1976 she married Alan Nelson,
a psychologist, with whom she lives near Santa Cruz,
California—continuing her work in counseling, teaching
writing workshops for women, and writing her own poems.
She has one daughter, born in 1978. The following poem, from*
Of Separateness & Merging, *suggests that the act of creation,
like mining, can be so joyfully intense and demanding
that all other concerns, for a time, cease to matter. Of her own
poems, Bass writes, "I want my words to serve as women's
art has always served—white stitched quilts, sienna pots,
woven water wheels, spears, bows, houses. To carry food, keep
warm, pass on the muscle of those who stood and those
who fell. Words to be a place to come home to."*

You do not know the breaking through
as it happens. You are in the mine
axing, axing and the metal dust
makes it hard to breathe—there are minutes you
give breathing up, your work is elsewhere.

Lifting great arms, slamming stone
your body must let go
or shatter. You blink sweat.
You cannot feel your hands, so full with blood.
They will pulsate, later
they will tremble. But now
they are ax, you are ax, and you
do not know what you are doing.

After, after you will look.
You will acknowledge. You will
see through the opening you have cleared.

Through the Flower

By Judy Chicago

Born Judy Gerowitz, Judy Chicago (1939–) grew up in
Chicago, where her parents were active in politics, and her
mother, who had wanted to be a dancer, encouraged her
daughter's artistic interests. After studying at the Chicago Art
Institute, she attended the University of California at
Los Angeles. In her autobiography, Through the Flower
(1975), she described the course of her growth and change
from her years as a graduate student in the 1950s and early
1960s, through her first years as a professional artist, to her
increasing assumption of the role of advocate for women's art.

As a student, Chicago emulated the painting styles of her
male teachers. From about 1967 on, she began to explore and
develop her own "form language," employing dome-like,
layered, and circular shapes in her work. In 1969, she changed
her name. In the early 1970s she was instrumental in
establishing art programs for women in California, including
the Feminist Art Program at the California Institute of
the Arts, which she directed with Miriam Schapiro (see section
1). Through such programs she also encouraged the creation
of female art communities in which women could control the
creation, sale, and distribution of their work. Meanwhile,
she continued to pursue her formal explorations in painting,
seeking an imagery that would enable her to express her most
personal feelings. Out of these explorations came a series
of works on the theme, "through the flower." The pictures
in this series, two of which are reproduced here, employ a
centered space to symbolize traditional cultural attitudes
towards female sexuality, and the flower to suggest women's
confinement within an image of fragility and delicacy.
Breaking through this flower into a new space where
redefinition can begin is, as Chicago has said in comments on
Chrysanthemum, a difficult and frightening, but exhilarating

*experience. In the concluding sentence of her autobiography
she reaffirms her belief in breaking "through the flower."
Seeing the process as one available to all women, she
describes it as "a process that can lead us to a place where*

**Plate 25. Judy Chicago. THROUGH THE FLOWER. Drawing, prismacolor on rag paper,
24 × 24 in. 1972.**

Photo, Frank J. Thomas. Courtesy, collection of Judy Chicago.

we can express our humanity and values as women through our work *and in our lives and in so doing, perhaps [we can] also reach accross the great gulf between masculine and feminine and gently, tenderly, but firmly heal it.*"

Plate 26. Judy Chicago. THROUGH THE FLOWER: CHRYSANTHEMUM. **Acrylic on canvas, 60 × 60 in. 1973.**

3: Their Own Images

Definitions and Discoveries

SECTION TWO FOCUSED ON WOMEN as they encountered both external and internal barriers to becoming artists. In this section of the anthology we present selections showing women artists on the other side of the "door": discovering, naming, and redefining themselves in their own terms. Beginning with Lucille Clifton's poem "Turning," we see a wide range of women artitsts, both present and past, who have moved beyond social, economic and cultural limitations. By rejecting physical stereotypes; by reclaiming the history, mythology, and religion of women and of their own ethnic groups; by redefining their relationships to women in their communities and families, as well as to other women artists, the artists in section 3 present *not* a chorus of frustration but a chorus of confidence in themselves and pride in their achievements.

Proud of her Black skin, no longer waiting like a "lady" to be freed from the limiting "cage" of racial and sexual stereotyping, the speaker in Lucille Clifton's poem turns not only *out of* these limitations but *in to* a positive, joyful sense of her true self. Having passed "through the flower," or the fragile, youthful state that society holds up to all women as ideal, she has become a mature "black fruit," nourished by her own strength and self-determination.

Part of the series of self-portraits which begins this section, Clifton's poem and the two poems which follow show women

167

artists in the process of saying "no" to the opinions of others, when those opinions are destructive to the artist's view of herself. Refusing to devalue themselves because of physical appearance, Clifton, Lisel Mueller, and Kathleen Fraser convey their awareness of the ways in which women are often made to feel inferior because they are not "pretty": because their skin may not be the "right" color; because their hair may be too curly or not curly enough, their noses too long or too short, their legs not shapely; because, growing older, they develop wrinkles. Since most societies have valued women's appearances above their achievements, women have inevitably been influenced by standards of female beauty, even though it is obvious that few women ever meet all criteria demanded by the physical ideal of their time and place.

Often, unreal standards of female beauty have been perpetuated or created through the visual images of male artists. Nineteenth-century poet Christina Rossetti observed that the male artist's portrait of a woman shows her "not as she is, but as she fills his dream."[1] Contemporary poet Lisel Mueller, however, refuses to judge her body in such terms—in this case, the portraits of nudes painted by the twentieth-century artist Edward Hopper. In Hopper's paintings, praised for their "meticulous clarity," individuals are isolated in a world "immobilized in a flat, brilliant light." Imagining herself in this light, Mueller openly confronts her bodily imperfections, reporting them with the factual eye of a camera. Knowing that she is not "a man's dream of heat and softness," Mueller redefines her self-worth in terms of her own experience: her body is her home; it is the familiar source of all her memories and dreams, which to her are more important than being judged "beautiful."

Poet Kathleen Fraser also says "no" to physical standards that demean her self-worth, defining herself and her body in her own new terms. Once ashamed of her legs because of their imperfections, Fraser humorously admits her former attempts to deny their existence. Now she recognizes with gratitude that these same legs have supported and carried her through many

[1] Christina Rossetti, "In an Artist's Studio," in Arthur M. Eastman and others, eds., *The Norton Anthology of Poetry* (New York, 1970), p. 861.

proud moments. Accepting the authority of her own experience over the opinions of others, Fraser has come to cherish the once-despised legs because they are part of a self she knows—and likes.

In Paula Modersohn-Becker's famed *Self-portrait*, we again see an artist taking pleasure in her body. Unlike the speakers in the preceding poems, however, who are conscious of rejecting physical stereotypes, Modersohn-Becker is beyond the point of defending herself against conflicting opinion: she has come all the way through "the door." In an era when "respectable" women were presumed to experience no sensual pleasure, when they were expected to be ignorant of their own bodies, hidden away under layers of restrictive clothing, Modersohn-Becker dared to paint herself naked. It was an unheard-of practice for women artists of her time. The self she presents, vibrantly alive, without shame in her body, bears no resemblance to the enticing yet delicate nudes favored by the male painters of her day. Modersohn-Becker's calm gaze, meeting that of the viewer, suggests that she recognizes no separation of her body from her mind and spirit.

Frida Kahlo's blunt self-portrait further challenges physical stereotypes. Having cut off her hair, and wearing a man's (her estranged husband's) clothing, Kahlo asserts that the inner self she values does not depend upon a traditionally feminine appearance. She challenges others to accept or reject her, as they choose—quite aware, of course, that she is likely not to be "loved any more." In openly defying convention, Kahlo represents other women artists whose work is a necessary act of experimentation.

Like Kahlo, contemporary sculptor Marisol feels free to experiment with portraying herself in unconventional ways. Her work frequently involves a trying-on of roles, which she may or may not wish to assume—just as, in a dream, one can become another person, or even inhabit an inanimate object. Marisol's emphasis is not upon breaking through female physical stereotypes, so much as it is upon breaking through the view of oneself as completely separated from other beings. By portraying herself in the form of other persons, sometimes in the form of

an animal, Marisol explores and reveals various aspects of her own consciousness.

In a somewhat similar manner, painter Marcia Marcus playfully tries on the role of the ancient Greek goddess Athena. In choosing to redefine herself through this female figure from ancient mythology, Marcus at the same time redefines Athena, who, according to myth, was not conventionally "feminine." Here, however, Athena, although she retains the helmet that is a symbol of her warrior role, is wearing an elegant gown. Goddess and artist meet in one figure that reflects a mind bold enough to combine and clothe its own fancies.

Marcus's *Self-portrait as Athena* moves us into a second major theme of section 3, in which we see women artists redefining and reclaiming history, myth, and religion. In Niki de Saint-Phalle's *Black Venus* we find a sculpture which re-interprets Greek myth in terms that are inclusive of, and meaningful for, Black women of today. Like a number of contemporary women, Saint-Phalle is aware that most Western myths handed down through time present few female models with whom women today—particularly women of ethnic and racial minority groups—can identify, or even wish to identify. Portraying the goddess of love and beauty as strong, active, and Black, rather than mild, passive, and white, Saint-Phalle affirms the being and beauty of the Black woman.

Wendy Rose, a Native American artist, also uses her art to redefine and reclaim history, legend and myth. Unlike *Black Venus*, which redefines a myth of one culture in terms of another, Rose's *Ghost Dance Woman* draws upon elements from the artist's own ancestral past. In this painting, which began as a self-portrait, Rose recreates the legend of the Ghost Dance, the name given by Native Americans to a religious movement of the nineteenth century which promised the reunion of human spirits after death. Preserving and transmitting this and other ancestral legends, which are easily lost in modern American society, Rose declares her allegiance to her native culture and clarifies her personal identity within this culture. Refusing to be assimilated into the melting pot of America, rejecting the racial prejudices of anthropologists, in both her painting and her

poem Rose draws strength and courage from her spiritual "Grandmother," thus establishing a vital connection with the lives, past and present, of others like herself.

Drawing from her more immediate past, Mexican-American artist Carmen Lomas Garza also redefines and establishes her personal alliance with members of her ethnic community. Like Wendy Rose, Garza has had to endure discrimination. Like Rose, Garza consciously reclaims in her art the sources of strength she finds in her family and community. Recognizing the importance of religion to her ethnic community, Garza often uses symbols of Roman Catholicism in her work. The importance of family ties finds expression in such graphics as *Abuelita* (a portrait of Garza's grandmother), which simultaneously establishes the artist's relationship and continuity with the older generation of women in her culture.

The life and work of ceramist Jade Snow Wong present a different resolution to the conflicts of being a woman artist of mixed cultural heritage. Born in San Francisco, the fifth daughter of Chinese immigrants, Jade Snow Wong has asserted a strong allegiance both to her own ethnic community and to the American society in which she became an independent artist. As a woman, she continues to honor her parents and community according to Chinese custom; at the same time she feels a deep appreciation for those American values which gave her the freedom to think and act for herself, refusing to submit to the life of the traditional Chinese daughter, whose entire career is her home. As an artist, Wong incorporates ancient Chinese ceramic styles and techniques with modern American technology. Drawing upon the positive elements in both Chinese and American cultures, yet departing from each when necessary, Jade Snow Wong has forged her own identity as an artist.

In the last part of this section we present yet a third major category of self-definition: art by women who consciously pay tribute to the support and encouragement, example, and inspiration of other women artists. Contradicting the stereotypes that women are too competitive with one another to form close, working relationships; that they prefer the authority of men to that of other women; that mothers and daughters must be at

odds; and that women have no collective traditions or power,
the final works in this section illustrate a wide range of women's
allegiances to the lives and work of others like themselves.

Two selections briefly indicate the span of centuries over
which mothers, sisters, teachers, and female friends of women
artists have provided counsel and encouragement, as well as
instruction, in the arts. In times when women were not allowed
in male art classes, a woman artist—frequently the daughter of
a painter—might share her knowledge with friends, family, or
students. In a self-portrait included here, Rolinda Sharples,
whose mother was a painter, pays tribute to her most important
mentor and source of emotional support. From another view-
point of a similar subject, Adélaïde Labille-Guiard portrays her-
self with two pupils—each as eager a beginner as she in her
youth had been. This group portrait suggests the artist's pride in
accomplishment, as well as her sense of responsibility to other
women artists—who were at that time barred from the honors
that she, almost alone among her sex, had managed to earn.

Angelica Kauffmann's painting of herself listening to the
muse of poetry illustrates the abstract concept of inspiration.
The muse—originally one of nine Greek goddesses who pre-
vailed over literature, art, and science—was traditionally
claimed by the male artist; but Kauffmann here assumes her
right as an artist also to lay claim upon the muse. The word
inspiration, meaning "to take in breath" or life, has often been
used by male artists to describe the source of their creativity—
frequently a very real woman, a lover, or a wife. Although
women have also been the source of artistic inspiration for one
another, Kauffmann's depiction of that theme was unusual.
Only recently have some women artists acknowledged, as May
Sarton has done, that for themselves "the muse . . . is *she*."[2]

Many women have been inspired mainly by example:
through the work of women artists with whom they had no
personal relationships. Generally out of the mainstream of
major art movements, most women have had to paint or write
in relative isolation, without access to (male) networks of sup-

[2] May Sarton, *Mrs. Stevens Hears the Mermaids Singing* (New York, 1975),
p. 147.

port. Their discovery of one another's work has often been of major importance to women artists in search of a compatible tradition—or even a friend with whom to share a poem or a sketch. In the past, women artists widely separated geographically, perhaps across oceans, might learn of each other through mutual acquaintances, or during rare travels. Sometimes these discoveries led to years of correspondence, as between Harriet Beecher Stowe and Elizabeth Barrett Browning. Frequently, such discoveries have been celebrated in artistic expression. Browning, for example, in awe of George Sand, the French writer whom she would meet years later, wrote poems in praise of Sand's courage and brilliant success in the male literary world. Emily Dickinson, inspired by Browning's work, wrote poems praising the poet she would never meet. Still other women, inspired by the courage and genius of Dickinson, have paid tribute to her in their work: Martha Graham, in a dance based on Dickinson's life; Barbara Morgan, in photographs of Graham's dance; Linda Pastan and other contemporary poets, in appreciation of Dickinson's work and life.

The concluding selections in section 3, then, suggest the living traditions in women's art. Largely overlooked in histories of art and literature, often criticized in their own and succeeding times for deviating from male traditions, women artists have, until recently, rarely been visible, and usually not as a group. Generally, they have been perceived as exceptions, without any traditions of their own. Recent scholarship that informs this volume provides ample evidence of the existence of such traditions, although many of the details remain to be explored.

How many more women artists have yet to be discovered, their traditions to be redefined? Today, many women artists have begun to deliberately seek out and learn from each other, as well as from women artists of previous times, thus helping to bring neglected talent to light, and to shed new light upon it. More and more, too, there is an audience willing to look beyond prejudice and stereotypes, to appreciate the art of women in its own terms, and, in this way, to pass with those artists through the "door" that leads us to a richer understanding of all our lives.

Turning

By Lucille Clifton

Lucille Clifton (1936–) was born in Depew, New York. She attended Howard University and Fredonia State Teachers' College. The author of various books for children and young adults, she has also written several books of poems, including Good Times, An Ordinary Woman, *and* Good News about the Earth. *She was a 1969 participant in New York's YW-YMCA Poetry Center's Discovery Series, and has read her poems in many colleges and universities. Her poems often describe the ugliness and bitterness resulting from racism, yet they present an optimistic and life-affirming point of view, which often becomes a celebration of herself and the lives of other Black individuals. As she says of herself, "I am a Black woman and I sound like one." We see some of this self-assured strength in the following poem, in which Clifton asserts her own identity against the "double jeopardy" of being both Black and female. Married, and the mother of six children, she lives with her family in Baltimore, Maryland.*

turning into my own
turning on in
to my own self
at last
turning out of the
white cage, turning out of the
lady cage
turning at last
on a stem like a black fruit
in my own season
at last

A Nude by Edward Hopper
(For Margaret Gaul)

By Lisel Mueller

*Lisel Mueller (1924–) was born in Hamburg, Germany, and
came to the United States with her family in 1939. She
received a B.A. from the University of Evansville, Indiana and
pursued graduate studies in folklore at Indiana University.
She has published four volumes of poetry:* Dependencies *(1965),*
Life of a Queen *(1970),* The Private Life *(1976), and* Voices
from the Forest *(1977). Her poems have also appeared in
numerous magazines, in anthologies of American poetry, and
in the volume* Voyages to the Inland Sea *(1971), where
she is represented together with two other midwestern poets.
Ms. Mueller, who has also taught poetry at several colleges
and universities, has won many awards for her poems;
her volume* The Private Life *was the Lamont Poetry selection
of the Academy of American Poets in 1975.*

*Lisel Mueller's poems have been described as celebrating
"the autonomy of self, the mysteries of intimacy, growth
and feeling. . . ." Such a celebration of personal growth and
autonomy can be seen in the accompanying poem, which was
written after visiting an exhibit of the work of the American
painter Edward Hopper, at the Chicago Art Institute in
the late 1960s. The poet contrasts the male painter's portrayal
of a woman with the speaker's experience of her own
body. Ms. Mueller lives in Lake Forest, near Chicago, with her
husband and two daughters. She is currently translating
selected poems by the German poet, Marie Luise Kaschnitz.*

The light
drains me of what I might be,
a man's dream
of heat and softness;
or a painter's
—breasts cozy pigeons,

arms gently curved
by a temperate noon.

I am
blue veins, a scar,
a patch of lavender cells,
used thighs and shoulders;
my calves
are as scant as my cheeks,
my hips won't plump
small, shimmering pillows:

but this body
is home, my childhood
is buried here, my sleep
rises and sets inside,
desire
crested and wore itself thin
between these bones—
I live here.

Poem in Which
My Legs Are Accepted

By Kathleen Fraser

*Kathleen Fraser (1937–) was born in Tulsa, Oklahoma, and
graduated from Occidental College, where she began writing
during her senior year. She worked as an assistant editor
for* Mademoiselle *and studied poetry at the New School for
Social Research, where she won the Dylan Thomas Poetry
Award in 1967—the same year in which her first book of
poems,* Change of Address, *was published. Her poems have
appeared in numerous journals, in the first* Young American
Poets *anthology of 1968, and in several recent anthologies of
poems by women. Fraser's other books of poems include*
In Defiance (of the Rains) *(1969),* Little Notes to You,
from Lucas Street *(1972), and* What I Want *(1974). In 1968 she
published* Stilts, Somersaults & Headstands, *a book of
children's game chants and play poems. She has taught at the
University of Iowa Writers' Workshop and at Reed College.
In 1977, she received a grant from the National Endowment
for the Arts. Currently she teaches at San Francisco State
University, where she is also director of the Poetry Center.*

*More interested, she has said, in process than in a "perfectly
distilled and 'finished' product," Fraser has made in her
own writing a record of personal change: of shifting relation-
ships, of pregnancy, of mothering her son, David, of her own
psychic journeys "to break through and remain in contact"
with herself. In the following poem we see one of these changes,
in which the poet learns to value and take delight in herself
on the basis of what she feels and has done, rather than
on the basis of the opinions of others.*

Legs!
How we have suffered each other,
never meeting the standards of magazines
 or official measurements.

I have hung you from trapezes,
 sat you on wooden rollers,
 pulled and pushed you
 with the anxiety of taffy,
and still, you are yourselves!

Most obvious imperfection, blight on my fantasy life,
strong,
plump,
never to be skinny
or even hinting of the svelte beauties in history books
 or Sears catalogues.
Here you are—solid, fleshy and
white as when I first noticed you, sitting on the toilet,
 spread softly over the wooden seat,
having been with me only twelve years,
 yet
as obvious as the legs of my thirty-year-old gym teacher.

Legs!
O that was the year we did acrobatics in the annual gym show.
How you split for me!
 One-handed cartwheels
 from this end of the gymnasium to the other,
 ending in double splits,
legs you flashed in blue rayon slacks my mother bought for the
 occasion
and tho you were confidently swinging along,
the rest of me blushed at the sound of clapping.

Legs!
How I have worried about you, not able to hide you,
embarrassed at beaches, in highschool
 when the cheerleaders' slim brown legs
 spread all over
 the sand
 with the perfection
 of bamboo.
I hated you, and still you have never given out on me.

With you
I have risen to the top of blue waves,
with you
I have carried food home as a loving gift
 when my arms began
 unjelling like madrilene.
Legs, you are a pillow,
white and plentiful with feathers for his wild head.
You are the endless scenery
behind the tense sinewy elegance of his two dark legs.
You welcome him joyfully
and dance.
And you will be the locks in a new canal between continents.
 The ship of life will push out of you
 and rejoice
 in the whiteness,

 in the first floating and rising of water.

Self-portrait

By Paula Modersohn-Becker

During her short life Paula Modersohn-Becker (1876–1907) produced over four hundred paintings and studies and one thousand drawings. Although she lived to see only one piece sold, her work has won ever-increasing acclaim.

Born into a cultured German family in Dresden, raised in Bremen, Modersohn-Becker began to study drawing at an early age from a local instructor. At sixteen she attended art school in London, where she lived with relatives. At her parents' insistence she completed two years at a teacher's training school before attending the Berlin School for women artists from 1896 to 1898. She then moved to Worpswede, near Bremen, the site of a colony of landscape artists. Here she made innumerable drawings of local peasants—mostly women, children, and the elderly—attempting, as she said, "to achieve grandeur through simplicity."

In 1900, with her close friend, the sculptor Clara Westhoff (who the following year married poet Rainer Maria Rilke), Modersohn-Becker journeyed to Paris, where she painted while Westhoff studied with the sculptor Rodin. Marrying Otto Modersohn, a widower and landscape painter, Modersohn-Becker returned with him in 1901 to Worpswede, where she was to feel an increasing lack of artistic challenge and stimulation, as well as a conflict with her duties as wife and step-mother to Modersohn's young daughter. She returned three more times to Paris to study new techniques from the work of Post-Impressionist painters and to develop her own style.

During her final stay in Paris, from February, 1906, to April, 1907, she announced her separation from her husband and devoted her entire energies to her work. Despite pressures from family and friends to return to Worpswede, Modersohn-Becker wrote that she was in the most "intensely happy" period of her life. Attempting a reconciliation, however, her husband visited her in Paris; during one of his visits she became pregnant, and she returned with him to Worpswede.

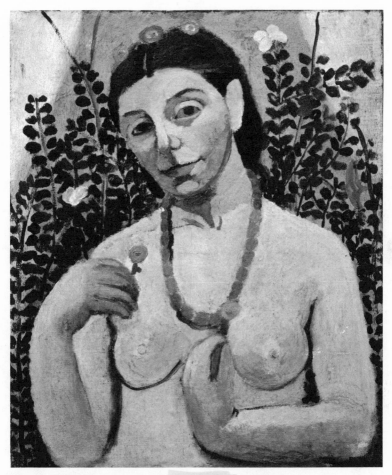

Plate 27. Paula Modersohn-Becker. SELF-PORTRAIT. Oil. 1906.

*In November 1907 she gave birth to a daughter and died, three
weeks later, of a lung embolism and heart attack.*

*Self-portrait (1906) is part of a series Modersohn-Becker
painted during the two final, extremely prolific, years
of her life. As in her other self-portraits, she has painted herself
naked—a daring practice for women of her time. Unlike
the conventional studio model presented by many male
painters of her day, Modersohn-Becker gazes unflinchingly at
her viewer, joyfully asserting in bold and spontaneous brush-
work her own sensuous vitality and strong creative spirit.*

Self-portrait with Cropped Hair

By Frida Kahlo

Born outside of Mexico City in the suburb of Coyoacán, Frida Kahlo (1910–1954) gave up plans to become a doctor and began painting after she was bedridden, at the age of sixteen, with a fractured spine, a crushed pelvis, and a broken foot— the result of a bus accident. Regarded today by many women artists as a heroic example of personal courage and artistic honesty, Kahlo is best known for her lifelong series of self-portraits, whose settings and details she drew from the most significant elements in her life: her more than twenty-five operations, her several miscarriages, her growing belief in the universal interconnectedness of all life, her Mexican heritage, and her turbulent marriage. An invalid most of her adult life, Kahlo often painted by using a specially-designed easel and mirror attached to her bed, in which she was almost totally confined after 1952, following the amputation of her right leg.

With self-revelation astonishing even by today's standards, Kahlo portrayed in Surrealist imagery her innermost views of herself as a woman: dressed, for example, in the elaborately festive regional costume she usually wore, yet with her heart and veins anatomically exposed; or lying undressed in a hospital bed, scarred and bleeding, surrounded by nightmare images of her miscarriages. In her own time, and by Mexican standards, such public disclosure of taboo subjects by a woman was startling, and for many years her work went without local recognition. Today her paintings are collected in such museums as the Museum of Modern Art in New York and The Museum of Modern Art in Mexico City, which held a retrospective exhibition of her work in 1973. In 1977 another retrospective was held at Mexico's Palace of Fine Arts, and during 1978 a large exhibition of her work— which opened at Chicago's Museum of Contemporary Art— toured the United States.

Mira que si te quise, fué por el pelo,
Ahora que estás pelona, ya no te quiero.

Plate 28. Frida Kahlo. SELF-PORTRAIT WITH CROPPED HAIR. Oil on canvas, 15¾ × 11 in. 1940.

In 1929 she married the famous Mexican muralist Diego Rivera. Their house, which is now the Frida Kahlo Museum, was a gathering place for Mexican, North American, and European artists, intellectuals, and progressive and leftist

*political leaders of the time. In 1939 Kahlo and Rivera
divorced, remarrying two years later. Her* Self-portrait with
Cropped Hair *was painted during their separation, after
Kahlo had cut off her own long hair, which her husband had
cherished. Above the portrait of herself in her husband's large
suit, Kahlo painted the words of a popular song: "Look,
if I loved you, it was for your hair. Now that you're bald,
I don't love you any more."*

Two Sculptures

By Marisol

The works of Marisol Escobar (1930–) strikingly demonstrate yet other forms of self-definition. Using herself as a model, Marisol frequently makes castings, drawings, and prints of her own face, hands, and body—often incorporating them in sculptured assemblages that seem, at first glance, to be of other people: a group of women seated in a row; four women with wooden bodies leaning against a wall; or a party scene. Yet even her wooden sculpture My Father *contains her self-image, in the form of a plaster hand, which she cast many times over her own to make it look old.*

Born in Paris of wealthy Venezuelan parents, Marisol was raised in Paris, Venezuela, and California. She studied at the Academie des Beaux-Arts in Paris, at the Art Students League in New York City, and (from 1951 to 1954) at the Hofmann School and the New School for Social Research. Her first one-person show was held in New York in 1957. Known also for her drawings and prints, Marisol has received numerous awards for her work, which has been widely exhibited in the United States and abroad, and is collected in such museums as the Whitney Museum of American Art and the Metropolitan Museum of Art in New York. In 1978 Marisol designed the stage sets at the Metropolitan Opera for a production by dancer Martha Graham. Also in 1978 she was elected to the membership of the American Academy and Institute of Arts and Letters.

While Marisol's style in the 1960s drew upon early American folk art, Pre-Columbian pottery, and painted Mexican boxes, her work projected her personal viewpoint toward the social and political concerns of the period, as can be seen in her handling of the subjects of aristocracy and poverty and in satirical portraits of leaders, including Lyndon B. Johnson. Her collaged sculpture The Party *is an example of such a critical piece, in which she explores one aspect of woman's identity, her own self-portraits serving here*

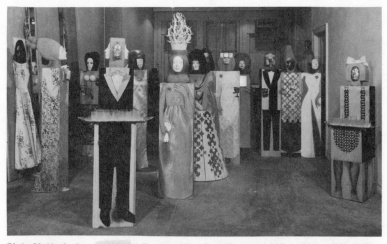

Plate 29. Marisol. THE PARTY (15 figures). Mixed media, 119 × 188 × 192 in. 1965–1966.

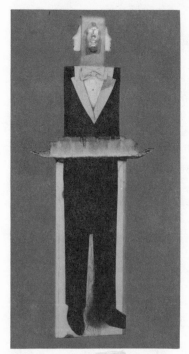

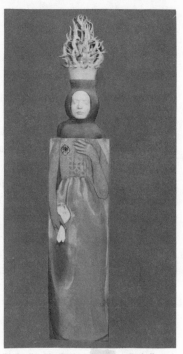

Plate 30. Marisol. THE PARTY. Detail. Plate 31. Marisol. THE PARTY. Detail.

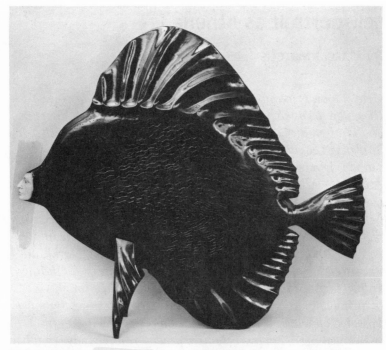

Plate 32. Marisol. ZEBRA SOMA. Wood, varnish, plastic, 65 × 78 × 15 in. 1971.

as a means of questioning who she is or who she might not want to be. Zebra Soma *is part of a later series of sculptures which began after her return, in 1969, from a trip to the Far East. She wanted, she has said, to create something beautiful and "very pure." The resulting sculptures, inspired by the experience of scuba diving, evoke her spiritual and physical sense of kinship with life under the sea.*

Self-portrait as Athena

By Marcia Marcus

Contemporary painter Marcia Marcus was born in New York City. She received a B.A. in fine arts from New York University and studied at Cooper Union (1950–1952) and at The Art Students League. Since 1951 her work has appeared in numerous one-person and group shows, including "Young American Artists 1960" and the Museum of Modern Art traveling show (in 1969) of portraits of and by artists. Her paintings are in many private collections and in the collections of such museums as the Whitney Museum of American Art, the Rhode Island School of Design, and the Clark and Phoenix Museums. The recipient of many awards, including a Fulbright Award to France in 1962, Marcus has taught painting and drawing at Cornell University, Purdue, Syracuse, Vassar College, and other institutions.

In speaking of her own creative process, Marcus says that her painting "takes great concentration." Like many other artists, Marcus says she often does not know in advance what her work will mean. Trusting her instincts, experimenting until "things fall into place," she does not consciously intend to make statements through her art—although statements, she says, later do emerge. Often her paintings begin from what seem to be almost accidental chains of events. Self-portrait as Athena, *the first of a five-year series of paintings which used Greek themes, resulted from Marcus' impressions of Greece (gained from her travels) and, later, from her chance reading of a book on Athenian art, which one of her two children had brought home from school. Once the painting was completed, Marcus says, she was able to see that her own sense of humor had also been at work.*

For centuries described as both the goddess of wisdom and the fierce battle-goddess of ancient Greece, Pallas Athena was born in full armor from the head of Zeus. As guardian of "the city" and of "civilized life," Athena—because of

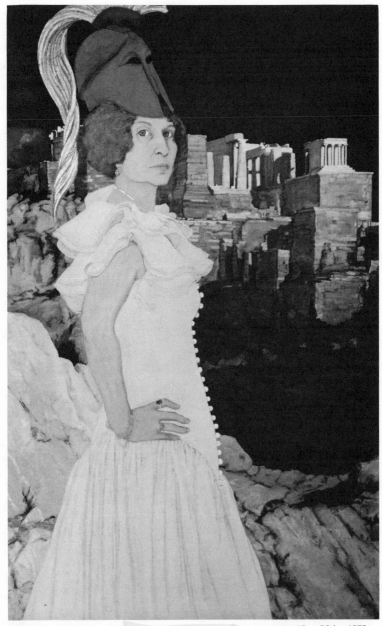

Plate 33. Marcia Marcus. SELF-PORTRAIT AS ATHENA. Oil on canvas, 58 × 36 in. 1972–1973.

*her warrior role and her great intelligence—has throughout
history been associated with roles generally assigned to
men, thus making her a model with whom few women
could openly have dared to identify. Paradoxically, Athena
was also said to have been the inventor of the flute and
the protector of household arts—two conventionally
"feminine" roles for which she is less well known.*

In Self-portrait as Athena, *Marcia Marcus—decked out in a
"feminine" dress as well as a battle helmet—presents an
image independent of stereotype. Forthright and proud,
without apology, Marcus asserts her right not only to declare
who she is or who she may in part resemble, but also
her right to experiment—even playfully—with unconventional
modes of self-expression.*

Black Venus

By Niki de Saint-Phalle

*Internationally acclaimed sculptor Niki de Saint-Phalle
(1930–) was born in Neuilly-sur-Seine, near Paris, France,
but grew up in New York City, where she lived from 1933 to
1951 and studied at the Convent of Sacre Coeur. In 1948
she married the writer Harry Matthews, and with him she
returned to Paris in 1951. She began painting in 1952, and in
1956—the year of her first one-woman show in St. Gallen,
Switzerland—she started to experiment with object-reliefs and
assemblage sculptures. In 1960 she began to use a technique
of splattering her sculptures by incorporating into them
small bags of paint shot through with a pistol.*

*Immediately renowned for this innovative technique,
Saint-Phalle went on to greater fame with her series of* **Nanas**—
*the first of her brightly painted, larger-than-life-sized
sculptures of women. Labelled "grotesque" by some critics,
the "hefty"* **Nanas** *nevertheless began to be exhibited
throughout Europe and the United States in museums and
galleries such as the Hanover Gallery (London), the Palais des
Beaux-Arts (Brussels), and the Alexander Iolas Gallery
(New York).*

In 1963, extending the concept of **Nanas** *to gigantic
proportions, Saint-Phalle created what is perhaps still her most
well-known piece: a sculpture of a woman, titled* **Hon,**
*which she built (in collaboration with artists J. Tinguely, with
whom she has lived since her divorce in 1960, and P. O. Ultvedt)
in Stockholm's Moderna Musset. Eighty-two feet long,
twenty feet high, and thirty feet wide,* **Hon** *(which is Swedish
for* **She***) lay on her back and contained numerous rooms
which viewers could enter through a doorway between her
legs. Complete with expanding and contracting heart and
lungs,* **Hon** *also contained a cinema with Greta Garbo movies,
a planetarium, an aquarium, a telephone, music rooms,
and a bar with a soda-pop machine where visitors heard
love-talk relayed by microphones from the "love nest."*

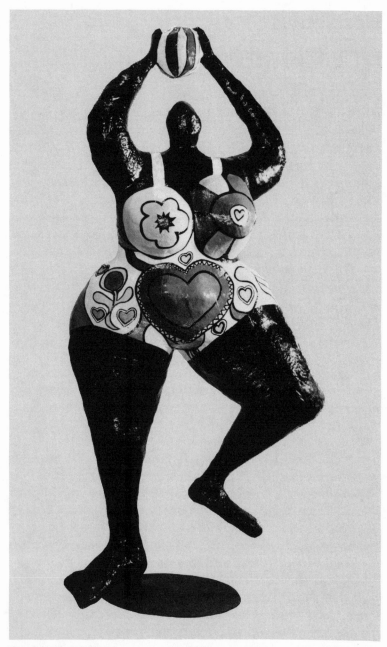

Plate 34. Niki de St. Phalle. BLACK VENUS. Painted polyester, 110 × 35 × 24 in. 1967.

Black Venus *(1967), shown here, is one of Saint-Phalle's later series of sculptures, in which she again used her art to challenge cultural stereotypes of women. In Greek myth and legend, as well as throughout centuries of Western art, Venus (or Aphrodite)—goddess of love and beauty, born of the foam of the sea—has been portrayed by male artists according to various standards of beauty which virtually excluded all non-white women. Saint-Phalle's sculpture presents us with the conception of the goddess as Black, reclaiming the right of the Black woman to take pride in her body—and, in the process, redefining the concepts of "beauty" and "love" themselves. Unlike the conventionally delicate, vulnerable, yet treacherously seductive Greek goddess,* Black Venus *is neither delicate nor subtle. Playfully holding a beach ball (caught up, perhaps, as this hardy Venus emerges from the sea), balanced on one leg of exceptional strength and with the other leg poised in the graceful gesture of dance,* Black Venus—*boldly wearing the symbol of love—is in harmony with herself and with her own inner power.*

Saint-Phalle's sculptures have appeared in more than two dozen one-woman shows in the United States and Europe, and are part of the permanent collections of museums such as the Musee d'Art Moderne in Paris and the Stedelijk Museum in Amsterdam. The mother of two sons, Saint-Phalle lives and works in Soisy-sur-Ecole, near Paris.

Native American Studies

By Wendy Rose

*Like many of today's women artists, painter and poet Wendy
Rose (1948–) brings to her work a complex self-awareness
drawn from her mixed racial and cultural experiences. Mostly
American Indian (Hopi and Chowchilla Miwok), partly
English and German, Rose was born in Oakland, California.
She attended school in the San Francisco Bay area, dropping
out of high school at the age of fourteen in an effort to survive in
a community that made her feel "unwanted, strange,
and ugly." Financially independent from then on, she worked
as a musician, a clerk in the "Indian gifts shop" in Yosemite
National Park, as a staff writer and artist for a national
Indian magazine, and at various other jobs. As an adult, Rose
re-entered school at the college level. Currently working
towards a Ph.D. in anthropology at the University of
California at Berkeley, she supports herself through sales of
her paintings and through publications and readings.*

*Widely shown and purchased throughout the United States,
her vivid paintings, which use themes and symbols from
her Native American culture, have also been printed as cover
illustrations and graphics in journals and anthologies. Her
poems have appeared in numerous literary magazines and
anthologies. Rose's six poetry collections include* Hopi
Roadrunner Dancing, Long Division: A Tribal History,
Academic Squaw: Reports to the World from the Ivory Tower,
and Lost Copper. *She has also written three books on
Native American art and an illustrated Hopi creation story.*

*Almost entirely self-taught, Rose has never had any
formal instruction in painting, nor has she taken more than a
few writing classes in college. "Being alone and unpopular
with my 'peers,' " says Rose, "may have been a great
motivating force in expressing myself on paper—words and
images. Maybe the reason I can combine the two . . . is that
I was alone enough not to be told that it was unusual or
difficult. Creativity can be tapped through solitude, exposed*

through rejection." In work such as Ghost Dance Woman and the following poem, Rose has transformed rejection into a source of strength. In her many self-portraits (which do not always resemble her physically) she identifies her various feelings and ideas with figures from her ancestral past, speaking also for her people—retelling and revitalizing stories which have been lost, devalued, or misinterpreted in American history and literature.

One such story is that of the Indian Ghost Dance movement of the last half of the nineteenth century, which spread from a Paiute Indian, named Wovoka, from Nevada throughout the western United States. Influenced by Christianity, intended as an evangelizing force, the movement encouraged Indians to induce trancelike, visionary states during ritual ceremonies, and to believe that they and all their ancestors would be restored to life after death. Never completely successful in converting the Indians of the Southwest, the movement lost most of its force after the Wounded Knee Massacre in 1890, which was primarily an attempt by the white political and military leadership to suppress the Ghost Dance. Of the painting reproduced here, Rose has written, "The woman in the painting is my identification, personally, with the idea behind the Ghost Dance: Indian survival in whatever form and by whatever means. It is not so much a fusion of past and present, as it is an acknowledgement that past and present are the same continuum, within the same cycle, and I am a part of it as a contemporary Indian woman."

Similarly, the "Grandmother" of the following poem is not a literal person but Rose's symbol of her matriarchal past, recognized in ritual dance and song. Contrary to popular belief, Indian nations, such as the Iroquois and the Hopi, were often matrilineal and/or matriarchal—with the line of descent running through women, who frequently owned the family land and property, determined the status of their children, and sat in tribal councils. Rose's Hopi "Grandmother" thus represents more than a literal family figure; she is a direct link with the poet's Native American heritage, which is threatened and confused by "the whiteman's witchery."

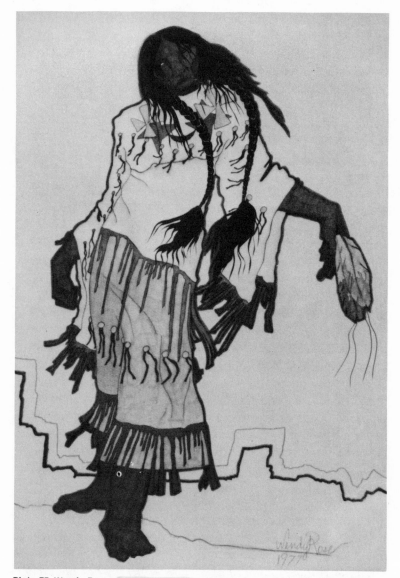

Plate 35. Wendy Rose. GHOST DANCE WOMAN. Watercolor and ink, 18 × 24 in. 1976.

Native American Studies, University of California at Berkeley, 1975

Grandmother holds my hand
so as to be born again as bride-shawl reeds[1] in
mid-dance; she touches my legs,
becomes wind, blows devils to the mesa.

Like me she is scarred, like me
riding high on her fear, like me
licking labored southern eyes[2] shut and
feeding on rock and water.

She is with me now—trembling in my throat,
wearing poems, confused with the pride
of our dance, our dance itself proud
swinging through the seasons

between the eyes of two worlds
that never match, can only stare
stupid and grey.

This cluster of tongues, this
dark flying world, this trying-on of
the whiteman's witchery
stretches the Grandmother's skin.
Shuffling Butterfly,[3] she
takes me
away.

[1] *Bride-shawl reeds:* The traditional Hopi bride carries some of her wedding paraphernalia in a long bundle, about which is wrapped a mat of woven reeds.
[2] *Southern eyes:* The eyes with which Rose identifies—those of Indians born and living in their homeland, who also suffer from cultural alienation.
[3] *Shuffling Butterfly:* A reference to the Butterfly clan of the symbolic "Grandmother," and a description of how she moves in the dance.

Knowing Who You Are

By Carmen Lomas Garza

See pages 111–112 for biographical information on Carmen Lomas Garza and for another part of the following interview with Olivia Evey Chapa. Biographical information on Chapa appears on page 111.

In this selection Garza discusses the purposes and function of her art: to define and to reinforce her positive self-image as a Chicana and the cultural identity of other Mexican-Americans who, like herself, have been alienated from their ethnic community by the imposition of the larger society's values. In her etchings of Mexican-American subjects—her neighbors in the ritual of spiritual healing or in the local gathering for the lottery—Garza has consciously worked to redefine and re-establish the importance of their religious and social traditions. Through her etchings of family members—her grandfather in his garden, or her grandmother (Abuelita) with an altar—Garza makes evident her loyalty to family ties and to the spiritual values which she has inherited from those closest to her. Working in the straightforward style of Mexican folk art, with its simplicity and directness of line and the omission of unnecessary detail, Garza is further able to bridge past and present. Combining her personal vision with traditional styles, she focuses on the quiet dignity and inner strength of subjects such as Abuelita, from whom she draws strength of her own, and with whom she proudly chooses to identify.

Carmen Lomas Garza: I took several education classes with Steinbaugh, a teacher at A & I. He encouraged students to speak out and try to straighten out racial misunderstanding. I always spoke out and invariably used emotional verbalization. I always received criticism from other Chicanos after classes when I spoke out. They didn't want me to speak up for Chicanos because they were embarrassed. They didn't want to be reminded that they were Mexicanos and that we had a culture and lan-

guage. The teacher understood that it was especially important that some realizations be made by everyone—Chicanos, Blacks, and Anglos—in his classes because they were the future teachers of Texas. There would always be fights in his classes and I would speak out; I had to defend my culture. They didn't want me to defend because they were at the point where they wanted to reject. It was a very negative feeling to reject what you are. The teacher tried to bring these feelings out because he was interested in educators and effective teachers. You cannot feel negative about yourself and be an effective teacher. My frustration and anger level was incredible because no one would help me defend the positive feelings I had about being a Chicana, my language, and my culture. But it was an invaluable experience for me. I really developed. I've gotten to the point now where I can control my emotions and can answer all the stupid comments and questions asked about Chicanos in an intelligent manner. I know now, from hearing other Chicanos answer questions like that and because my self-confidence has developed, that I can defend the positive feeling I have about being a Chicana. . . .

Before the Chicano Movement I didn't have anything to do with politics, religion, economics; it was just art. The Chicano Movement made me socially aware that you have to be in touch with everything. You can't ignore any aspect of your life. I think an artist should be in tune with everything that is happening, not just with art. . . .

I did a pencil drawing of my grandmother as a study. At that time, I was very much involved with altars in the homes because I had done a little research for my master's degree on our culture. One aspect of our culture which has influenced me greatly is altars in Chicano homes. My grandmother is a very strong symbol of altars because she has four altars in one bedroom, another altar in another bedroom, and another altar in the living room. She is very religious. My parents have an altar right in the middle of the house and the new additions have been built around that altar. It's been a very big influence in my life. This etching is based on the pencil drawing that I did of my grandmother and the altar is my addition. It's a continuation

of what I had been doing in my junior and high school years of drawing the people around me.

Olivia Evey Chapa: Putting all those things in the picture says something about her. It also says something about all of us. Here again, all of us have seen that scene in our lives. When we see this, then we think: I remember. . . .

Garza: . . . When other Chicanos see it, they relate to it. . . .

Chapa: What does being a Chicana artist mean to you?

Garza: I think that to appreciate art, understand it, like it, and love it, you have to learn about it. You have to be educated in art and it's the responsibility of the artist to educate the public on what art is all about. It's very difficult for the laymen (I hate the word but I have to use it) to understand works of art that are so abstract, so advanced, and so far out, that they might reject it. I think that in order to teach Chicanos about art I have to relate to them. I have to show them something that they'll understand. Obviously, we all understand something about our lives as Chicanos and Chicanas. So here's the connection or link; here's my contact into educating Chicanos about art. That's why I choose the subject matter that I do. It's a very direct subject matter. For example in *Abuelita*, everybody has a grandmother, has had a grandmother, or has seen a grandmother. There are emotional ties. If I can't make a contact with you on a purely intellectual level, then at least I can make a contact with you on an emotional level. If I can't make contact on a political level, certainly I can make a contact on an enjoyable, childhood experience level. You've gone through it and so have I. You understand and relate to it and, I'll show you, I'll make art out of it. I'll make it a valuable experience by depicting it in an aesthetic form. It's a responsibility. When I was asking myself and others: what is Chicano art?—immediately I felt that if you are going to be a Chicano artist, you are going to be carrying a lot of responsibility. You are going to have to develop to the utmost that you can because you are leading the artistic front for the Chicano Movement. A lot of Chicanos are going to be seeing your work and saying, "Look these are our Chicano artists," and you'd better be damned good for them to feel that way about you. It is important when they push you up front and say, "These are our

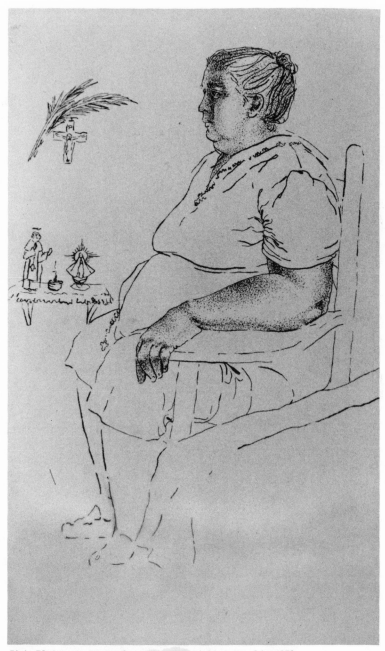

Plate 36. Carmen Lomas Garza. ABUELITA. Etching, 7 × 6 in. 1972.

artists. We have our artists too, just as any other culture. They are just as good and even better because they are ours, they come from us, and therefore, they are us." . . .

There's another thing I need to say about Chicano artists. In my search for the answer to: What is Chicano art?, I've talked to a lot of Chicano artists. The majority are males. A lot of answers that I've heard from Chicano artists will define Chicano art and will narrow it to this much—half an inch. Anything else outside of that is not Chicano art and you're not a Chicano. It really bothers me because it's a very unexplored narrow way to define.

Chapa: It limits the creativity especially when it's said with authority.

Garza: Right, *afuerza te quieren decir*[1] that if you're not doing Chicano art, you're not a Chicano. "*Quien eres tu pa' decir me?*"[2] is how I feel. I've been involved for a long time. I know what I'm doing. I know what I'm saying. I've been through a lot of hassles and these are the answers I've finally come up with. You can't get an answer from anybody. It's going to have to come from you; your own answer. That's one thing that that guy from Houston [who heard me speak about our art] didn't see. He wanted to hear from us what Chicano art is. I was telling him that it's going to have to be your search within yourself. We can tell some things—I can tell you this; they can tell you that. But you're going to have to do a lot of it on your own. There's going to have to be a lot of soul-searching. It all has to do with your identity—how you feel about yourself. If you have a terrible self-image, your work is not going to be anywhere. You have to have a positive image and know what you are and who you are. Once you start searching, then you can start developing and your work will reflect that. You'll explode into something much bigger and greater.

[1] *Afuerza te quieren decir:* what they are implying is.
[2] *Quien eres tu pa' decir:* who are you to tell.

Fifth Chinese Daughter

By Jade Snow Wong

*Ceramicist Jade Snow Wrong (1922–) was born in San
Francisco of first-generation Chinese parents, owners of an
overall factory in which the family made their home. Although
her father was a Christian and made some concessions to
Western ways, he ruled family life according to Chinese
custom. Only Chinese was spoken; children were strictly
disciplined and were expected, from an early age, to take part
in family work; and the birth of a son was openly preferred to
the birth of a daughter. Throughout her childhood Jade
Snow Wong attended an American school by day, a Chinese
school in the evenings and on Saturdays. In the remaining
hours she relieved her mother, who worked in the factory,
of most daily household duties until—earning money for
college—she worked in the homes of others. With these and
other jobs, and several scholarships, she supported herself
through college despite parental opposition, earning a B.A.
from Mills College in 1942.*

*The selections below are excerpts from her two auto-
biographies,* Fifth Chinese Daughter *(1950) and* No Chinese
Stranger *(1975). She speaks in the formal third person
appropriate to Chinese tradition, which deems it unbecoming
to talk at length using* I *or* me*—a tradition which she
honored until after her father's death. Following the publica-
tion of* Fifth Chinese Daughter *and its translation into
several Asian languages, Jade Snow Wong was sent by
the U.S. State Department on a speaking tour of many Far
East countries. She has won numerous awards for her
distinctive art work, which has appeared in one-woman shows
in museums such as the Chicago Art Institute and the
Detroit Institute of the Arts, in many group exhibitions, and
which is part of the permanent collections of museums
that include the International Ceramic Museum in Italy and
the Metropolitan Museum of Art, New York. Currently
she lives in San Francisco with Woody Ong, her Chinese-
American husband and work partner, and their four children.*

Always aware of her indebtedness and allegiances to both her Chinese and her American heritage, she here describes her earliest experiences with her art, which she discovered in her final year at Mills.

She Finds Her Hands

The instructor was a quiet-mannered man, with amazing capabilities in all the crafts. More than anyone else Jade Snow had met, he knew the nature and use of materials from the reeds of the fields to precious silver and gold. But instead of giving his students ready answers to their numerous questions, he would encourage them to work out problems for themselves by saying, "I don't know." Indeed, in handworking materials as Jade Snow found, too, no one can ever know the final answer and form at the very beginning of any project. This method made learning slow and painful, for it meant that students made mistakes, but in the end they learned better and more, and they developed individual ingenuity.

The course started with woodworking, and Jade Snow made a bookcase; proceeded to paints and pigments, and she painted the bookcase with linseed oil and pigment which she herself had ground together; metal work, and she slaved to snip off a round of copper, anneal and pound it into an ashtray; weaving, and she made herself a primitive loom from an old berry crate; paper work, and she made her own paste and paper dolls and decorated paper beads. Finally there was work in clay, emphasizing ceramic sculpture and pottery.

One day, the class transferred to the pottery studio which was little more than a gray shack underneath some lovely cork elm trees. In this small room, about ten by twenty feet, were a sink, one electric, and three foot-treadled potter's wheels, many shelves and one cabinet. Two auxiliary rooms held a firing kiln, an old pie oven for drying green ware, glazes and glazing equipment. Fine clay dust had settled over everything. But what marvels the shelves in the main room held! The instructor told them to wander around and get acquainted with the place, but to be careful of breakage.

On some shelves were drying, half-completed forms. Others held finished work, and when Jade Snow's eyes lighted on them

she felt shocked excitement. The articles were reaching out and speaking to her! She couldn't herself understand the stimulation and response. Among these completed examples of student pottery were pitchers, vases, cups, bowls. Some were imperfect, thick, warped, or crude. But they were all glazed in beautiful, clear, and unfamiliar shades of blues, greens, and yellows. Some were delicate, and some virile, but they all had that hand quality which was the stamp of a creator's love of his craft. It was a provoking awakening, a discovery of another new thing in the world at which to wonder and marvel.

This wonder and marvel of pottery never ceased for Jade Snow. The instructor now gave them simple lectures on the nature of clay, what they should and should not do with it, on glazes and firings, and then left them alone with their hands and the materials. As the class hours were short, Jade Snow would return at odd times, on weekends and evenings, to make little bowls or to trim or glaze pots. She played with simple forms, decorations, and textures, and the hours, like the fishing trips during her childhood, would simply fly while all troubles were forgotten in the joy of creating. The clay forms became a satisfying reflection of personal will and skill.

One day after class hours, Jade Snow said to the instructor: "This is a craft course and not an art course; most people speak of them as separate knowledges. I wish now that I had taken an art course. Perhaps I would know more about what forms I am making. Where does art begin and craft end?"

The usual and expected "I don't know" was not forthcoming this time. Instead, the instructor burst out, "That's just an eighteenth-century idea—the division between art and craft. The good artist must first be a good craftsman, and a good craftsman who works in good taste is an artist in his work. As you work and accumulate knowledge in a craft, you develop as an artist, and an artist cannot be considered a good artist unless he is skilled in the techniques of his craft. In fact, I found that theoretical study of art did not mean much to me until I began to work with my hands in crafts; then, I appreciated and understood the limitations and achievements of art forms."

"Then I don't need to take art courses to make good pottery?" Jade Snow asked wonderingly.

"You work and work with your materials, and you will find that with experience your eyes and hands will help you make better pottery than any theoretical analysis of form."

So Jade Snow worked with her hands, eyes, and mind in the pottery studio where she felt completely at home. She never found time to read any books on pottery making.

In crafts, she found, one learned more by seeing and feeling for oneself than by instruction. She did not ask her instructor for much personal help, but all about her in various stages of completion were his own pottery forms and colors to serve as silent standards of criticism. He himself seemed a tireless worker, maintaining the best possible equipment and stock of materials for his students, and constantly re-establishing new and higher requirements for making pottery. Whenever he had perfected one technique or form he progressed to another unknown. Whatever formulas he discovered and all his voluminous notes on experiments, were at the disposal of his students. Through innumerable informal talks with him as each worked separately, Jade Snow developed a "feeling" for art, an inspiration for good pottery, and the knowledge that sober, hard work was the most important quality of all.

Her first products were certainly bad or mediocre. While inspired by the work of others, her pottery was nevertheless her own creation, a combination of the clay she chose, the form she achieved, and the glazes she used. They reflected the quality of her workmanship and the impulses of her heart more than any other material she had used. The final satisfaction was that they were physical remembrances of certain personal moments in time which could never be considered lost so long as the pottery was not broken beyond repair. Jade Snow made as many pieces as time and energy would allow in the short month remaining before graduation, and while she regretted that she had discovered the fascination of clay so late in her college days, she rejoiced that at least she had discovered it.

No Chinese Stranger

In the passages that follow, Wong recalls the strongest impressions of her childhood, then traces the influence of her background upon her struggle to establish herself as an artist.

By the time Jade Snow was six, in the late 1920s, the education of the young became a community problem. The Hip Wo Christian Academy was founded on a coeducational basis, and Father Wong served on its board for years. After Jade Snow began Commodore Stockton School, she spent three evening hours each weekday, and 9:00 A.M. to noon on Saturdays, at Hip Wo, learning poetry, calligraphy, philosophy, literature, history, correspondence, religion, and public speaking.

Father Wong continued to study Chinese classics all his life. He had a phenomenal memory for complex ideographs and could recite fluently lengthy lessons from his youth. Every evening after both schools, Jade Snow would sit by him as he worked at a sewing machine, singsonging her lessons above its hum. After Chinese lessons, she was dismissed to do American homework, feeling luckier than Chinese girls who knew no written Chinese because they didn't attend school, and luckier than Westerners who had no dual heritage to enrich their lives.

Jade Snow observed from birth that living, learning, and working were inseparable. Mama was the hardest-working seamstress in their factory, at her machine the minute housework was passably done, continuing there after the children had gone to bed, sewing and saving to have more than the four necessities. She accepted her life. "The path to virtue is narrow and difficult at first, but becomes broad and easy to those who walk it. The path to evil is wide and easy at first, but becomes narrow and difficult to those who walk it." Her children were therefore closely supervised, hearing her avowal, "A strict mother produces a worthy child, but a tender mother produces a weakling." Over and over, she admonished Jade Snow, "Face is given to you by others, but shame only you can bring to yourself."

Jade Snow never doubted that she too must work and save, but she had one other means to better herself which was denied to Mama: education. How to elevate herself from this factory-basement beginning was her responsibility and most important endeavor, for her father scorned mediocrity. He would not consider that excellence could be limited by economics.

Active as he was in the community, Father Wong was never too busy to supervise and discipline his children at home. To eliminate squabbling, he provided each child with his personal

desk, study light, and scissors. As they grew older, each received
a typewriter and sewing machine. For accurate identification,
metal tools were filed with three notches, and wooden handles
were burned with his company name (United Cooperation).

United Cooperation

Table manners were indicative of a lady's background: how
to hold a pair of chopsticks (with palm up, not down); how to
hold a bowl of rice (one thumb on top, not resting in an open
palm); how to pass something to elders (with both hands, never
one); how to pour tea into the tiny, handleless porcelain cups
(seven-eighths full so that the top edge would be cool enough to
hold); how to eat from the center serving dish (only the piece in
front of you—never pick around); and finally, not to talk at table.

There were other edicts: not to show up outside of one's room
without being fully dressed; not to be late, ever; not to be too
playful. In every way, every day, Jade Snow was molded to be
trouble-free, unobtrusive, quiescent, cooperative. "It is clever
to be obedient" were familiar words.

She was molded by being told, then by punishment if she
was forgetful. Physical punishment was instant, unceremo-
nious, and wordless. At the table, it came as a sudden whack on
her hand from her father's chopsticks. Away from the table, it
could be the elimination of a privilege, or a blow on her legs
with a bundle of tied cane. Once when she screamed from its
sting (she had been late getting home from the YWCA), her
father reminded her of her good fortune. In China, he had been
hung by his thumbs before being whipped by an uncle or a fam-
ily friend called upon to do the job dispassionately. . . .

If in those early years Jade Snow had a healthy fear of Daddy's
thunder and strength, she also respected his individualism, and
she grew up into womanhood handling her own affairs with a
spirit of independence which expressed itself in an occupation
concerned with art. Her book was an uplanned by-product.
After her graduation from Mills College and four years before
her marriage, she had started a small business in hand-thrown

pottery. Lacking capital, she persuaded a Grant Avenue gift shop merchant to permit her to work at her potter's wheel in one of his two windows. Her finished pottery was displayed in a section of his showroom.

Nearly her father's age, Mr. Fong, the proprietor, was a stranger, and she had approached him wholly because of his location and available space. By usual Chinese standards, Jade Snow should have found a middleman to negotiate terms. But she was unconventional and less patient than most Chinese, so she just walked in "cold" and asked. Not being a Christian, he didn't believe in going one step out of his way to do a kindness. Yet by Chinese custom, if a stranger appealed to him, a request became his responsibility. He could have rejected a middleman but not her. Though noncommittal, he was occasionally helpful, and he taught her about shopkeeping and packing breakables.

Mr. Fong was a widower and lived alone behind the store. Occasionally his only son came home on Army leave, and he would walk to his father sitting by the cash register at the rear of the store, addressing him, "Father."

Mr. Fong, remaining seated, watching his store, never looking at young Fong, would ask without expression, "Have you eaten?"

Sometimes the answer was, "Yes, I have." No further conversation followed. If it was, "No, I haven't," Father Fong asked, "Would you like to eat?" To this question the answer was, "No." There was never the bustle of preparing a celebration meal.

The son would pick up his father's Chinese newspaper, open it, and read it while standing at the rear of the store, a few feet from his father. Silence prevailed. Then young Fong would fold up the paper and leave.

After he had departed, Father Fong would pick up the paper and remark, "This is the trouble with the younger generation. They cannot leave the paper the way they found it." As he criticized, the father carefully rearranged the paper so that every corner was even, and folded it as smoothly as it had been delivered.

This taciturn exchange was not surprising, and perhaps was

even briefer because they spoke in the presence of a nonfamily female. To ask, "Have you eaten?" is the practical Chinese way of saying, "How are you?" The person replying usually answers affirmatively, for not to have eaten would indicate a lack of time, appetite, or funds. A friend also returns the question, "Have *you* eaten?" And if one runs into a friend while marketing, one always hears, "Buy more good things to go with your rice." No one is being personal; concern over food has been historically of first importance for working Chinese.

After Jade Snow began working in Mr. Fong's window, which confined her clay spatters, her activity revealed for the first time to Chinatown residents an art which had distinguished Chinese culture. Ironically, it was not until she was at college that she became fascinated with Tang and Sung Dynasty achievements in clay, a thousand years ago.

Her ability to master pottery made her father happy, for Grandfather Wong believed that a person who could work with his hands would never starve. When Father Wong was young, Grandfather made him learn how to hand-pierce and stitch slipper soles, and how to knot Chinese button heads, both indispensable in clothing. But to Mother Wong, the merits of making pottery escaped her—to see her college-educated daughter up to her elbows in clay, and more clay flying around as she worked in public view, was strangely unladylike. As for Chinatown merchants, they laughed openly at her, "Here comes the girl who plays with mud. How many bowls could you sell today?" Probably they thought: Here is a college graduate foolish enough to dirty her hands.

It has been the traditional belief from Asia to the Middle East, with Japan the exception, that scholars do not soil their hands and that a person studied literature in order to escape hard work. (This attitude is still prevalent in most Asian countries outside of the People's Republic of China and Japan.)

From the first, the local Chinese were not Jade Snow's patrons. The thinness and whiteness of porcelains imported from China and ornate decorations which came into vogue during the late Ching Dynasty satisfied their tastes. They could not understand why "silly Americans" paid dollars for a hand-thrown bowl utilizing crude California colored clays, not much

different from the inexpensive peasant ware of China. That the Jade Snow Wong bowl went back to an older tradition of understated beauty was not apparent. They could see only that she wouldn't apply a dragon or a hundred flowers.

Many years later when Jade Snow met another atypical artist, a scholar and calligrapher born and educated in China, he was to say to her, "I shudder if the majority of people look at my brush work and say it is pretty, for then I know it is ordinary and I have failed. If they say they do not understand it, or even that it is ugly, I am happy, for I have succeeded."

However, there were enough numbers of the American public who bought Jade Snow's pottery to support her modestly. The store window was a temporary experiment which proved what she needed to know. In the meantime, her aging father, who was fearful that their home and factory might be in a redevelopment area, made a down payment with lifetime savings to purchase a small white wooden building with six rentable apartments at the perimeter of Chinatown. Jade Snow agreed to rent the two tiny empty ground-floor storefronts which he did not yet need, one for a display room, with supplies and packing center at its rear, the other for the potter's wheel, kiln, glazing booth, compressor, and other equipment. Now, instead of paying Mr. Fong a commission on gross sales, she had bills to pay. Instead of sitting in a window, she worked with doors thrown open to the street.

Creativeness was 90 percent hard work and 10 percent inspiration. It was learning from errors, either from her lack of foresight or because of the errors of others. The first firing in an unfamiliar new gas kiln brought crushing disappointment when the wares blew up into tiny pieces. In another firing, glaze results were uneven black and dark green, for the chemical supply house had mistakenly labeled five pounds of black copper oxide as black iron oxide. One morning there was a personal catastrophe. Unaware of a slow leak all night from the partially opened gas cock, she lit a match at the kiln. An explosion injured both hands, which took weeks to heal.

The day-to-day work of potterymaking tested her deepest discipline. A "wedged" ball of clay (prepared by kneading) would be "thrown" (shaped) on the potter's wheel, then dried

overnight and trimmed, sometimes decorated with Chinese brush or bamboo tools. It took about a hundred thoroughly dried pieces to fill a kiln for the first firing that transformed fragile mud walls into hard bisque ware. Glazes, like clays the results of countless experiments, were then applied to each piece. A second twelve-hour firing followed, with the temperatures raised hour by hour up to the final maturing point of somewhere around 2,000 degrees Fahrenheit. Then the kiln was turned off for twenty-four hours of cooling. Breakage was a potential hazard at every stage; each step might measure short in technical and artistic accomplishment. A piece she worked on diligently could disappoint. Another made casually had been enhanced successively until it delighted. One piece in ten might be of exhibition quality, half might be salable, and the others would be flawed "seconds" she would discard.

Yet Jade Snow never wavered from her belief that if moments in time could result in a thing of beauty that others could share, those moments were immeasurably satisfying. She owned two perfect Sung tea bowls. Without copying, she tried to make her pottery "stand up" in strength and grace to that standard.

It became routine to work past midnight without days off. Hand work could not be rushed; failures had to be replaced, and a host of other unanticipated business chores suddenly manifested themselves. She had kept comparable hours when she worked all through college to meet her expenses. Again, the hope of reaching valued goals was her spur. If she should fail, then she could accept what tradition dictated for most Chinese daughters—to be a wife, daughter-in-law, and mother. But unlike her college, the American business world was not dedicated to helping her. Because she was pioneering in a new venture, her identity was a liability. Her brains and hands were her only assets. How could she convert that liability? How could she differ from other struggling potters?

To enlarge her production base, she experimented with enamels on copper forms conceived in the fluid shapes of her pottery, layering jewel tones for brilliant effects. They differed from the earth tints of clay and attracted a new clientele. With another kiln and new equipment, she made functional forms, believing that fine things should become part of the user's every-

day life. The best results were submitted to exhibitions. Some juries rejected them, some accepted, and others awarded prizes.

To reach a market larger than San Francisco, she wrote to store buyers around the country, and, encouraged, she called on them. Traveling to strange cities far across the United States, as a rare Oriental woman alone in hotel dining rooms, she developed strong nerves against curious stares. That trip produced orders. Stipulated delivery and cancellation dates made it necessary to hire first one and then more helpers who had to be trained, checked, kept busy and happy.

The strains increased. So did the bills, and she borrowed in small amounts from her sympathetic father, who said, "A hundred dollars is easy to come by, but the first thousand is very, very tricky. Look at the ideograph for hundred—solidly square. Look at it for thousand—pointed, slippery. The ancients knew

Hundred Thousand

this long ago." When hundreds were not enough, tactful Western friends offered help. Oldest Brother, noticing her worries and struggles, sniffed scornfully, "You'll be out of business in a year."

She had learned to accept family criticism in silence, but she was too deeply involved to give up. Money was a worry, but creating was exciting and satisfying. These were lonely years. Jade Snow's single-minded pursuit did not allow her pleasant interludes with friends. To start a kiln at dawn, then watch till its critical maturing moment, which could happen any time between early evening and midnight or later (when gas pressure was low, it took until the next dawn), kept her from social engagements.

Then, gradually, signs indicated that she was working in the right direction. The first was a letter from the Metropolitan Museum of Art in New York, where the Eleventh Ceramic National Syracuse Show had been sent.[1] The curator wrote, "We

[1] An annual show sponsored by the Syracuse Museum of Fine Arts. Entries accepted at regional centers were shipped to Syracuse, New York, for final selection and awards. The exhibition was then circulated for a year to various museums.

think the green, gold, and ivory enamel bowl a skillful piece of workmanship and are anxious to add it to our collections." They referred to a ten-inch shallow bowl which Jade Snow had made.

A reviewer in *Art Digest* wrote, "In plain enamels without applied design, Jade Snow Wong of San Francisco seemed to this critic to top the list."

Recognition brought further recognition. National decorating magazines featured her enamels, and in the same year, 1947, the Museum of Modern Art installed an exhibit by Mies Van der Rohe which displayed 100 objects of fine design costing less than $100. A note introducing this exhibit read, "Every so often the Museum of Modern Art selects and exhibits soundly designed objects available to American purchasers in the belief that this will encourage more people to use beautiful things in their everyday life. . . ." Two of Jade Snow's enamels, a dinner plate in Chinese red and a dessert plate in grayish gold, were included in the exhibition, which subsequently went to Europe.

So it did not seem unusual to receive an interviewer from *Mademoiselle,* but it was indeed unexpected to receive one of

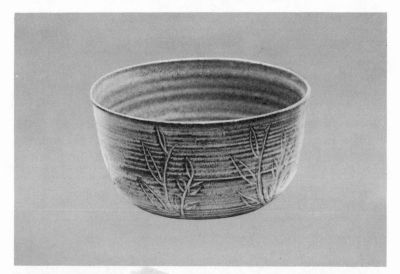

Plate 37. Jade Snow Wong. LEAVES. Hand-thrown stoneware with incised design, 3¾ in. h.; 7 in. w; 3¼ in. base. 1960.

the magazine's ten awards for 1948 to women outstanding in ten different fields. They invited Jade Snow to fly to New York to claim her silver medal.

The more deeply one delves into a field, the more one realizes limitations. When Bernard Leach, the famous English potter, accepted an invitation from Mills College to teach a special course, Jade Snow attended. Another summer, Charles Merritt came from Alfred University's staff to give a course in precise glaze chemistry. Again, she commuted to Oakland. She became friends with these two unusual teachers. Both agreed that in potterymaking, one never found a final answer. A mass-produced bathtub may be a technical triumph; yet a chemically balanced glaze on a pot can be aesthetically dull. Some of the most pleasing glaze effects could never be duplicated, for they were the combination of scrapings from the glaze booth. Like the waves of the sea, no two pieces of pottery art can be identical.

After three years of downs, then ups, the business promised to survive. Debts had been cleared. A small staff could handle routine duties. A steady clientele of San Franciscans came to her out-of-the-way shop. A beginning had been made. . . .

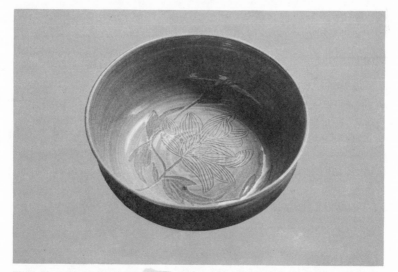

Plate 38. Jade Snow Wong. PEONY. Korean porcelain, incised design, 2¾ in. h; 8¼ in. w.; 5½ in. base. 1975.

Rolinda Sharples and Her Mother

By Rolinda Sharples

Rolinda Sharples (1794–1838) was the daughter of English parents who came to the newly-established United States after the American Revolution. The family settled in Philadelphia, where uncertainty over her husband's financial investments prompted Rolinda's mother, Ellen, to put to practical use the training in drawing she had received as part of the ornamental education of a well-to-do English girl. She became a successful professional portrait painter, and her sitters included both Martha and George Washington and the Marquis de Lafayette.

In turn, Ellen Sharples encouraged her daughter to develop an interest in painting and to take it seriously as a profession in order to ensure her own financial independence. In her teens Rolinda was rewarded by her mother with praise and small sums of money for her work. The daughter responded to these signs of interest and support by developing and rapidly improving her skills. After the death of Mr. Sharples, Ellen and Rolinda returned to England, where Rolinda pursued her training and began to produce both portraits and group compositions. In 1827, she was elected an honorary member of the Society of British Artists. Her death in her early forties from breast cancer cut short her very promising career.

The accompanying portrait of the artist and her mother conveys the warm attachment of the two women and testifies to Rolinda Sharples's sense of her mother's important role in her life.

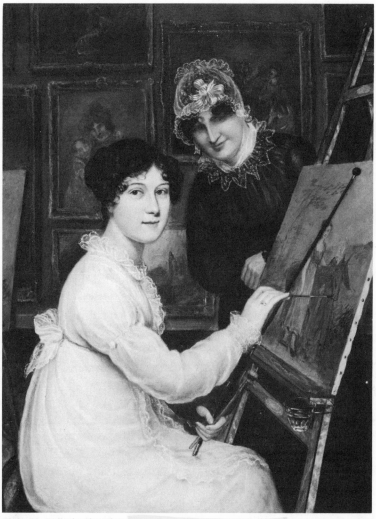

Plate 39. Rolinda Sharples. ROLINDA SHARPLES AND HER MOTHER. **Oil. Early 19th cent.**

Portrait of the Artist
with Two Pupils

By Adélaïde Labille-Guiard

Admitted in 1783 to the famed Paris Academy of the arts,
Adélaïde Labille-Guiard (1749–1803) was the first woman in
thirty years to be so honored. She had begun her art
studies with the miniaturist François Elie Vincent, near
her father's haberdashery shop, and she had developed her
skill in pastel portraits under the instruction of the renowned
pastelist Quentin de la Tour, with whom she studied
from 1769 (the year of her marriage to Louis Guiard) to 1774.
Although by 1783 she had also begun working in oils,
her exhibits of pastels came to the attention of members of
the Academy. Guarding against possible rumors that her work
might not be her own—an accusation (now thought false)
that had already cost another artist, Margareta Haverman, her
membership—Labille-Guiard completed a series of pastel
portraits of Academy members themselves. Praised for
painting "like a man," her membership in the Academy was a
mixed honor: unlike male members, women were not
permitted to attend drawing classes, to vote, or to hold office.
Neither were they allowed apartments in the Louvre,
for fear of the scandal that might result from the presence of
women students in the dense company of male painters
and students. The main advantage to Labille-Guiard was that
as a member of the Academy she was allowed to show
her oil paintings in its prestigious Salon. This not only helped
to ensure her future reputation as a painter, but also led
her to commissions by the royal family, by members of
aristocracy, and—after the Revolution—by eight deputies of
the new National Assembly.

Having separated from her husband, Labille-Guiard took
her own large apartment in 1783, which she shared with
several of her young women students. Remarried later to the
well-known painter André Vincent, she remained a devoted

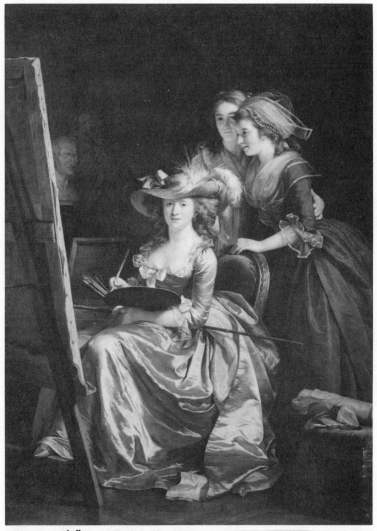

Plate 40. Adélaïde Labille-Guiard. PORTRAIT OF THE ARTIST WITH TWO PUPILS, MLLE. MARIE-GABRIELLE CAPET (1761–1818), AND MLLE. CARREAUX DE ROSEMOND (d. 1788). Oil on canvas, 83 × 59½ in. 1785.

teacher, working for many years to improve the lot of other women artists. At the time of the Revolution (during which her most ambitious painting was burned for political reasons) she presented a plan to the diplomat leader

Talleyrand, asking for state-subsidized art education for
women who lacked other financial means. This plan eventually
failed, but Labille-Guiard was successful, in 1791, in
changing one major policy of the Paris Academy: the rule
against allowing more than four women members at any one
time—a quota which had also prevented the work of her
students from appearing in the Salon. In view of her long, open
resistance to this rule, Labille-Guiard's painting of herself
with two pupils (1785) takes on added meaning. Her students
may not have been able to exhibit their own work on the
walls of the Salon, but they were there, nonetheless.

The Artist in the Character of Design

By Angelica Kauffmann

The story of Angelica Kauffmann (1741–1807) is one of international success and honors achieved by means of exceptional talent and sustained hard work. In an age when the patronage of kings and courts, or money of one's own, smoothed the way to commissions and fame, she rose to prominence largely as a result of what she herself called "my work and industry." Born in Switzerland, the daughter of a painter father who supervised her artistic education, Kauffmann was a child prodigy who was painting professionally before she was fifteen. Upon the death of her mother, while Angelica was still in her teens, she and her father embarked on a life as travelling painters through Switzerland, Austria, and Italy. Friendships with some of the leading painters of the day and with the important art critic and theoretician Abbé Winckelmann were a happy result of these travels, and brought Kauffmann in contact with the Neo- classical style in painting. Her own work began to show the Neoclassical interest in Greek culture and in the use of allegorical figures to express moral and philosophical ideas.

In 1765 Kauffmann travelled to England, where, during the next fifteen years, she emerged as one of the leading painters in London. The establishment of the Royal Academy of Art in London in 1768 saw her election as one of the founding members—one of only two women so honored. (No other women would be admitted until 1922.) Her work—historical and allegorical paintings, portraits, and decorative designs for domestic interiors—earned her both wide recognition and a large income.

Later in her life Kauffmann lived again in Italy with her second husband, an artist who functioned as her business manager. (Her first marriage, to a ne'er-do-well, was short and unhappy.) Her home became a center for visiting artists

and writers, including the German poet Goethe. Upon her death in Rome, she was given the most elaborate funeral that had been held for any artist since Raphael.

Kauffmann's career was not unmarked by the need to struggle with prevailing prejudices against women. She had frequently to protect her personal reputation against the suspicion and innuendo levelled against an independent woman artist. And she had to fight the barriers erected against women who wished to do historical painting, which was then considered the most prestigious genre. The ability to draw from the nude model was deemed essential to the painting of historical subjects, but women everywhere (such as Labille-Guiard in France) were excluded from such training. Even as a member of the Royal Academy, Kauffmann was forbidden access to nude models—male or female—in the Academy's studio. Nonetheless, Kauffmann created historical paintings of great originality, and in fact helped to introduce this kind of painting into England.

In her self-portrait The Artist in the Character of Design Listening to the Inspiration of Poetry, Kauffmann shows her indebtedness, as a Neoclassical painter, to the arts of ancient Greece. The explanation of Kauffmann's choice of the muse of poetry as the inspiration of a painter may also be found in classical sources: the word poetry derives from the Greek poieein, meaning "to make" or "to create." Thus Kauffmann pays homage to the act of creation itself, the source of all the arts. Most importantly, however, Kauffmann has given the two figures—herself and the muse—almost identical postures and facial expressions, and Poetry is affectionately embracing the painter. In this close identification of herself with the muse, Kauffmann would seem, at one stroke, both to locate the source of creative inspiration within herself and also to reclaim for women that female muse which has traditionally been the male artist's prerogative.

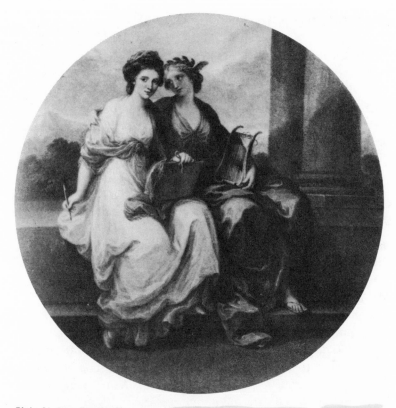

Plate 41. Angelica Kauffmann. THE ARTIST IN THE CHARACTER OF DESIGN, LISTENING TO THE INSPIRATION OF POETRY. Oil on canvas, 24 in. diameter. 1782.

To George Sand

By Elizabeth Barrett Browning

*One of the most famous poets of the nineteenth century,
Elizabeth Barrett Browning (1806–1861) was born with
extraordinary intelligence, talent, and determination into a
family which respected and encouraged her gifts in every
possible way. She began writing poems at the age of six, at
which time her father addressed her as the "Poet Laureat[e]
of Hope End" (the family home near Herefordshire, England).
Privately tutored, and with access to many books, she
read the histories of England and Rome at the age of seven, the
history of Greece at eight, and Shakespeare and Pope at nine.
By age eleven she had decided to be a writer; her poem
"The Battle of Marathon" was published the following year.
At fourteen, knowing her goals were unconventional for
a woman, she wrote: "My mind is naturally independant [sic]
and spurns that subserviency of opinion which is generally
considered necessary to feminine softness. . . . Better oh how
much better to be the ridicule of mankind, the scoff of society,
than lose that self-respect which tho' this heart were
bursting would elevate me above misery. . . ."*

*Publishing widely while still in her teens, by the time she
was in her twenties Elizabeth Barrett had been nominated
for Poet Laureate of England, was corresponding with writers
of renown, received regular assignments from literary
quarterlies, and was fluent in seven languages besides her own.
In 1828, two years after her mother's death, she moved
with her father and her many brothers and sisters to
50 Wimpole Street, in London—the home she seldom left
during the next eighteen years. (Although popular legend
portrays her as an invalid until her marriage, there is little
evidence that she was actually ill.) In 1846, she eloped, against
her father's will, with the poet Robert Browning, who
had begun a correspondence with her based on his admiration
of her work. She moved with him to Italy, where she bore
one son in 1849, and where she lived—traveling sometimes to
Paris and London—until her death.*

*Because it has long been more acceptable for a woman to
write of conventional subjects, such as love and religion,
than of controversial social and political issues, Elizabeth
Barrett Browning is today still best known for her widely
anthologized poems to her husband—poems which are rightly
regarded as among the finest love poems in the history
of literature. It is less commonly known that Elizabeth
Browning also published a sizeable body of poems on subjects
such as abolition, prostitution, child labor, and the rights
of women. She formed friendships and pursued corre-
spondence with many writers and social activists of her time,
including Julia Ward Howe, Margaret Fuller, and Harriet
Beecher Stowe. In 1857 she published her most famous
political work,* **Aurora Leigh,** *an epic, novel-length poem, told
in the first person by a heroine who is "a poet profoundly
absorbed with the significance of her own life as a woman."
Based partly on her own experiences and those of other
women writers,* **Aurora Leigh** *is said to have taken part of its
title from the given name of French novelist George Sand,
who had been born Amantine-Aurore-Lucile Dupin.*

*Sand (1804–1876) was then one of the most prolific and
popular writers of her time. She had come to Paris at the age of
twenty-seven, leaving an unhappy marriage to begin her
career as a writer. Supporting herself by writing for journals,
she published her first novel within two years—after she
had adopted men's clothing and a pen name as her way of
coping with a culture which did not believe in the talents of
women. Throughout the rest of her long career she continued
to write an average of two novels a year, plus many short
journalistic pieces, working usually at night in order to
combine a full social and personal life with her work. The
mother of two children, whom she supported by her
writing, Sand returned for a part of each year to her country
estate (hers by inheritance, but her husband's by marriage),
thus maintaining the outward form of marriage so important
to her husband and to society.*

*A great admirer of Sand, Elizabeth Browning twice visited
her (against the wishes of Robert Browning)—many years,
however, after she had written the sonnets which are*

reprinted here. *In the following lines, published in 1844 in her
two-volume* Poems, *we can see the poet's recognition of
Sand's struggle with being a woman and an artist in a society
which thought the two could not be combined. We also
see the importance to Browning of the work of another woman
artist whose personal confidence and artistic achievements
inspired and illustrated her own.*

I. A Desire
Thou large-brained woman and large-hearted man,
Self-called George Sand! whose soul, amid the lions
Of thy tumultuous senses, moans defiance,
And answers roar for roar, as spirits can!
I would some mild miraculous thunder ran
Above the applauded circus, in appliance
Of thine own nobler nature's strength and science,
Drawing two pinions, white as wings of swan,
From thy strong shoulders, to amaze the place
With holier light! that thou to woman's claim,
And man's, mightst join beside the angel's grace
Of a pure genius sanctified from blame,—
Till child and maiden pressed to thine embrace,
To kiss upon thy lips a stainless fame.

II. A Recognition
True genius, but true woman! dost deny
Thy woman's nature with a manly scorn,
And break away the gauds and armlets worn
By weaker women in captivity?
Ah, vain denial! that revolted cry
Is sobbed in by a woman's voice forlorn!—
Thy woman's hair, my sister, all unshorn,
Floats back dishevelled strength in agony,
Disproving thy man's name! and while before
The world thou burnest in a poet-fire,
We see thy woman-heart beat evermore
Through the large flame. Beat purer, heart, and higher,
Till God unsex thee on the heavenly shore,
Where unincarnate spirits purely aspire.

Two Poems

By Emily Dickinson

See page 98 for additional biographical information on Emily Dickinson.

Although history has made much of Emily Dickinson's personal solitude, less attention has been paid to her far-reaching knowledge of the literature of her female contemporaries. Set apart from both the literary and the social give-and-take enjoyed by most male writers of her time, Dickinson nevertheless was well aware of current trends of thought and style, and she responded to them in ways of her own. She read and reread the work of nearly every living English and American woman writer—George Eliot, the Brontës, Helen Hunt Jackson, Rebecca Harding Davis, and many others. She was also familiar, through books, with their personal lives—reading, for example, Julia Ward Howe's abridgement of George Sand's autobiography. She read in its entirety Elizabeth Barrett Browning's Aurora Leigh, *from which she abstracted and reassembled scenes and metaphors into many, highly original poems of her own (a fact recently documented by several Dickinson scholars). The two poets never met, yet Dickinson's love and respect for the work of her contemporary is apparent in her poems and in many letters to friends which refer directly to Browning's achievements. Adapting Browning's own statement (in* Aurora Leigh*) that the name of the poet is "royal," Dickinson referred in one letter to Browning and Sand as "queens"; and in a poem written after Browning's death, she spoke of the poet as "the Head too High to Crown."*

In "I think I was enchanted" Dickinson metaphorically recognizes her indebtedness to Elizabeth Browning, comparing the great spiritual power of Browning's poems to divine, religious inspiration, as well as to witchcraft—thereby redefining "witchcraft" itself. Exuberantly praising her great mentor, Emily Dickinson did not know that someday her own fame would equal and perhaps surpass that of Elizabeth Barrett Browning. Unlike Browning, Dickinson—with few

exceptions—was not sought out by the world of readers, nor by
the writers whom she knew so well through their work.
In her poem which begins, "This is my letter to the world,"
Dickinson speaks with characteristic self-awareness and
courage of her solitary role in the service of her art—an art
which was to have more influence on twentieth-century
poetry than the writing of any other woman of the nineteenth
century.

593
I think I was enchanted
When first a sombre Girl—
I read that Foreign Lady—
The Dark—felt beautiful—

And whether it was noon at night—
Or only Heaven—at Noon—
For very Lunacy of Light
I had not power to tell—

The Bees—became as Butterflies—
The Butterflies—as Swans—
Approached—and spurned the narrow Grass—
And just the meanest Tunes

That Nature murmured to herself
To keep herself in Cheer—
I took for Giants—practising
Titanic Opera—[1]

The Days—to Mighty Metres stept—
The Homeliest—adorned
As if unto a Jubilee
'Twere suddenly confirmed—

I could not have defined the change—
Conversion of the Mind
Like Sanctifying in the Soul—
Is witnessed—not explained—

[1] *Titanic Opera* refers to the heroic scale of Elizabeth Barrett Browning's epic
poem *Aurora Leigh*.

'Twas a Divine Insanity—
The Danger to be Sane
Should I again experience—
'Tis Antidote to turn—

To Tomes of solid Witchcraft—
Magicians be asleep—
But Magic—hath an Element
Like Deity—to keep—

441

This is my letter to the World
That never wrote to Me—
The simple News that Nature told—
With tender Majesty

Her Message is committed
To Hands I cannot see—
For love of Her—Sweet—countrymen—
Judge tenderly—of Me

Martha Graham, Letter to the World, 1940 (Kick)

By Barbara Morgan

Barbara Morgan (1900–) was raised in California in a family which encouraged her, from a very early age, to develop her various artistic and intellectual interests. She studied art at the University of California at Los Angeles, where she returned to teach in 1926, and began to experiment with cameras during the summers she spent touring and painting in the Southwest with her husband, freelance writer and photographer Willard D. Morgan. In 1930 they moved to New York. Morgan continued to paint, despite her dislike of the metropolis; and her first one-woman show opened in 1934 at the Mellon Gallery in Philadelphia, two years after the birth of her first son. Painting during daylight hours became more difficult, however, after the birth of her second son in 1935, and she turned to photography as a means of reconciling her conflicting interests as artist and mother. Working after the children were asleep, or when her husband took care of them, Morgan carefully structured her time so that her work could fit "into the pattern of the unexpected, that is expected when 'raising children.' "

In 1936 Morgan visited an exhibition of photographs, drawings, and sculptures in memory of the great dancer Isadora Duncan. Finding that the exhibition focused more on Duncan as woman than on "how she moved," Morgan was shocked to think that an artist's lifework could be so "casually lost." Believing that the work of Martha Graham (1894–) had the "revolutionary importance for us today that Duncan's work had for yesterday," Morgan embarked upon a four-year project which resulted in the book Martha Graham: Sixteen Dances in Photographs, *designed entirely by Morgan, down to the last details of printing, and published in 1941.*

230

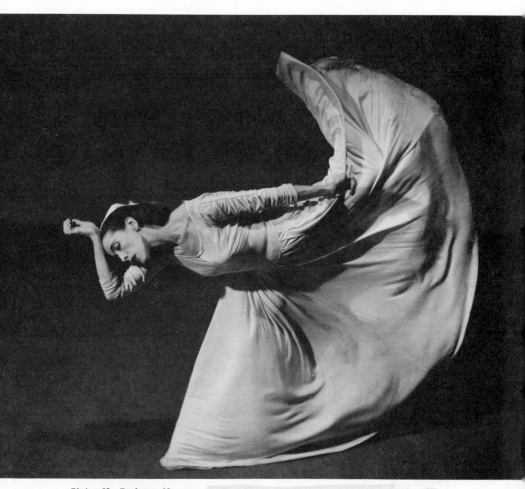

Plate 42. Barbara Morgan. MARTHA GRAHAM, LETTER TO THE WORLD, 1940 (KICK). Photograph.

At that time, Martha Graham's fame as an innovator in dance was at a height which remains undiminished today. At the pioneering Denishawn School of Dancing, Los Angeles, where she first trained, Graham not only moved beyond the forms and methods of classical ballet; she also discovered that a fusion of the dance forms of Indian, Egyptian, Greek, Spanish, and Native American cultures provided an avenue for the release of her own emotions in dance. She came

to believe in modern dance as "the affirmation of life through movement . . . the product not of invention but of discovery—the discovery of what the body will do, and what it can do in the expression of emotion." In 1926, she began to teach and perform with her own company at the Eastman School of Music in Rochester, New York. There she began to develop unique techniques that have since been incorporated into modern dance: for example, the contact of the entire body with the floor as valid dance movement. Graham—who said that she identified herself completely with her roles— often created dances out of significant moments in the lives of legendary heroes such as Saint Joan and the biblical Judith, as well as dances whose social and political subjects range from the Spanish Civil War to the American immigrant experience. All of these works, however, have one theme in common: the need to strip away surface convention in order to understand underlying emotions.

"Letter to the World," a dance based on the life of Emily Dickinson, was Graham's interpretation of the contrast she saw between the "inner life" revealed in Dickinson's poems and "the well-bred, polite, conventional lady that her neighbors saw." Through "becoming" the "inner" Dickinson, Graham gave new life to the poet's own vision—a vision of independence and freedom of thought which continues to inspire artists today.

The Barbara Morgan photograph reproduced here, like each photograph in Sixteen Dances, was taken during rehearsals. Morgan's aim was to capture the "essential emotion" of each dance, to "arrest time" by translating each climactic motion into a permanent visual image. To do this she attended rehearsal after rehearsal, as well as performances, until she had identified eight key gestures or themes of each dance. She would then "previsualize" the various combinations of gesture, spacing, lighting, and framing needed to capture each precise moment—a planning process that often took one month for each picture. Kick, one of her most famous photographs, represents the moment when Emily Dickinson, portrayed by Graham, faces the awareness

that her happiness "must be found in the intensity of her work."

Barbara Morgan's photographs have appeared in more than twenty one-person shows, including exhibitions at the Smithsonian Institution and the Montclair Art Museum, and were included in a 1978–1979 exhibition at the International Center of Photography in New York. Her work has been collected in publications that include two monographs and a book titled Summer's Children: A Photographic Cycle of Life at Camp. She is currently completing two volumes, The Dynamics of Composition and a revised, larger edition of Martha Graham: Sixteen Dances in Photographs. A photographer of people, nature, and manufactured objects, Morgan has also worked in photomontage, a technique in which, by layering strata of persons, places, and symbols, she illustrates the fragmented and shifting patterns she sees in modern society. Like Martha Graham, Morgan believes that her art should be an affirmation of life that acts as a counter to the destructive, anonymous, technological forces which threaten the beauty, courage, and hope in the individual human being.

Emily Dickinson

By Linda Pastan

*Linda Pastan (1932–) was born in New York City. She
graduated in 1954 with a B.A. from Radcliffe, received the
Dylan Thomas Poetry award from* Mademoiselle *in 1955,
and her M.A. from Brandeis University in 1957. Since then her
poems have appeared in more than one hundred periodicals
and anthologies, including* The Nation, American Poetry
Review, Poetry Now, Ms., *and* Rising Tides, *an anthology of
twentieth century American women poets. Her first book
of poems,* A Perfect Circle of Sun, *appeared in 1971. Her other
books of poems include* Aspects of Eve *(1975) and* The
Five Stages of Grief *(1978). Based on themes of exile and
reunion, many poems in* Aspects of Eve *blend symbols from
ancient Greek and Hebrew mythology with complex
personal subjects of sorrow and joy in daily living.*

*Awarded a creative writing fellowship by the National
Endowment for the Arts, Pastan has also been a fellow of
the Breadloaf Writers' Conference and recipient of first
prize in the New York Poetry for Public Places Program.
She has given poetry readings throughout the country, and
has recorded her poems for the Library of Congress. The
former editor of* Voyages *magazine, Pastan has published
critical reviews in many journals. Currently she lives
in Potomac, Maryland, with her husband and three
children.*

*Pastan's poems have been described as "deceptively
simple" in structure; and readers may wish to compare and
contrast her style with that of Emily Dickinson, whose
"serious mischief/of language" Pastan admires. The poem
that follows is one of many different poems by contemporary
women poets on the subject of Dickinson's life and work.
Concluding section 3 of this book, "Emily Dickinson"
returns us to the theme of the artist's need to distinguish
between appearance and reality, and presents another
example of the continuing influence of women artists
upon one another's thought and work.*

We think of her hidden in a white dress
among the folded linens and sachets
of well kept cupboards, or just out of sight
sending jellies and notes with no address
to all the wondering Amherst neighbors.
Eccentric as New England weather
the stiff wind of her mind, stinging or gentle,
blew two half imagined lovers off.
Yet legend won't explain the sheer sanity
of vision, the serious mischief
of language, the economy of pain.

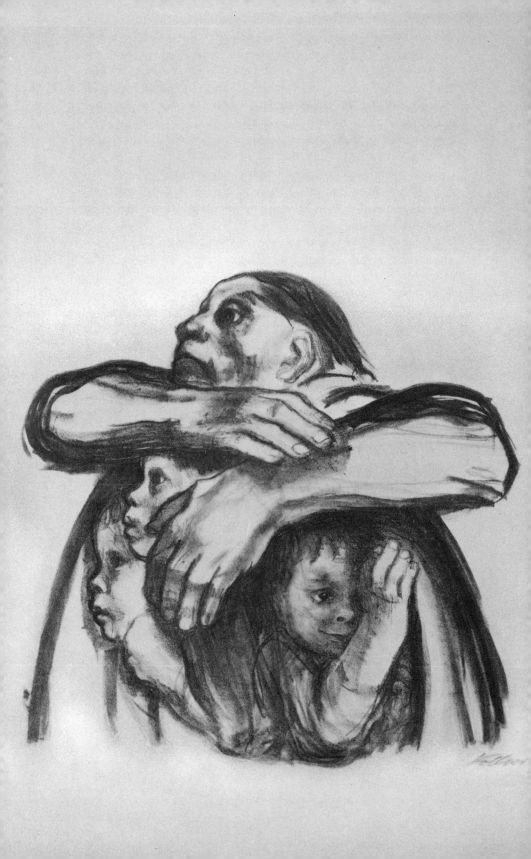

4: Lend Your Hands

Women's Art and Social Change

IN SECTION THREE WE SAW women artists defining themselves in newly autonomous ways. As they discovered new sources of identity and strength within themselves and in their relationships to their families, their inherited cultures, and other women artists, they created in their art new visions of personal freedom and growth. In this section of the book, we see such artists as they extend that vision from the personal into the public realm, moving from a sense of responsibility for the self to a sense of responsibility for others. The art in this section takes society, its political, economic and social problems, for its subject matter. It is an art of social criticism and social concern.

The content of this art is strong, often controversial. For these are women living in a twentieth-century world of organized and institutionalized violence brought against groups of people and against whole nations: a world of wars, recessions and poverty, of nuclear and urban crises, of racial and sexual oppression and unrest. Their art reflects this reality. But it does something more as well. The artists in this section work, through their art, to change society. They share the belief that art can make things happen: that through word, image, and rhythm, art can inspire strong feelings, help its audience to name and so deal with its fears and its hopes; that art can thus change consciousness, affect lives, and lead to action.

Such a belief means that these artists are especially aware of their audience, and so in this section of the book the role of the audience in relation to the work of art receives special attention. We shall find the artists themselves voicing their belief in their responsibility to their audience—a sense of responsibility that is moral and political as well as esthetic. This sense of responsibility to the audience may in fact influence the very process whereby the work of art is created, helping, for example, to determine the media chosen. Consequently, in this section we find a famed artist who chooses to work with prints and posters, because these can be easily and inexpensively reproduced and distributed; we meet artists who paint murals on the walls of public buildings rather than oil paintings to be hung in museums. The performing arts—dance and music—are also more prominent here, since these are art forms which by their very nature are more public, and which depend upon the presence of an audience for their fullest realization. Even those artists who choose the lyric poem, traditionally a vehicle for the expression of the private sensibility, are especially aware of their relationship to their audience: the poems are less examples of individual self-expression than they are ways of connecting, of sharing the artist's social concern with readers.

This concern with sharing extends also to relationships among the artists themselves. For reasons that we shall note as we examine individual selections, many women artists today are choosing to work as members of egalitarian groups or collectives, rather than individually and privately. Some of the selections will show these new attempts to collectivize and democratize the artistic process, as women artists combine their skills to create works that make broad social as well as artistic statements.

We begin this section with examples from the work of an artist who has been called "a giant of our century." Kaethe Kollwitz lived in Germany through the violence of both the first and second World Wars, and through the inflation, the poverty and unemployment, and the political unrest that led to the rise of the Nazi party and of Adolf Hitler. Over a span of more than

half a century, she created in etchings, woodcuts, lithographs, posters, and sculptures a record of that world. Beginning with her girlhood, Kollwitz responded to the beauty she saw in working-class people (to capture the "broad freedom of movement" of their gestures was an early impulse in her art), and, as an adult, to their economic and political situation. Increasingly she developed a sense of her responsibility, as an artist, to be "an advocate" for the poor and the oppressed, seeing it as her "duty" to "voice the sufferings" of humankind. In assuming this responsibility, Kollwitz developed an art unique both in the depth of its social commitment and in its portrayal of the working class as active agents in their own history. Her art portrayed not only the sufferings but also the active protests and rebellions, and the survival-strengths, of the women, men, and children with whom she wanted, as she once said, to reestablish the "lost connection" between the artist and the people.

Because of her primacy as an artist of social concern, we have included in this section a fairly extensive set of selections from Kollwitz's work. In addition to reproductions of some of her graphic works, there are excerpts from a brief autobiography she once wrote, as well as passages from her letters and from the diary that she kept for over thirty years. Again and again she records a sense of artistic commitment inseparable from her political and social concerns. The persistence of that commitment is nowhere better conveyed than in the moving metaphor of the "seed-corn," or "seed for the planting," that she introduces early into her diary and returns to periodically throughout her life. The seed that must be carefully saved, then planted and cultivated to insure new growth, is Kollwitz's image for her own talent, which is to be nurtured in the service of humanity. Later, it becomes her image for all the young men who, drafted into the armies of two world wars, are "ground up" and destroyed. Dead, they cannot lead forward into new life. Her famous lithograph *Seed for the Planting Must Not Be Ground*, included here, which protested the conscription of extremely young boys into the German army in World War II, is a frequently-reproduced example of her response to the large-scale military violence of the two world wars. Kollwitz's sense of the

suffering wreaked by war and its aftermath on all members of society is seen especially in her treatment of women. Women appear as mothers, wives, and workers, as suffering but also as sustaining and protecting figures. The death of one of her sons in World War I profoundly influenced Kollwitz, and motherhood became one of her great subjects. In drawing the faces of a group of huddled women, Kollwitz often included her own face, witness to her sense of involvement, of identification. And the self-portraits through which she chronicled her own aging, four of which are included here, are not private explorations, but public offerings of the self, testimony to the effects of war, suffering, and loss. The body ages and bends, the face grows lined. But nobility of spirit infuses and transfigures feature and form.

Kaethe Kollwitz died in April, 1945, a few months before the nuclear bombs dropped on Hiroshima and Nagasaki inaugurated yet a further escalation of twentieth-century violence. In 1968, the contemporary poet Muriel Rukeyser published her poem "Kaethe Kollwitz." "My lifetime," Rukeyser says to Kollwitz in the poem, "listens to yours." For Rukeyser's lifetime, too, has been spent, as she says, "between wars." Born in 1913 on the eve of World War I, she has lived through the Civil War in Spain in the 1930s, the second World War, the Korean War in the 1950s, and the war in Vietnam in the 1960s, and against many of these wars Rukeyser has protested as citizen and as poet. In this poem she identifies with the "revolutionary look" of the figures in some of Kollwitz's graphics, and with the sense those figures convey to her, that "I am in the world/ to change the world." In her book *The Life of Poetry*, Rukeyser has described poetry as "one source of power," a power that resides in its ability "to equip our imaginations to deal with our lives." Her own poem demonstrates the power Kollwitz's art to grip Rukeyser's imagination, and the potential power of both artists, as their lives join in the poem, to seize and thus "equip" the imaginations of readers, providing them with images that may encourage them, too, to "change the world."

The effects on human beings of war and political repression continue to concern younger women artists today. The songs of

singer and composer Holly Near frequently take their substance
from the events of the political world in which she lives. In the
example of Near's song-writing included here, "It Could Have
Been Me," we see her, as the title indicates, identifying with
groups of people in three different societies who have been the
victims of violence springing from war or from dictatorship. For
Near also, as for Kollwitz, a concern for the audience for which
she creates is an important motivation in her work. A trip to
Vietnam in the early 1970s enabled Near to see the artist-
audience relationship at work in a different society, one in
which the very scarcity of paper and other artistic supplies
raised questions as to what kind of art should be created, by
whom and for whom. The trip thus prompted Near to rethink
the question of the relation of the artist to her audience in her
own society; and the statement included here, on the artist's
cultural responsibility, is one outgrowth of that thinking. Rec-
ognizing the unofficial censorship that prevails in the mass
media, where the objective of appealing to audiences in the
millions often dictates the removal of any material that will not
please the largest number of viewers, Near sees a need for
"alternative" art events that will more specifically serve the
needs of diverse groups in our society. As a feminist, Near is
especially aware of the needs of women for spaces and places of
their own in which to express and share their feelings and ex-
periences. As she describes her active involvement with her
audiences, learning from them and in turn encouraging them to
formulate their own goals and intentions, Near offers a descrip-
tion of a kind of artist-audience interaction that enables audi-
ences to participate in the creative process. Such participation
is central to Near's belief in the power of art to affect and change
lives, and thus to contribute to larger social change.

Of all the arts music perhaps has the most power to engage
the emotions of its audience immediately and directly. Ruling
groups at various times in history have recognized this power
by banning songs around which protesting groups have rallied.
For Bernice Reagon, the discovery of this power of music was
central to her development as an artist. In "Black Music in Our
Hands," Reagon, who like Near is a song writer and performer,

describes the development of her thinking on the role of music in her life. As a child and young girl, making and hearing music had been a source of private pleasure for her, associated with her church and social life. But with her involvement in the civil rights movement of the 1960s, her experiences in jail and thereafter, music became a way of uniting in political protest people of different classes and races. As Reagon found that she could use a song as an "instrument," or a "tool" to move people to take a stand, to encourage them to organize and to act on their beliefs, she experienced, as she describes it, a new sense of the power of art. Interestingly enough, this new sense of art's effectiveness released a sense of power within herself, "a kind of power . . . I did not know I had." Just as we saw women in section 3 discovering their strengths and using them as the source of new works of art, so here we see that the process is reciprocal: the new act of creation, especially when accompanied by a sense that the creation matters, that an audience exists which will respond to it, may in turn release hitherto unrecognized strengths within the self. In both cases the process is liberating, freeing, as Reagon recognizes. A sense of the power emanating from the singer and communicated through her lyrics to the audience comes through in the song, "There's A New World Coming," included here, in which Reagon encourages the oppressed peoples of many nations to "take over their lives."

The work of visual artist Betye Saar also began to reflect her political awareness as a result of the civil rights movement of the 1960s. "I found my work changing because of my strong feelings," she has said. One of those feelings was anger, at the discrimination experienced by Black people, and in creating such works as *The Liberation of Aunt Jemima,* included here, Saar was giving artistic shape and expression to that anger. She was also beginning, like Reagon, to use art as a tool in a political struggle. The stereotypical Aunt Jemima, who for years smiled at consumers from boxes of General Mills pancake flour, is relegated to the flat background of the assemblage Saar has created, and in the foreground is a three-dimensional, weaponed figure whose grin is more ambiguous. Aunt Jemima has become a figure whose reserves of will, long hidden behind the stereotype, emerge now in a figure that conveys her conviction—as Koll-

witz's workers did to Rukeyser—that "I am in the world/ to
change the world."

Women of other minority racial and ethnic groups are also
using art today to communicate their belief in the need for both
specific and broad social change. The members of the Lower
East Side Collective, which included Black, Puerto Rican,
Asian-American, Jewish, and Italian women, created together
the *Wall of Respect for Women* mural for a particular New
York City neighborhood in which they lived. Addressed to the
women's needs for specific reforms, such as improved working
conditions and wages, and better housing and child care facili-
ties, as well as to the broad need for the union of all races and
classes in working for social justice, this and other murals
which the group created are examples of the art being produced
today by women who choose to work in groups rather than indi-
vidually. Made under the guidance of project director Tomie
Arai, the mural was the result of the collaborative efforts of all
the participants, many of whom were not professional artists.
The very process of creating the mural thus demonstrates the
principles of egalitarianism and political unity celebrated in the
mural itself.

The professional dance group Wallflower Order is another
example of such a collective, in which the work of art emerges
out of the shared experiences and suggestions of all of the mem-
bers. Emphasizing their non-hierarchical nature—no one person
directs the others as subordinates—Wallflower Order sees its
procedure as one way for women today to overcome their tradi-
tional isolation and to take decision-making into their own
hands. Such groups as Wallflower Order reflect that question-
ing of established authority which arose in the 1960s and 1970s
in the civil rights movement, the anti-Vietnam war movement,
the women's movement, and in various other social move-
ments focused on issues such as health, education, and environ-
ment. As women artists establish their own alternative groups,
they are creating a growing number not only of dance, music,
film and visual art collectives through which to create work,
but also presses, publishing houses, magazines, and exhibit
areas in which to publish, perform, and display their art. In
working with and through such alternative institutions, these

women artists are participating in efforts to change the tradi-
tional distribution of leadership and power in society.

Like the Lower East Side mural group, Wallflower Order sees
not only its process of working collectively, but the art created
through that process, as having social and political meaning and
purpose. The dance performance *Collections for Her-Story*,
scenes from which are included here, grew out of experiences in
the lives of the dancers and also out of their research into wom-
en's history. Such history, as we have seen elsewhere in this
book, has often been scattered, fragmented, or lost. In restoring
and recreating some of the "missing pages" of that history, the
collective sees itself as providing women with some of the ma-
terials—or, as Bernice Reagon or Betye Saar might say, with the
tools—through which both individual and social change may be
achieved.

A similar purpose led artist Judy Chicago to initiate the large-
scale collaborative effort, *The Dinner Party*, which is included
here as a third example of contemporary collective activity by
women artists. *The Dinner Party* required five years and the
skills of some 400 workers, predominately women, to complete.
It is a multi-media exhibit that commemorates women in a
variety of countries, periods, and fields of endeavor in Western
civilization. As such, it is intended to provide women with a
sense of their history and culture and thus, like the work of
Wallflower Order, to correct some of the distortions and omis-
sions of the past. In protesting distortions and omissions, such
art works are affirmatively encouraging constructive change.

We conclude with two poems that capture the concerns ex-
pressed throughout this section by many of the artists, whether
working individually or collectively. Adrienne Rich's poem
reflects her painful awareness of that world of large-scale vio-
lence which has gripped the imaginations of so many of the
artists, but it offers us a vision that transcends violence. Rich
imagines a world of the future in which women, aware of their
own abilities and enriched by a sense of their past, have made
violence obsolete. If this is dream or vision, it, too, is the kind of
dream that turns "into responsibilities." Rich's celebration in
the poem of the "hands" that create, shape, and heal, recalls an

image that has pervaded this section of the book, from the strong hands of Kollwitz and the people she portrayed, to the repeated imagery of hands in Rukeyser's poem on Kollwitz, to the title of Bernice Reagon's essay, to the creative hands of the women pictured at work on *The Dinner Party*—all examples of women revealing both vision and reality in their art, an art that in turn may encourage others to deal with the realities of their lives and their society.

The poem with which the book concludes, Muriel Rukeyser's "Wherever," returns us, with its imagery of planting and seeding, to the humanitarianism of Kollwitz with which this section began. "Wherever" expresses the belief that has motivated all of the artists in this section, the belief that protest, engaged in as a result of one's social concern, is not negative but positive, a constructive, even a creative act. For Rukeyser it is akin to making a poem, feeding a child, or planting a seed—all actions undertaken in a spirit of faith and hope. And the "we" in Rukeyser's poem includes everyone, summoning all people, women and men, to share in the responsibility of creating, and creatively changing, our world.

The Artist and the People

By Kaethe Kollwitz

*One of the outstanding graphic artists of the twentieth
century, Kaethe Kollwitz (1867–1945) was born Kaethe
Schmidt, in Koenigsberg, in what was then East Prussia. From
her maternal grandfather, a nonconformist religious leader,
and her father, a socialist thinker, she inherited a tradition
of political humanitarianism. Both of her parents were
talented in drawing, and the young Kaethe grew up in a close-
knit family in which, despite her father's once saying it
was a "pity" she had not been born a boy, her own artistic
aspirations were encouraged. The fifth of six children, two of
whom died in infancy, Kaethe was especially close to her
younger sister, Lise, who also showed artistic talent, but who
abandoned art upon her marriage. Kaethe herself studied
art with a private instructor in Koenigsberg and at segregated
art schools for women in Berlin and Munich, since women
were not admitted to the male academies. In 1891 she married
Karl Kollwitz and moved to Berlin, where her husband
practised socialized medicine as a physician for a workers'
health insurance fund. Two sons were born, Hans in 1892, and
Peter in 1896. For fifty years Kaethe Kollwitz lived and
worked in the same tenement building in Berlin's working-
class district, successfully combining the duties of wife and
mother with the steady production of artistic works—
an achievement her father had thought would not be possible.
From the time of her first interest, as a young girl, in
portraying the dockers and workers of the city of Koenigsberg,
Kaethe Kollwitz was drawn to the working class as the
subject of her art. Between 1893 and 1908 she produced two
major cycles of prints:* **The Revolt of the Weavers,** *based on an
unsuccessful nineteenth-century uprising of unemployed
handloom workers, and* **The Peasant War,** *which depicted a
bloody and unsuccessful sixteenth-century revolt of German
peasants against serfdom and feudalism. In her portrayal*

of struggle from the workers' and peasants' points of view, Kollwitz was developing what has been called "an art of those at the bottom."

Increasingly, however, her social subjects came not from history but from her immediate environment. In etchings, lithographs, woodcuts, and posters, she portrayed the poverty, illness, and hunger—as well as the strength and joy— of the men, women, and children whom she daily saw in her husband's medical clinic. Much of her work began to center, too, on mothers and children, and on the theme of maternal concern. Sometimes this theme was expressed in the simple tenderness of pictures such as the Mother and Child reproduced here; often it appeared in a dread context, as in the woodcut, The Mothers, also shown in these pages, part of a series of seven prints produced by Kollwitz in 1922–1923 under the general title, War. By this time she had also embarked on what would become perhaps the longest and certainly the most searching physical and psychological exploration of a woman's life in Western graphic art, her series of self-portraits, which would number eighty-four at her death.

By the eve of World War I Kaethe Kollwitz was widely known and respected as an artist, both at home and abroad, although her work increasingly offended the political authorities in Germany. With the war came personal tragedy— the death of her eighteen-year-old son Peter, killed almost immediately after he enlisted. His death inspired Kollwitz to create, over a fifteen-year period, two monumental sculptures, The Mourning Mother and The Mourning Father, for the graveyard in which he was buried. Meanwhile, her social and artistic conscience—the two were ever inseparable for her—continued to respond to the dangerous economic and political conditions of post-war Germany, and in the 1920s and 1930s she produced graphic works depicting the hunger, unemployment, and inflation that were the results of the war, and that were leading to dangerous political unrest. Determined to create an art not only of, but for, the people, Kollwitz made as many prints as possible of her

*works and refused to number the prints, in order that the price
for each would be the same. Confining herself to graphics
in black and white, she could thus also keep the cost of her
prints low.*

*Both through her art and through open political statement,
Kollwitz warned against the rise of Adolf Hitler and of
the party which brought him to power in 1933. The Nazis
retaliated in their turn, forcing her resignation from the
Prussian Academy of Arts, to which she had been the first
woman elected, banishing her works from public view, and
burning many of them. Refusing to emigrate from Germany
for fear of reprisals against their family, Kaethe and Karl
Kollwitz continued to live and work in Berlin. But the years of
World War II saw the death of Karl Kollwitz in 1940, and
in 1942 the death of a grandson, Peter, who was killed
in battle just as the uncle for whom he had been named had
been killed twenty-eight years before. Until her own death
in 1945 at the age of seventy-eight, after she had finally been
forced to leave Berlin because of the bombings, Kaethe
Kollwitz continued to produce her art and to hold fast to her
faith in socialism and pacificism as the bases for the future
unity of all humankind.*

The Early Years

*Kollwitz's son Hans repeatedly urged her to set down the story
of her life. Although she was reluctant to do so, when she
was fifty-five she at last presented him with a handwritten
account. The following excerpts from that account, covering
her childhood and young womanhood, show the early
strength of purpose that enabled her to pursue her art; her ideas
about the needs and characteristics of the creative artist;
and her earliest perceptions of human beauty, in which lay a
social impulse that later became a major force in her life
and work.*[1]

[1] Some of the excerpts as given here are not in the sequence of the original ac-
count, in which Kollwitz often followed a thematic, rather than a chronological
order.

I was hard-working and conscientious, and my parents took pleasure in each new drawing I turned out. . . . I was showing unmistakable talent for drawing, and so was Lise. I still remember overhearing my father in the next room saying . . . something that bothered me for a long time afterwards. He had been astonished by one of Lise's drawings, and said to Mother: "Lise will soon be catching up to Kaethe."

When I heard this I felt envy and jealousy for probably the first time in my life. I loved Lise dearly. We were very close to one another and I was happy to see her progress up to the point where I began; but everything in me protested against her going beyond that point. I always had to be ahead of her. This jealousy of Lise lasted for years. When I was studying in Munich there was talk of Lise's coming out there to study too. I experienced the most contradictory feelings: joy at the prospect of her coming and at the same time fear that her talent and personality would overshadow mine. As it turned out, nothing came of this proposal. She became engaged at this time and did not go on studying art.

Now when I ask myself why Lise, for all her talent, did not become a real artist, but only a highly gifted dilettante, the reason is clear to me. I was keenly ambitious and Lise was not. I wanted to and Lise did not. I had a clear aim and direction. In addition, of course, there was the fact that I was three years older than she. Therefore my talent came to light sooner than hers and my father, who was not yet disappointed in us, was only too happy to open opportunities for me. If Lise had been harder and more egotistic than she was, she would unquestionably have prevailed on Father to let her also have thorough training in the arts. But she was gentle and unselfish. ("Lise will always sacrifice herself," Father used to say.) And so her talent was not developed. As far as talent in itself goes—if talent could possibly be weighed and measured—Lise had at least as much as I. But she lacked total concentration upon it. I wanted my education to be in art alone. If I could, I would have saved all my intellectual powers and turned them exclusively to use in my art, so that this flame alone would burn brightly.

In the years when a young person is developing, his gifts feed

on everything that pours into him from all sides. During those years almost everyone has some talent, because he is receptive. My parents followed the principle of giving us the opportunity to develop ourselves without their pushing our noses into things. For example, the bookcases were open to all of us children, and no one checked up on what books we chose. They were mostly good books anyway. I read Schiller in a large, handsome edition with engravings by Kaulbach; and I read Goethe. Goethe took root in me very early, and all my life he has meant a great deal to me.

. . . I was about sixteen when I made my first drawing of characteristic workman types. . . . A year later, at my father's request, I showed this drawing to my teacher in Berlin, Stauffer-Bern, who recognized it as altogether typical—both of me and of the environment from which I came.

. . . My ignorance of the physical aspects of life lasted for many years. I had the wildest ideas about how babies were born. . . . I was convinced that I too might have a baby out of the blue. . . .

As I look back upon my life I must make one more remark upon this subject: although my leaning toward the male sex was dominant, I also felt frequently drawn toward my own sex—an inclination which I could not correctly interpret until much later on. As a matter of fact I believe that bisexuality is almost a necessary factor in artistic production; at any rate, the tinge of masculinity within me helped me in my work.

I turn now from discussion of my physical development to my nonphysical development. By now my father had long since realized that I was gifted at drawing. The fact gave him great pleasure and he wanted me to have all the training I needed to become an artist. Unfortunately I was a girl, but nevertheless he was ready to risk it. He assumed that I would not be much distracted by love affairs, since I was not a pretty girl; and he was all the more disappointed and angry later on when at the age of only seventeen I became engaged to Karl Kollwitz.

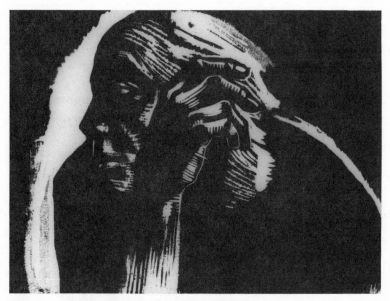

Plate 43. Kaethe Kollwitz. SELF-PORTRAIT, 1924. Woodcut.

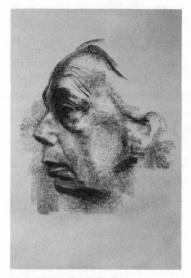

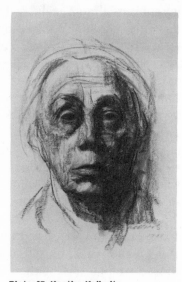

Plate 44. Kaethe Kollwitz.
SELF-PORTRAIT, PROFILE, 1927. Lithograph.

Plate 45. Kaethe Kollwitz.
SELF-PORTRAIT, 1934. Charcoal and
crayon, 17 × 13¼ in.

My father . . . was very skeptical about my intention to follow two careers, that of artist and wife. . . . Shortly before our marriage my father said to me, "You have made your choice now. You will scarcely be able to do both things. So be wholly what you have chosen to be."

. . . The quiet, hardworking life we led was unquestionably very good for my further development. My husband did everything possible so that I would have time to work.

. . . The jury . . . voted that the *Weavers* be given the small gold medal. . . . From then on, at one blow, I was counted among the foremost artists of the country. To this day the *Weavers* is probably the best-known work I have done. . . .

I should like to say something about my reputation for being a "socialist" artist, which clung to me from then on. Unquestionably my work at this time, as a result of the attitudes of my father and brother and of the whole literature of the period, was in the direction of socialism. But my real motive for choosing my subjects almost exclusively from the life of the workers was that only such subjects gave me in a simple and unqualified way what I felt to be beautiful. For me the Koenigsberg longshoremen had beauty; the Polish *jimkes*[2] on their grain ships had beauty; the broad freedom of movement in the gestures of the common people had beauty. Middle-class people held no appeal for me at all. Bourgeois life as a whole seemed to me pedantic. The proletariat, on the other hand, had a grandness of manner, a breadth to their lives. Much later on, when I became acquainted with the difficulties and tragedies underlying proletarian life, when I met the women who came to my husband for help and so, incidentally, came to me, I was gripped by the full force of the proletarian's fate. Unsolved problems such as prostitution and unemployment grieved and tormented me, and contributed to my feeling that I must keep on with my studies of the lower classes. And portraying them again and again opened a safety-valve for me; it made life bearable.

[2] *Jimkes:* dockhands.

From Her Diary

The following are excerpts from a diary that Kollwitz kept from 1909 to 1943. By 1915, the date of the first excerpt below, her son Peter had been killed in World War I at the age of eighteen.

February 15, 1915: ... I do not want to die, even if Hans and Karl should die. I do not want to go until I have faithfully made the most of my talent and cultivated the seed that was placed in me until the last small twig has grown. This does not contradict the fact that I would have died—smilingly—for Peter, and for Hans too, were the choice offered me. Oh how gladly, how gladly. Peter was seed for the planting which should not have been ground. He was the sowing. I am the bearer and cultivator of a grain of seed-corn.[3] What Hans will become, the future will show. But since I am to be the cultivator, I want to serve faithfully. Since recognizing that, I am almost serene and much firmer in spirit. It is not only that I am permitted to finish my work—I am obliged to finish it. This seems to me to be the meaning of all the gabble about culture. Culture arises only when the individual fulfils his cycle of obligations. If everyone recognizes and fulfils his cycle of obligations, genuineness emerges. The culture of a whole nation can in the final analysis be built upon nothing else but this.

February 21, 1916: ... Art for the average spectator need not be shallow. Of course he has no objection to the trite—but it is also true that he would accept true art if it were simple enough. I thoroughly agree that there must be understanding between the artist and the people. In the best ages of art that has always been the case.

Genius can probably run on ahead and seek out new ways. But the good artists who follow after genius—and I count myself among these—have to restore the lost connection once more.

[3] *Seed for the planting,* also translated as *seed-corn:* The source of this image, from which Kollwitz drew the strength to continue her work, is in a line by Goethe, "Seed for the planting must not be ground."

A pure studio art is unfruitful and frail, for anything that does not form living roots—why should it exist at all?

Now as for myself. The fact that I am getting too far away from the average spectator is a danger to me. I am losing touch with him. I am groping in my art, and who knows, I may find what I seek. When I thought about my work at New Year's 1914, I vowed to myself and to Peter that I would be more scrupulous than ever in "giving the honor to God, that is, in being wholly genuine and sincere." Not that I felt myself drifting away from sincerity. But in groping for the precious truth one falls easily into artistic oversubtleties and ingenuities—into preciosity. I suddenly see that very clearly, and I must watch out. Perhaps the work on the memorial will bring me back to simplicity.[4]

October 11, 1916: When I think I am convinced of the insanity of the war, I ask myself again by what law man ought to live. Certainly not in order to attain the greatest possible happiness. It will always be true that life must be subordinated to the service of an ideal. But in this case, where has that principle led us? Peter, Erich, Richard, all have subordinated their lives to the idea of patriotism. The English, Russian and French young men have done the same. The consequence has been this terrible killing, and the impoverishment of Europe. Then shall we say that the youth in all these countries have been cheated? Has their capacity for sacrifice been exploited in order to bring on the war? Where are the guilty? Are there any? Or is everyone cheated? Has it been a case of mass madness? And when and how will the awakening take place?

July 1917: My fiftieth birthday has passed. Different from the way I used to imagine it. Where are my boys?

And yet the day was good, this whole period is good. From so many sides I am being told that my work has value, that I have accomplished something, wielded influence. This echo of one's life work is *very* good; it is satisfying and produces a feeling of

[4] *The memorial* refers to the sculptures of the mourning mother and father, to be placed in the Belgian graveyard where Peter and others fallen in World War I were buried. Kollwitz would work on the sculptures for many years.

gratitude. And of self-assurance as well. But at the age of fifty this kind of self-assurance is not as excessive and arrogant as it is at thirty. It is based upon self-knowledge. One knows best oneself where one's own upper and lower limits are. The word fame is no longer intoxicating.

But it might have turned out differently. In spite of all the work I have done, success might have been denied me. There was an element of luck in it, too. And certainly I am grateful that it has turned out this way.

January 4, 1920: I have again agreed to make a poster for a large-scale aid program for Vienna. I hope I can make it, but I do not know whether I can carry it out because it has to be done quickly and I feel an attack of grippe coming on.

I want to show Death. Death swings the lash of famine— people, men, women and children, bowed low, screaming and groaning, file past him.

While I drew, and wept along with the terrified children I was drawing, I really felt the burden I am bearing. I felt that I have no right to withdraw from the responsibility of being an advocate. It is my duty to voice the sufferings of men, the never-ending sufferings heaped mountain-high. This is my task, but it is not an easy one to fulfil. Work is supposed to relieve you. But is it any relief when in spite of my poster people in Vienna die of hunger every day? And when I know that? Did I feel relieved when I made the prints on war and knew that the war would go on raging? Certainly not. Tranquility and relief have come to me only when I was engaged on one thing: the big memorial for Peter. Then I had peace and was with him.

April 1921: ... Now my work disgusts me so that I cannot look at it. At the same time total failure as a human being. I no longer love Karl, nor Mother, scarcely even the children. I am stupid and without any thoughts. I see only unpleasant things. The spring days pass and I do not respond. A weariness in my whole body, a churlishness that paralyzes all the others. You don't notice how bad you get when in such a state until you are beginning to rise out of it. ...

(text continued on page 258)

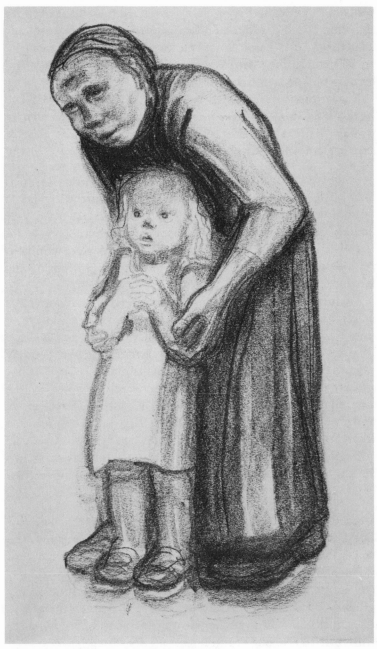

Plate 46. Kaethe Kollwitz. MOTHER AND CHILD. N. d.

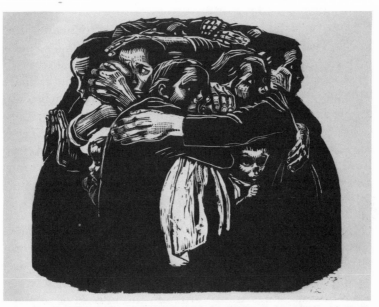

Plate 47. Kaethe Kollwitz. THE MOTHERS (VI from "Seven Woodcuts of War"). 1922–1923.

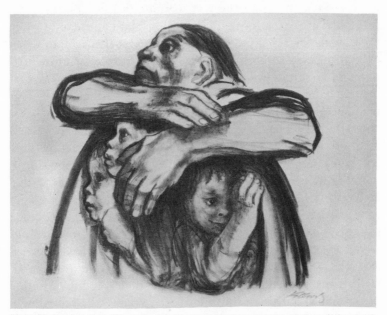

Plate 48. Kaethe Kollwitz. SEED FOR THE PLANTING MUST NOT BE GROUND. Lithograph, 18½ × 15½ in. 1942.

(text continued from page 255)

However, I did have one fine experience in these dull, dead weeks. That was before I fell ill. At the Tiergarten I saw a nurse with two children. The older boy, about two and a half, was the most sensitive child I have ever seen. As the nurse put it, like a little bird. For this reason she did not like him. But the boy was utterly charming. On his little face and in his thin body impressions from outside were constantly reflected. A great deal of fear, oppression, hope, almost blissful joy; then again anxiety, etc. Like a butterfly whose wings are constantly quivering. Never have I seen a baby more moving, more affecting, more helpless and in need of protection and love.

November 1922: . . . I know, of course, that I do not achieve pure art [as certain artists do]. But still it is art. Everyone works the way he can. I am content that my art should have purposes outside itself. I would like to exert influence in these times when human beings are so perplexed and in need of help.

New Year's Eve, 1925: Recently I began reading my old diaries. Back to before the war. Gradually I became very depressed. The reason for that is probably that I wrote only when there were obstacles and halts to the flow of life, seldom when everything was smooth and even. So there were at most brief notes when things went well with Hans, but long pages when he lost his balance. And I wrote nothing when Karl and I felt that we belonged intimately to one another and made each other happy; but long pages when we did not harmonize. As I read I distinctly felt what a half-truth a diary presents. Certainly there was truth behind what I wrote; but I set down only one side of life, its hitches and harassments. I put the diaries away with a feeling of relief that I am safely out of those times. Yet they were times which I always think of as the best in my life, the decade from my mid-thirties to my mid-forties. A great many things were very confused in those days. Then came the war and turned everything topsy-turvy. Knocked one down flat on the ground. Half alive and half dead, one crawled in silence, living a humble life drenched with suffering. One rose to one's feet very slowly

indeed. New happiness came with Hans, Ottilie, the babies.[5] Karl was always at my side. And that is a happiness that I have fully realized only in these last years—that he and I are together. Now we are wonderfully fond of one another. He is no longer the same man he once was, as I am no longer the same woman. He has left many things behind him, has grown out of and above them. What has remained is his "innocence," as Sophie Wolff calls it. He has a really innocent heart, and from that comes his wonderful inward joyousness.

February 13, 1927: I can scarcely imagine another art which penetrates so deeply into you as music does. Plastic art is concrete; you are confronted by something definite. But here in the adagio it is *sheer soul.* What I always vaguely envision when I want to do a woman "who sees the suffering of the world." Only looks. No words.

April 16, 1932: . . . Where should I exhibit the figures here in Berlin? . . . I dislike the idea of having them *inside* the Memorial Hall because it has been so taken over by the Right. Left outside they would not be guarded and might be scrawled over with swastikas or damaged.[6]

Easter 1932: For a short time I have once more had that glorious feeling of happiness, that happiness which cannot be compared with anything else, which springs from being able to cope with one's work. What I've had in my best periods—and how short-lived these were. How long were the stretches of toilsome tacking back and forth, of being blocked, of being thrown back again and again. But all that was annulled by the periods when I had my technique in hand and succeeded in doing what I wanted. Now only a faint reflection of all that is left.

And then the unspeakably difficult general predicament. The misery. People sinking into dark wretchedness. The repulsive political hate-campaigns.

[5] *Ottilie, the babies:* The wife and children of her son Hans.
[6] At this point, Kollwitz feared that the Nazis would vandalize her work, to which they were much opposed. Within a few years, they were to remove completely all of her art work from public display.

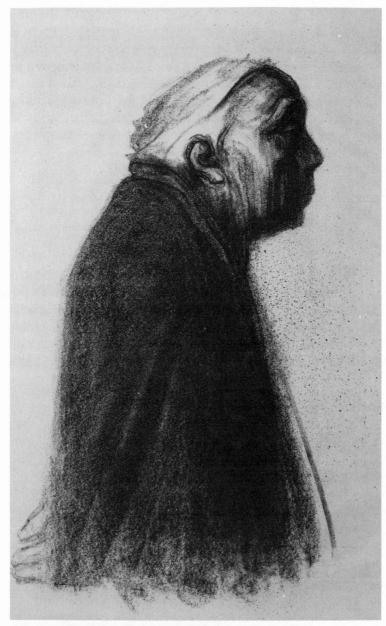

Plate 49. Kaethe Kollwitz. SELF-PORTRAIT, PROFILE, FACING RIGHT, 1938.

From Letters

The following are excerpts from two letters by Kollwitz, to her life-long woman friend Jeep, and to her sister, Lise, written in the last years of her life.

January 1942: Dear Jeep! . . . Today I have finished my lithograph, "Seed for the planting must not be ground."[7] This time the seed for the planting—sixteen-year-old boys—are all around the mother, looking out from under her coat and wanting to break loose. But the old mother who is holding them together says, No! You stay here! For the time being you may play rough-and-tumble with one another. But when you are grown up you must get ready for life, not for war again.

For October 14, 1942: Dear Lise! . . . [Today, on] your birthday, I said I would write to you. And now I don't really know what to write. It was like this when we were one another's best playmates; we knew each other so well, knew all about one another, so that we had little to say. Now too. Our sorrows, our wishes and our hopes are common to both of us. Yours are mine and mine are yours. When one or the other of us is gone, the other will feel a good deal poorer.

Lise, we will hope that we can remain together for a while yet, and experience a few more things that will be a joy to our hearts. . . . Your old Kaethe.

[7] Kollwitz refers here to the lithograph by this title that is reproduced in these pages.

Käthe Kollwitz

By Muriel Rukeyser

*Muriel Rukeyser (1913–) has been described as "among the
great poets of human concern and compassion of our time."
The publication of a collected edition of her poems in 1979
celebrates a career that has spanned five decades and
has included fourteen volumes of poetry and six of prose, plus
translations, pamphlets, and books for children.*

*Born in New York City, Rukeyser began publishing poetry
in her teens. She attended Vassar College and Columbia
University, has taught at several colleges, and has been the
recipient of fellowships, awards and honorary degrees.
Her political concern has paralleled and been interwoven with
her life as a poet and has included reporting in the 1930s
on the Spanish Civil War; participating in the resistance
movement against the war in Vietnam (and being jailed briefly
in 1972); and working for the release of political prisoners
in Greece, Chile and Spain. It has been noted that imagery of
doors, gates, locks, of things shut and broken open, is
persistent in her poetry: two of her volumes are entitled
Breaking Open (1973) and The Gates (1976). Such imagery
conveys her strong sense of the need for creative rebellion, for
unlearning and relearning.*

*Rukeyser's feminism has always been an integral part of her
political and poetic consciousness. Speaking of herself
and of all women, she has said, "I was brought up to be scared,
not to cross the street. We have to unlearn those things."
Two recent anthologies of poetry by women, No More Masks!
and The World Split Open, take their titles from poems
by Rukeyser, signifying the profound influence she exerts on
younger women poets today.[1]*

[1] In the title of the poem printed here, Rukeyser uses the German spelling
Käthe, an alternate to *Kaethe,* more commonly used in English. Both spellings
are correct.

I

Held between wars
my lifetime
 among wars, the big hands of the world of death
my lifetime
listens to yours.

The faces of the sufferers
in the street, in dailiness,
their lives showing
through their bodies
a look as of music
the revolutionary look
that says I am in the world
to change the world
my lifetime
is to love to endure to suffer the music
to set its portrait
up as a sheet of the world
the most moving the most alive
Easter and bone
and Faust walking among the flowers of the world
and the child alive within the living woman, music of man,
and death holding my lifetime between great hands
the hands of enduring life
that suffers the gifts and madness of full life, on earth, in
 our time,
and through my life, through my eyes, through my arms
 and hands
may give the face of this music in portrait waiting for
the unknown person
held in the two hands, you.

II

Woman as gates, saying:
"The process is after all like music,
like the development of a piece of music.

The fugues come back and
 again and again
interweave.
A theme may seem to have been put aside,
but it keeps returning—
the same thing modulated,
somewhat changed in form.
Usually richer.
And it is very good that this is so."[2]

A woman pouring her opposites.
"After all there are happy things in life too.
Why do you show only the dark side?"
"I could not answer this. But I know—
in the beginning my impulse to know
the working life
 had little to do with
pity or sympathy.
 I simply felt
that the life of the workers was beautiful."

She said, "I am groping in the dark."

She said, "When the door opens, of sensuality,
then you will understand it too. The struggle begins.
Never again to be free of it,
often you will feel it to be your enemy.
Sometimes
you will almost suffocate,
such joy it brings."

Saying of her husband: "My wish
is to die after Karl.
I know no person who can love as he can,
with his whole soul.
Often this love has oppressed me;
I wanted to be free.
But often too it has made me
so terribly happy."

[2] These lines and others in quotation marks closely follow passages in Koll-
witz's *Diary and Letters*.

She said: "We rowed over to Carrara at dawn,[3]
climbed up to the marble quarries
and rowed back at night. The drops of water
fell like glittering stars
from our oars."

She said: "As a matter of fact,
I believe
 that bisexuality
is almost a necessary factor
in artistic production; at any rate,
the tinge of masculinity within me
helped me
 in my work."

She said: "The only technique I can still manage.
It's hardly a technique at all, lithography.
In it
 only the essentials count."

A tight-lipped man in a restaurant last night
 saying to me:
"Kollwitz? She's too black-and-white."

III
Held among wars, watching
 all of them
 all these people
 weavers,[4]
 Carmagnole[5]

Looking at
 all of them
 death, the children

[3] *Carrara:* a city in Italy near which Kollwitz vacationed in the summer of 1907
with her family and some friends.
[4] *Weavers* refers to Kollwitz's print cycle *The Revolt of the Weavers* (1893–
1898), a series of six etchings and lithographs depicting a revolt of unemployed
handloom workers in Silesia in the sixteenth century.
[5] *Carmagnole* is a reference to Kollwitz's 1901 etching titled *Carmagnole* or
Dance Around the Guillotine. The carmagnole was a popular song and dance
during the French Revolution.

 patients in waiting-rooms
 famine
 the street
 the corpse with the baby
 floating, on the dark river

A woman seeing
 the violent, inexorable
 movement of nakedness
 and the confession of No
 the confession of great weakness, war,
 all streaming to one son killed, Peter;
 even the son left living; repeated,
 the father, the mother; the grandson
 another Peter killed in another war; firestorm;
 dark, light, as two hands,
 this pole and that pole as the gates.

What would happen if one woman told the truth about
 her life?

The world would split open

IV Song: The Calling-Up
Rumor, stir of ripeness
rising within this girl
sensual blossoming
of meaning, its light and form.

The birth-cry summoning
out of the male, the father
from the warm woman
a mother in response.

The word of death
calls up the fight with stone
wrestle with grief with time
from the material make
an art harder than bronze.

V Self-Portrait

Mouth looking directly at you
eyes in their inwardness looking
directly at you
half light half darkness
woman, strong, German, young artist
flows into
wide sensual mouth meditating
looking right at you
eyes shadowed with brave hand
looking deep at you
flows into
wounded brave mouth
grieving and hooded eyes
alive, German, in her first War
flows into
strength of the worn face
a skein of lines
broods, flows into
mothers among the war graves
bent over death
facing the father
stubborn upon the field
flows into
the marks of her knowing—
Nie Wieder Krieg[6]
repeated in the eyes
flows into
"Seedcorn must not be ground"[7]
and the grooved cheek
lips drawn fine
the down-drawn grief
face of our age
flows into

[6] *Nie Wieder Krieg: Never Again War,* the title of a famous lithograph produced by Kollwitz in 1924 as an anti-war protest.
[7] *"Seedcorn must not be ground":* see graphic bearing this title, p. 257, and Kollwitz *Diary* excerpts.

Pieta, mother and[8]
between her knees
life as her son in death
pouring from the sky of
one more war
flows into
face almost obliterated
hand over the mouth forever
hand over one eye now
the other great eye
closed

[8] *Pieta:* a bronze sculpture, 1937–1938, of a mother holding her dying son in her
lap.

Singing for a New Day

By Holly Near

Born on a cattle ranch in northern California, Holly Near
(1949–) began performing when she was seven, singing in her
community at school events, teas, weddings, and conven-
tions. After a year at the University of California, Los Angeles,
she acted in films and television. During the war in Vietnam
she toured with the F.T.A. (Free the Army) show, a group of
artists who traveled and performed for servicemen and
women opposed to the war and to racism.

Raised on the music of the Weavers, Judy Garland, Edith
Piaf, Aretha Franklin, and the songs and stories of the
labor movement, Near brings to her music a deep commitment
to social change. She has performed at international
meetings against the atom and hydrogen bombs in Hiroshima,
Japan; at the international women's music festival in
Denmark; in concerts throughout the United States; and at
rallies and benefits for the rights of women and minorities,
including women in prison, lesbian/gay organizations,
and support groups for the resistance in Chile.

Increasingly her music has become focused on women's
lives. For this anthology, she has provided the following
statement: "In part, woman identification means to me that I
become aware of the needs of women and I make responding to
those needs a priority. It means I learn to love women in
a world that has taught me to hate women. It means I defend
women. It means I am proud to be a woman. It means
that personally and politically I must always remember I am a
woman and I must live my life from that perspective."

The following are excerpts from an interview Near recently
held with a small, informal group in her home in Ukiah,
California. As is evident here, Near encourages in her
performances an active personal and political response to her
music. She has recorded four albums on her own label,
Redwood Records, including A Live Album, *in which her song*
"It Could Have Been Me" is recorded. One of her sisters,

Laurel Near, is a member of the dance group Wallflower
Order, also included in section 4.

Music! It is so powerful! I try to be careful how I use it. I believe
that as I keep writing/singing about the details of people's lives,
I will be on the right track. Learning to respect and experience
those details, that is the challenge for me. I tour a great deal so
my life isn't really "normal," in that I do not come home every
night after work. I go to someone's home and I have learned to
make it mine for the moment, but it is a different home every
night. This gives me a wonderful opportunity to experience
many different lives while living my own. I kid folks some-
times, "Be careful what you say around a songwriter or it may
end up in a song!" What's so wonderful is, in response to that,
people start talking like crazy!

I don't just write about my own life. I let a multitude of expe-
riences wash through me and then I write a song. Sometimes I
don't even remember where I got the idea. It might have come
from something I experienced years ago and it is just now sur-
facing as a song. Even if the story/song does not come direct
from my own life, the music makes me feel close to it, as if I had
lived it myself.

Audiences—supporters and critics both—have been very help-
ful to me. They let me know when they hink I am on the
wrong track, and when I am being helpful. I get a lot of letters. I
read every line in search of the writers' perceptions. When I am
confused, perhaps I will get clarity. When I am depressed, per-
haps I will get insight. When I am tired, perhaps I will get re-
fueled. And I must admit that if I get an uncaring critical letter,
it really hurts and I have to work hard to let it go. I wonder if
audiences know how powerful they are. I know they often feel
powerless because, although they know the artist through the
artist's work—what does the artist know about them? And the
artist has the stage, the mike, the spotlight. Part of all that is
true. But the audiences have a great deal of power when they
decide to use it. For me, they inspire or make me feel insecure.
They can mold and define my spirit. The concert is a joint effort,

involving everyone who prepares it and participates in it. I love my concerts. On a good night, we all get well fed.

I like it when people acknowledge cultural responsibility. For example, there's a group of women in the Bay Area that got together just to discuss the role of the audience. They talked about how they should react constructively when an artist does something they don't like, how to offer support in both praise and criticism, how to be empowered by a cultural experience rather than diminished by traditional star-is-better-than-thou indoctrination. Most music industry events, I think, perpetuate in audiences a feeling of smallness, helplessness, and unrealistic (and in my mind) undesirable goals.

It doesn't take long to sum up the major theses of most popular music: he loves me; he left me; I need him; I needed him, but now I need his best friend. Rather limited scope. One of the things I suggest to songwriters who are trying to write music about women's lives is to look at the details. Sometimes the most mundane things, when put to poetry, are the very things that can fill our lives with passion, fire, color, and truth. Writers can find the details that reflect the kind of society that we live in, how people are dealing with it, and how we might muster up the energy and the courage to change it. I try to keep my work personal whenever possible to avoid the feeling of distance that often comes with abstractions. We can agree or disagree on concepts, but my mind is not challenged to its full capacity and my energies not pressed to action unless there are specifics I can hold on to.

Linger on the details
The part that reflects the change
There lies revolution
Our everyday lives, the changes inside
Become our political songs[1]

Listen to the songs of Bernice Reagon, Meg Christian, Violetta Para, the poems of Pat Parker. Or go back in time and listen to

[1] From "You Bet," 1978, lyrics by Holly Near, music by Meg Christian, in the album *Imagine My Surprise*.

the songs sung by Edith Piaf. The level of consciousness has changed over the years, but the commitment to life is strong throughout. Remarkable poetry, creating whole worlds and documenting eras in a single song.

Women one by one are beginning to discover the wonders of their lives. There are millions of songs to be written about our growth and failures. Songs that help us weep away grief, loss, sadness. Songs that help us scream our rage, our fears, our nightmares. Songs that support loving and tenderness. Songs t it illuminate our differences, that teach us to acknowledge our bigotries and encourage change. Songs that celebrate our rebirth, our spirituality, our power, our politics, our insight, our instincts, and our vision. Women's music has served to bring some of us together in one place so we can get to know ourselves and each other. We have by no means touched all women nor will we for some time, I admit. It takes a long time to build a culture that represents the true inner spirit of half the population of the world. But we have begun.

All-women's concerts where women's music is presented can fill some important needs. I get a lot of letters from women whose lives have been changed because of a concert. Of course this pleases me and warms my heart. I know that it isn't just the music that has affected us. It is the whole event. The audience in particular plays a strong role—the woman behind us who laughed and cried, the woman in front of us who sang so clearly a beautiful harmony part, the women who strode down the aisles without fear, the women all around, caring about each other. Perhaps up until that moment, we may never have felt the love and support we needed. Sometimes music simply opens the door—the door we were silently pounding on before we came to the concert.

This is why we need more nurturing options and alternatives. We need more open doors. Building alternatives is a massive and challenging task. The sky is the limit. How exciting to say to your imagination, "Go hog wild, honey, 'cause it has never been done before in this time and space, and we will never know if it will work until we try it out." It is like baking a cake

from scratch, with the memory of how it is supposed to taste somewhere in your mouth. For example, when producing a concert we have to ask, "What are the goals, the intentions? Who do we want to reach? How do we want to feel?" These are questions we are seldom forced to answer, since we are TV babies, trained to passivity. We have learned to just turn it on and accept what we get, to be told what our goals, our ideas, our feelings should be. When you're building your own culture, you have to take responsibility yourself, you have to make choices. It is hard to deal with choices, but to have a choice is the greatest feeling in the world.

One of the choices, as I've said, has to do with focus—toward whom, to what purposes, do we want to direct our energies? Sometimes we want to celebrate a particular part of our lives— for example, in women-only concerts, Native American solidarity gatherings, Gay Pride parades, Gray Panther meetings. Other times, an event is presented in order to introduce the life-style and issues of a group to a larger audience. This is often called "outreach." It could include anything from a big community picnic on July Fourth to a teeth-gritting appearance on the Johnny Carson show. Choices. Hard, but I'd rather have them than not. I like to work on many levels, and the key for me is to be sure we are building a culture that is respectful, challenging, exciting, entertaining, thought-provoking, energizing, and fun!

I know that censorship is a big issue in people's minds when discussing art. I think every country has censorship to some degree. When I visited Vietnam, I heard artists discussing the same issue, the issue of artistic freedom. They were arguing over the validity of abstract art in that time when the war was raging and hardship prevailed. One artist felt that to restrict abstract artists would be dangerous censorship. Another felt that with a shortage of supplies (paper, paint, and musical instruments were hard to come by), the artist must be responsible for using the materials in a way that met the needs of the most people. She felt that abstract art is only appreciated by a few, that many people were made to feel dumb in the presence of

abstract art, and that in a time when people needed lots of support for their courage, creativity, and endurance, it was not fair to use supplies for art that did not help them.

People believe that we have artistic freedom here. But no societal systems are neutral about art. Look at it closely. Men in power have the freedom to get richer (and more powerful) through the expression of violence against women in art, commercials, movies, and music. Women's response to that is, in effect, censored, because we don't have control over or access to the money and technology that would make it possible for us to present our response to the same number of viewers/listeners. We present a concert and 3000 people come, so they say we have artistic freedom. But had we been able to present such a concert on prime-time TV, we might have affected millions. It is important that such programs as *Roots* have been viewed by huge numbers of people, bringing the issue of racism into every home in America.[2] But it is once a year. It is not an example of what most of the people, most of the time, have an oporunity to see, hear, or experience. The culture to which most people are exposed is controlled by those who are white, male, upper-class, and profit-oriented; and it reflects their interests and their values. Are there any lesbian love songs on the radio? No. Is it because they haven't been recorded and submitted to stations; is it because there is no audience for them? No; there are twenty million gay people in the U.S. alone. It is because of censorship—the censorship that comes about through the control of programming by those who have the money and the power to control it. If we get a few crumbs of cultural diversity (as in *Roots*) they are still dependent on the same sources: the wealthy foundations, or the big corporations seeking profit and credit for being supporters of culture.

We are bombarded with cultural ideas that do not represent our lives. To me, a representative culture does not mean the

[2] *Roots* portrayed the history of a Black family, from its origins in Africa, to enslavement in the United States, and through its subsequent fortunes into contemporary times. The story was presented in two dramatically complete segments—the first in 1977, the second in 1978—each serialized nightly on television for a period of one week, during prime viewing time.

melting pot. I fight that idea. I prefer that there be many strong, real cultures that live and breathe—not one idealized white, middle-class soup. But most artists who do not fit into the system have to work long, full-time jobs and try to find time and energy to create on the side, working late into the night to discover their own culture, to preserve their own souls. And then all of us, who need a living, breathing culture, tend to fall under the weight of this, submitting to whatever we can get—which is very little when you consider what we are putting into this society through our labor.

We do not always have the freedom we need, the tools and the time we need, the clear minds we need, to produce or to become really great artists. But I look around at women who are committed to improving the quality of life, many of whom are incorporating music into their work wherever they may be around the world, and I wonder what it is that draws me to them, what strong bond, what common yet unspoken (perhaps even unimagined) vision do we share? With each experience, with each song, a little more of the answer shines through. Our effort is filled with painful failures, remarkable lessons, and great celebration. In my lifetime I will never see the end, never see the whole picture. But I'm fine with that. If I don't have a bird's-eye view, at least I have a bug's-eye view—and it's worth having!

It Could Have Been Me

In May, 1970, students at Kent State University in Ohio were protesting the United States' invasion of Cambodia when members of the Ohio National Guard who had been brought in to keep order fired on the crowd, killing four students. In the same month, students at Jackson State College in Mississippi who were similarly protesting were fired upon by the police, and two students were killed. Holly Near wrote the following song in 1974, when 10,000 people gathered at Kent State to protest that the war in Southeast Asia was still not ended.

CHORUS (use "work")

It could have been me but instead it was you,
So I'll keep doing the work you were doing as if I were two,
I'll be a student of life, a singer of songs,
a farmer of food and a righter of wrong,
It could have been me but instead it was you,
And it may be me dear sisters and brothers before we are
 through,
But if you can (work, die, sing, live) for freedom, freedom,
 freedom, freedom,
If you can (work, die, sing, live) for freedom I can too.

1. Students in our country at Kent and Jackson State,
Shot down by a vicious fire one early day in May,
Some people cried out angry, "You should have shot more of
 them down,"
But you can't bury youth my friend, we grow the whole world
 round.
CHORUS (use "die")

2. The junta took the fingers from Victor Jara's hands,
They said to the gentle poet, "Play your guitar now if you can,"
Well Victor started singing until they shot his body down,
You can kill that man but not his song when it's sung the
 whole world round.[3]
CHORUS (use "sing")

3. A woman in the jungle so many wars away,
studies late into the night, defends her village in the day,
Although her skin is golden like mine will never be,
Her song is heard I know the words and I'll sing them till
 she's free.[4]
CHORUS (use "live")

[3] *Victor Jara:* Victor Jara was one of Chile's most popular folk singers. In September 1973, in Santiago, he and 6,000 others, primarily university students, were held prisoners for three days by the military, who were engaged in overthrowing the liberal constitutional government of Socialist President Salvador Allende. Large numbers of students were killed. Jara's fingers were chopped off with an axe, and he was then machine-gunned to death.
[4] *A woman in the jungle* refers to Vietnam.

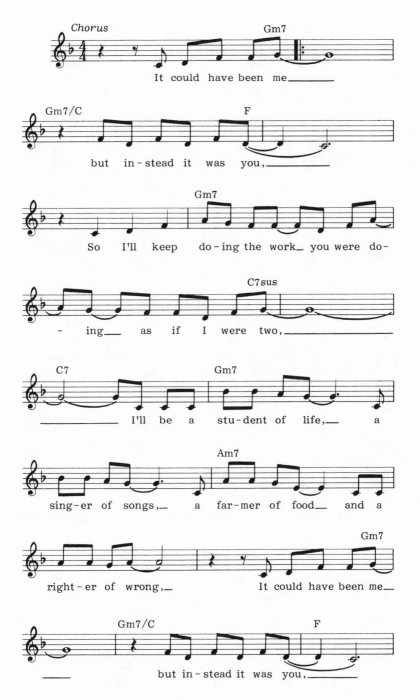

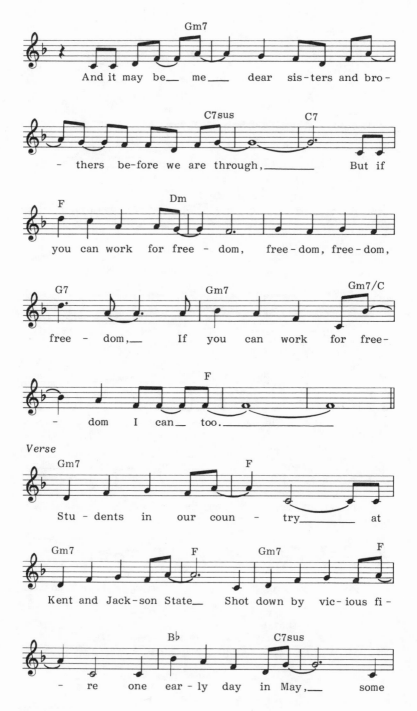

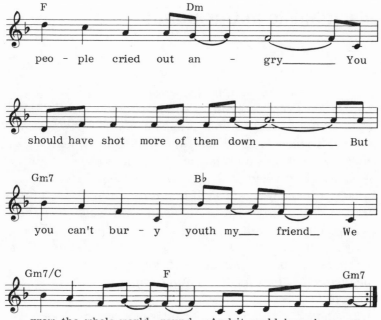

peo - ple cried out an - gry____ You

should have shot more of them down_____ But

you can't bur - y youth my___ friend___ We

grow the whole world_ round._ And it could have been me__

Black Music in Our Hands

By Bernice Reagon

*Song writer, performer, music historian, and political activist,
Bernice Reagon grew up in Albany, Georgia, amid the gospel
music of the Baptist Church. As she explains in her essay,
her involvement in the Black Civil Rights movement of
the 1960s, when she was one of the original Freedom Singers
of the Student Nonviolent Coordinating Committee (SNCC),
"changed my view of music." The ability of music to unite
people in common political, economic, and social awareness,
to convey the story of a people's struggles, and to make
those not present "feel the intensity of what was happening in
the south" eventually led her to devote herself to researching
the history of Black music, and to composing and performing
songs of her own.*

*Expelled from Albany State College for her involvement in
SNCC, she transferred to Spelman College in Atlanta,
where she studied Black history and music and graduated in
1969. She further pursued her studies in oral history at
Howard University, from which she received a Ph.D. in 1975.
Reagon currently lives with her daughter and son in Wash-
ington, D.C., where she is consultant and field researcher in
Black music for the Smithsonian Institution. Her work has led
to extensive travels in Africa, Haiti, and the United States
to collect materials on Black music and culture, some of which
have been presented at the annual Smithsonian summer
folk festivals. She is also oral director of the D.C. Black
Repertory Company, for which she has written a musical
narrative and a songtalk; and she performs with a group of five
Black women, Sweet Honey in the Rock, which she or-
ganized. Her recordings, which include* Songs of the South
(Folkways, 1964) and Give Your Hands to Struggle *(Paredon,
1975), show her continued involvement in the Black
liberation movement, and in similar movements in all parts
of the world.*

In Our Hands:
Thoughts on Black Music

In the early 1960s, I was in college at Albany State. My major interests were music and biology. In music I was a contralto soloist with the choir, studying Italian arias and German lieder. The Black music I sang was of three types:

1) Spirituals sung by the college choir. These were arranged by such people as Nathaniel Dett and William Dawson and had major injections of European musical harmony and composition. 2) Rhythm 'n' Blues, music done by and for Blacks in social settings. This included the music of bands at proms, juke boxes, and football game songs. 3) Church music; gospel was a major part of Black church music by the time I was in college. I was a soloist with the gospel choir.

Prior to the gospel choir, introduced in my church when I was twelve, was many years' experience with unaccompanied music—Black choral singing, hymns, lined out by strong song leaders with full, powerful, richly ornate congregational responses. These hymns were offset by upbeat, clapping call-and-response songs.

I saw people in church sing and pray until they shouted. I knew *that* music as a part of a cultural expression that was powerful enough to take people from their conscious selves to a place where the physical and intellectual being worked in harmony with the spirit. I enjoyed and needed that experience. The music of the church was an integral part of the cultural world into which I was born.

Outside of church, I saw music as good, powerful sounds you made or listened to. Rhythm and blues—you danced to; music of the college choir—you clapped after the number was finished.

The Civil Rights Movement changed my view of music. It was after my first march. I began to sing a song and in the course of singing changed the song so that it made sense for that particular moment. Although I was not consciously aware of it, this was one of my earliest experiences with how my music was supposed to *function*. This music was to be integrative of and

consistent with everything I was doing at that time; it was to be
tied to activities that went beyond artistic affairs such as con-
certs, dances, and church meetings.

The next level of awareness came while in jail. I had grown up
in a rural area outside the city limits, riding a bus to public
school or driving to college. My life had been a pretty consistent,
balanced blend of church, school, and proper upbringing. I was
aware of a Black educated class that taught me in high school
and college, of taxi cabs I never rode in, and of people who used
buses I never boarded. I went to school with their children.

In jail with me were all these people. All ages. In my section
were women from about thirteen to eighty years old. Minis-
ters' wives and teachers and teachers' wives who had only
nodded at me or clapped at a concert or spoken to my mother.
A few people from my classes. A large number of people who
rode the segregated city buses. One or two women who had
been drinking along the two-block stretch of Little Harlem as
the march went by. Very quickly, clashes arose: around age,
who would have authority, what was proper behavior?

The Albany Movement was already a singing movement
and we took the songs to jail. There the songs I had sung because
they made me feel good or because they said what I thought
about a specific issue did something. I would start a song and
everybody would join in. After the song, the differences among
us would not be as great. Somehow, making a song required an
expression of that which was common to us all. The songs did
not feel like the same songs I had sung in college. This music
was like an instrument, like holding a tool in your hand.

I found that although I was younger than many of the women
in my section of the jail, I was asked to take on leadership roles.
First as a song leader and then in most other matters concern-
in the group, especially in discussions, or when speaking with
prison officials.

I fell in love with that kind of music. I saw that to define
music as something you listen to, something that pleases you,
is very different from defining it as an instrument with which
you can drive a point. In both instances, you can have the same

song. But using it as an instrument makes it a different kind of music.

The next level of awareness occurred during the first mass meeting after my release from jail. I was asked to lead the song that I had changed after the first march. When I opened my mouth and began to sing, there was a force and power within myself I had never heard before. Somehow this music—music I could use as an instrument to do things with, music that was mine to shape and change so that it made the statement I needed to make— released a kind of power and required a level of concentrated energy I did not know I had. I liked the feeling.

For several years, I worked with the Movement eventually doing Civil Rights songs with the Freedom Singers. The Freedom Singers used the songs, interspersed with narrative, to convey the story of the Civil Rights Movement's struggles. The songs were more powerful than spoken conversation. They became a major way of making people who were not on the scene feel the intensity of what was happening in the south. Hopefully, they would move people to take a stand, to organize support groups or participate in the various projects.

The Georgia Sea Island Singers, whom I first heard at the Newport Festival, were a major link. Bessie Jones, coming from within twenty miles of Albany, Georgia, had a repertoire and song-leading style I recognized from the churches I had grown up in. She, along with John Davis, would talk about songs that Black people had sung as slaves and what those songs meant in terms of their struggle to be free. The songs did not sound like the spirituals I had sung in college choirs; they sounded like the songs I had grown up with in church. There I had been told the songs had to do with worship of Jesus Christ.

The next few years I spent focusing on three components: 1) The music I had found in the Civil Rights Movement. 2) Songs of the Georgia Sea Island Singers and other traditional groups, and the ways in which those songs were linked to the struggles of Black peoples at earlier times. 3) Songs of the church that now sounded like those traditional songs, and came close to having, for many people, the same kind of freeing power.

There was another experience that helped to shape my present day use of music. After getting out of jail, the mother of the church my father pastored was at the mass meeting. She prayed, a prayer I had heard hundreds of times. I had focused on its sound, tune, rhythm, chant, whether the moans came at the proper pace and intensity. That morning I heard every word that she said. She did not have to change one word of a prayer she had been praying for much of her Christian life for me to know she was addressing the issues we were facing at that moment. More than her personal prayer, it felt like an analysis of the Albany, Georgia Black community.

My collection, study, and creation of Black music has been, to a large extent, about freeing the sounds and the words and the messages from casings in which they have been put, about hearing clearly what the music has to say about Black people and their struggle.

When I first began to search, I looked for what was then being called folk music, rather than for other Black forms, such as jazz, rhythm and blues, or gospel. It slowly dawned on me that during the Movement we had used all those forms. When we were relaxing in the office, we made up songs using popular rhythm and blues tunes; songs based in rhythm and blues also came out of jails, especially from the sit-in movement and the march to Selma, Alabama. "Oh Wallace, You Never Can Jail Us All" is an example from Selma. "You Better Leave Segregation Alone" came out of the Nashville Freedom Rides and was based on a bit by Little Willie John, "You Better Leave My Kitten Alone". Gospel choirs became the major musical vehicle in the urban center of Birmingham, with the choir led by Carlton Reese. There was also a gospel choir in the Chicago work, as well as an instrumental ensemble led by Ben Branch.

Jazz had not been a strong part of my musical life. I began to hear it as I traveled north. Thelonious Monk and Charlie Mingus played on the first SNCC benefit at Carnegie Hall. I heard of and then heard Coltrane. Then I began to pick up the pieces that had been laid by Charlie Parker and Coleman Hawkins and whole lifetimes of music. This music had no words. But, it had power, intensity and movement under various degrees of pres-

sure; it had vocal texture and color. I could feel that the music knew how it felt to be Black and Angry. Black and Down, Black and Loved, Black and Fighting.

I now believe that Black music exists in every place where Black people run, every corner where they live, every level on which they struggle. We have been here a long while, in many situations. It takes all that we have created to sing our song. I believe that Black musicians/artists have a responsibility to be conscious of their world and to let their consciousness be heard in their songs.

And we need it all—blues, gospel, ballads, children's games, dance, rhythms, jazz, lovesongs, topical songs—doing what it has always done. We need Black music that functions in relation to the people and community who provide the nurturing compost that makes its creation and continuation possible.

There's a New World Coming

Drawing upon the "nurturing compost" of Black culture, Bernice Reagon's music reflects a breadth of political and social concerns. When, in April, 1975, despite continuing United States involvement, the Vietnamese people succeeded in bringing the war to an end, Reagon was inspired to write the song that follows, in which she relates the struggle of the Vietnamese to that of oppressed people everywhere.

CHORUS:
There's a new world coming!
Everything's gon' be turning over
Everything's gon' be turning over
Where you gon' be standing when it comes? (Repeat CHORUS)

VERSE 1:
For far too many years
I been marching, singing and talking
Doing things I thought would make me free
While people halfway around the world
They been fighting, dying and bleeding
And now it seems that they are gonna be! (CHORUS)

VERSE 2:

You know the book, The Bible?
You read it and you will see
It will surely come to pass
This is how it's gonna be:
Those that were meek and humble
Would come to gain the earth
Them that shuddered at the bottom
Would rise and rule the world! (CHORUS)

VERSE 3:

The nations of Asia and Africa
They're taking over their lives
The sisters and brothers south of us
Are finally gettin' wise
Then take a look, United States
Of the North American clime
With your strange mixture of wealth and hate
You won't be exempt this time! (CHORUS twice)

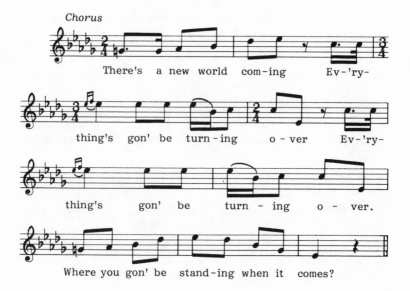

Chorus

There's a new world com-ing Ev-'ry-
thing's gon' be turn-ing o-ver Ev-'ry-
thing's gon' be turn-ing o-ver.
Where you gon' be stand-ing when it comes?

Verse I

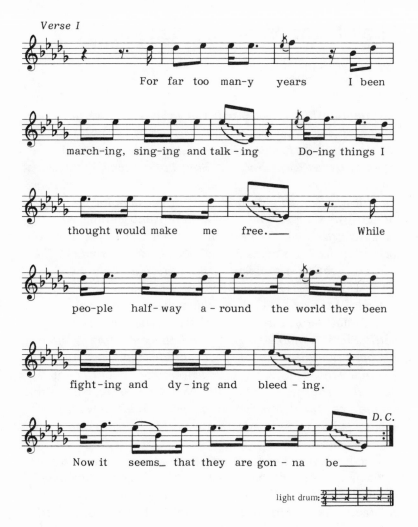

For far too man-y years I been

march-ing, sing-ing and talk-ing Do-ing things I

thought would make me free.___ While

peo-ple half-way a-round the world they been

fight-ing and dy-ing and bleed-ing.

Now it seems_ that they are gon-na be___

light drum:

The Liberation of Aunt Jemima

By Betye Saar

*The relationship between redefining the self, as we have seen
women doing in section 3, and discovering the political
dimension of such redefinition, is especially apparent in the
work of Betye Saar (1926–). Born in Pasadena, California,
and living now in Los Angeles, Saar has worked in painting,
graphics design, collage, and three-dimensional assemblages
or "boxes," such as* The Liberation of Aunt Jemima. *As a
graphics artist Saar had been interested in the mystical and the
occult, using Tarot cards and zodiac signs in her work. The
Black liberation movement of the sixties, and her own
anger at what was happening to Black people, led her to create
a series of satirical pieces in which she redefined such
traditional, derogatory images of Black people as pickaninnies,
Little Black Sambo, and Aunt Jemima, converting symbols
of oppression into symbols of revolution. Thus, her Aunt
Jemima, still wearing the headgear and apron of the house
servant, is equipped with a rifle and a revolver. Saar sees Aunt
Jemima as "the figure that [traditionally] classifies all Black
women," but whose strength always lay beneath her
subservience.*

*In her art Saar has been interested in exploring both the
African and the American roots of Black culture. She has
created collages out of materials, such as bones and feathers,
related to secret African tribal rituals; and she has created
others that use old photographs, pieces of clothing and jewelry,
seeds, and flower petals to evoke both the personal and the
collective history of Black American women.*

*Saar is the mother of three daughters. Her work has been
recognized in a one-woman show at the Whitney Museum
of American Art in 1975 and in many other exhibitions.*

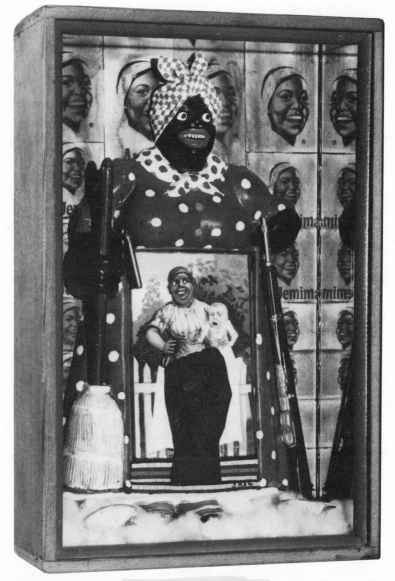

Plate 50. Betye Saar. THE LIBERATION OF AUNT JEMIMA. Mixed media, 11¾ × 8 × 2¾ in. 1972.

Wall of Respect for Women

By the Lower East Side Collective

Since the late 1960s, there has been a renaissance of interest and activity in mural art in the United States. Mural art can be traced back through Western culture to the wall decorations of Greek and Roman houses and public buildings or to the work of such artists as Giotto in thirteenth-century Italy. Certain countries, such as Mexico, have had a long tradition of mural art. In the depression years of the 1930s in the United States, the Federal Arts Project provided government funds for the creation of vast numbers of murals in such public buildings as post offices and city halls. The current activity in mural painting, however, is primarily a grass-roots movement of local community groups, and especially of blue-collar and racially-mixed urban groups.

The Lower East Side Collective in New York City is such a group, and its purposes in creating both the Wall of Respect for Women *and two other murals which it painted in 1974 and 1975 are typical of other mural groups throughout the country. Such purposes include creating works of art that are relevant to the lives of both the artists and the people in the community; helping to discover and train young and unknown artists; and promoting community pride. Mural art is above all a public art. The art object is not hidden away behind museum walls, but is part of a public space. As a public art, it aims to be a "people's art," and its subject matter deals directly with the realities of community life. Women and men are shown working, both at home and at paid jobs; and the imagery of the murals expresses the struggles and hopes of the people portrayed, as well as their history and culture as racial and ethnic groups.*

Mural art by women in such collectives as the Lower East Side Collective is also likely to have, as more specific aims, the depiction of the struggles of women for equality, the need for all women to unite in this struggle, and the celebration of the past and present achievements of women. In the Wall of Respect *women are shown sewing, doing laundry,*

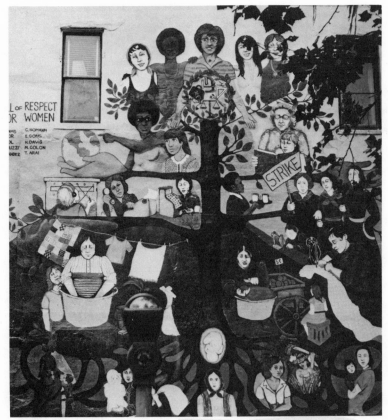

Plate 51. Lower East Side Collective. WALL OF RESPECT FOR WOMEN. 1974–1975.

caring for children, working in sweatshops, and protesting against injustices. Their struggle for equality, however, is seen as part of a larger struggle. "The symbol of the woman pointing to the globe was our way of expressing that the women's fight for equality is part of the greater struggle of all people in the world for their basic human rights," explains Tomie Arai, the artist who supervised work on the mural as project director for the Cityarts Workshop, a community resource organization. The women in the mural are Asian, Black, Puerto Rican, Jewish, and Italian, as are the artists themselves: Tomie Arai, Mercedes Colon, Harriet Davis, Eleanor Gong, A. Hernandez, Cami Homann, Nadine Jannuzzi, Phyllis Seebol, Carol Taylor, and Loretta Williams.

Collections for Her-Story: O

By Wallflower Order

Wallflower Order began with four women, all of whom had studied dance at the University of Oregon in Eugene. In 1975, they formed the Wallflower Order Collective, still based in Eugene, and now numbering five dancers and a composer. Although their main emphasis is on dance—they are trained in ballet, modern, and jazz dance, and have recently added the martial art Ch'aun Fa Kung-Fu to their dance movement— they also incorporate theater and original music into their work. The performance pieces that result are a combination of dance, theater, poetry, and song. The content of the pieces is often personal, arising from the life experiences of the members and from their relationships with each other.

Being a collective is important to Wallflower Order. It means six opinions coming together to form a synthesis; it also means that they direct themselves, rather than working under a separate director. Basic to Wallflower Order's approach are workshops in which each member is encouraged

Plate 52. Wallflower Order. COLLECTIONS FOR HER-STORY: O. 1977.

Photo, Jane Gibbons. Courtesy, Wallflower Order.

to develop her own talents and to take responsibility both
for herself and for the group as a whole. In their workshops on
movement, participants work with partners and in groups
to explore and express their feelings through dance movement.
Ideas and feelings are also shared in the discussion work-
shops. Wallflower Order sees its audience (as Holly Near sees
hers) as vital to its creative health and growth. Audience
questioning and criticism of the group's politics, beliefs,
and work process often lead to fresh artistic expression and to a
more conscious articulation of the collective's ideas and
philosophy.

The two photographs reproduced here are from scenes in
Wallflower Order's 1977 show, Collections for Her-Story,
which toured the United States. The group has said of the
background of this performance: "Women and their events
are conspicuously missing from books and tales of history. . . .
In putting together this concert we read factual accounts
as well as myths and legends that must help to fill in the
missing pages of lost or forgotten herstory. As each member of
the collective explored her past, we collectively discovered
our [own] herstory and our visions for the future. We took this
material and have presented it imagistically through our

Plate 53. Wallflower Order. COLLECTIONS FOR HER-STORY: O. 1977.

dances in an attempt to recreate and visualize women's events and evolution."

Collections for Her-Story *was a sequence of fourteen pieces, pivoting on the eighth, or transition dance, "O." Preceded by dances which showed "the drudgery of working women, the boredom . . . of upper-class women, and the frustration of women in 'boxes,' " "O" focused on the unifying energies of women. "The dancers, by giving birth to themselves, come forth from self-absorption into the commonality of woman-hood." Blue-green, sack-like costumes enclosing the dancers' entire bodies create movements and shapes suggestive of such images as waves, larvae, butterflies, and birds. "We begin the piece by lying on the floor, undulating in waves. The waves become rolls and up into spins. We begin to circle around the floor, passing each other in a cluster of spinning, flapping blue wings, building the intensity to a climax. As we cluster in a circle facing each other, our breath and our new blue bodies melt together . . . as the lights fade."*

The women who created and performed Collections *are: Alex Dunnette, Kris Keefer, Laurel Near, Lyn Neeley, and Linda Schur, dancers; and Susie Milleman, musician.*

The Dinner Party

By Judy Chicago and The Dinner Party Project

*See page 163 for biographical note on Judy Chicago. Between
1974 and 1979, Judy Chicago and a group of co-workers,
which over the five years included approximately 400, created
in a Santa Monica studio a multi-media art work which
commemorates and celebrates the long history of women, their
art and their achievements in Western civilization. The
idea for the project originated when Chicago, attending an
academic dinner where the men professors did all the talking,
"started thinking that women have never had a Last
Supper but they have had dinner parties. Lots and lots of dinner
parties where they facilitated conversation and nourished
the people." This idea subsequently grew into an art work of
spectacular size and scope. A triangular table, measuring
46½ feet on each side, bears 39 place settings, each with an
individually-designed fabric runner and plate, and each
representing an important woman from myth or history. The
women thus symbolized range from the early mother
goddess Gaea and an Egyptian pharaoh, through such well-
known women as Sappho, Queen Elizabeth I, Susan B.
Anthony, and Virginia Woolf, to the contemporary American
painter Georgia O'Keeffe. The table, in turn, rests on a
porcelain-tiled floor on which are inscribed in gold the names
of 999 other women. This room-sized sculpture, together
with videotapes, films, and photographs of the history of the
project, had its opening exhibition at the San Francisco
Museum of Modern Art in the spring of 1979.*

*In the course of creating the project, Chicago and her
co-workers researched the lives of over 3000 women. Often
balked by the lack of information available in standard
reference books and by the general absence of any historical
context for women, they themselves began to create that
context through their research. The elaborately worked table
runners are one outcome of that research. Each reproduces the*
(text continued on page 298)

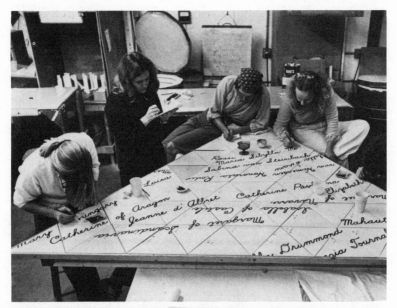

Plate 54. The Dinner Party Project. PREPARATION OF FLOOR TILES. 1979.

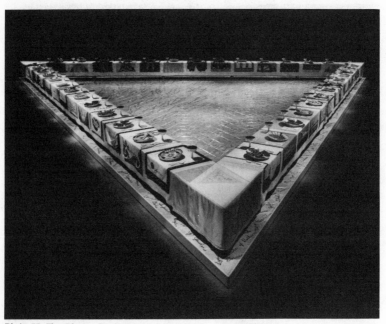

Plate 55. The Dinner Party Project. THE DINNER PARTY. 1979.

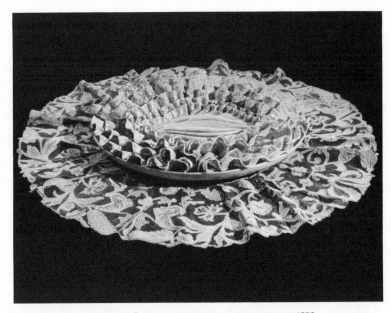

Plate 56. Judy Chicago. EMILY DICKINSON PLATE ON HEIRLOOM LACE. 1979.

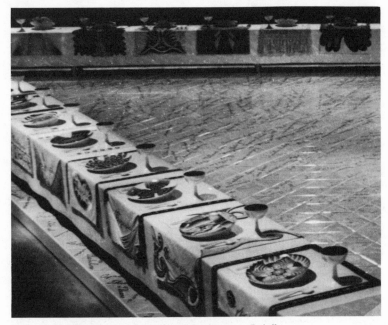

Plate 57. The Dinner Party Project. THE DINNER PARTY. Detail.

(text continued from page 295)
needlework techniques, stitches, and fabric most appropriate
to the historical period and class of the woman being
represented.

The china plates, all designed by Judy Chicago, are intricate
and highly-tooled works of art. To create them, Chicago
learned the traditional female art of china painting and
also spent two years making test plates. Each plate is fired six
to eight times, as different layers of color are added. The
Emily Dickinson plate, pictured here, includes real lace
which has been dipped in liquid ceramic and fired.
The layers of "immobile lace" represent the Victorian
tradition from which Dickinson struggled to free herself; the
plate's center in incongruously "thick," representing the
poet's strength.

The project is the most ambitious enterprise to date in Judy
Chicago's career as an artist. Working alone on the project
for the first two years, she continued throughout to lead and
inspire it. But The Dinner Party, whose costs amounted to over
$150,000, would not exist without the skills of the many
artists who contributed to it as ceramicists, needleworkers,
weavers, and researchers. It is an example of cooperative
and communal work which at one and the same time recreates
and gives to women their own cultural heritage, and makes,
through its strong visual impact, an important artistic
and political statement. In its recognition of the importance of
the household arts to women, of the obstacles women
have faced both in creating art and in receiving recognition for
their work, and in its revelation of the continuous history
of women's achievement, The Dinner Party encompasses
many of the concerns of this book.

The artists gilding names for the floor tiles of The Dinner
Party in the photograph on page 296 are, left to right, Betsy
Quayle, Kathleen Schneider, Audrey Wallace, Judye Keyes
and Ann Isolde.

Your Small Hands

By Adrienne Rich

See page 159 for biographical information on Adrienne Rich. In 1974, Rich won the National Book Award with Diving into the Wreck, *a collection which reflected her sense of living in a time of violence and division. In this volume and others over the previous decade, she had also increasingly identified herself with women and the needs of women. In 1976, she published* Of Woman Born: Motherhood as Experience and Institution, *a prose study of the history of motherhood in our culture. And in 1978, she published* The Dream of a Common Language, *a collection of poems focused on women and their relationships to each other as mothers, daughters, sisters, lovers, and friends, as well as "spirit-sisters of a collective past and future." "Your small hands," which is from that book, speaks of the actual strengths of women past and present, and of their potential for achievements in the future, using the imagery of hands that can be found also in the work of Kollwitz and Rukeyser. Writing out of her continuing awareness of living in a strife-ridden world, Rich ends this poem with a vision of the total abolition of violence in the hands of women.*

Your small hands, precisely equal to my own—
only the thumb is larger, longer—in these hands
I could trust the world, or in many hands like these,
handling power-tools or steering wheel
or touching a human face. . . . Such hands could turn
the unborn child rightways in the birth canal
or pilot the exploratory rescue-ship
through icebergs, or piece together
the fine, needle-like sherds of a great krater-cup[1]
bearing on its sides

[1] *Krater-cup:* A large bowl or vessel, usually for mixing wine and water, often decorated on the outside, as in this poem, with scenes of religious or social significance. (Also spelled *crater.*)

figures of ecstatic women striding
to the sibyl's den[2] or the Eleusinian cave—[3]
such hands might carry out an unavoidable violence
with such restraint, with such a grasp
of the range and limits of violence
that violence ever after would be obsolete.

[2] *Sibyl:* A woman prophet or oracle in ancient Greece or Rome.
[3] *Eleusinian cave:* In Eleusis in Greece an annual spring religious festival cele-brated the reunion of the goddess Demeter with her daughter Persephone, re-turned from the underworld. Persephone's return symbolized the rebirth of the vegetation in spring after its winter death. Demeter and Persephone were thus goddesses of birth and rebirth and of fertility.

Wherever

By Muriel Rukeyser

See page 262 for biographical information on Muriel Rukeyser.
The poem that follows is from her 1973 collection, Breaking
Open. *In its simple statement of the artist's social aims,*
"Wherever" speaks for the creative spirit of protest motivating
all of the artists in this section, as well as to the creative
spirit in every person.

Wherever
we walk
we will make

Wherever
we protest
we will go planting

Make poems
seed grass
feed a child growing
build a house
Whatever we stand against
We will stand feeding and seeding

Wherever
I walk
I will make

About the Authors

ELAINE HEDGES is professor of English and coordinator of women's studies at Towson State University in Baltimore. She received her Ph.D. in literature from Harvard University. For the past decade, she has been active in the women's movement, and in 1972–1973 chaired the Commission on the Status of Women of the Modern Language Association. She has published articles on women's studies and on nineteenth-century American fiction and architecture; and her books include an edition of Charlotte Perkins Gilman's *The Yellow Wallpaper* and an anthology, *Land and Imagination: The American Rural Dream.*

INGRID WENDT took the master of fine arts degree at the University of Oregon, where she was recipient of the Neuberger Award in Poetry. Her poems have appeared in numerous journals, including *Calyx, Feminist Studies, West Coast Review,* and *San Jose Studies,* and have been included in *No More Masks!, Intro 1,* and other anthologies. Her collected poems are being published in a volume titled *Moving the House.* At present, she teaches poetry writing under the sponsorship of the Oregon Arts Foundation as writer-in-residence in twenty-seven public schools of Eugene, Oregon.

A Note on Language

IN EDITING BOOKS, The Feminist Press attempts to eliminate harmful sex and race bias inherent in the language. In order to retain the authenticity of historical and literary documents, however, our policy is to leave their original language unaltered. We recognize that the task of changing language usage is extremely complex and that it will not be easily accomplished. The process is an ongoing one that we share with many others concerned with the relationship between a humane language and a more humane world.

Index

Page numbers in italics refer to plates and illustrations.

Grateful acknowledgment is made for permission to reprint the following material:

Joan Aleshire, "Exhibition of Women Artists (1790–1900)." "Exhibition of Women Artists" first appeared in *13th Moon*, vol. lV, no. 1 © 1978. Used by permission of *13th Moon* and Joan Aleshire.

Bethami Auerbach, "The Search for the Perfect Rye Bread." Copyright © 1977 by Bethami Auerbach. Permission of Bethami Auerbach.

Ellen Bass, "You do not know the breaking through." From *Of Separateness & Merging* by Ellen Bass, Autumn Press, Inc. Copyright © 1977 by Ellen Bass. Reprinted by permission of the author.

Hortense Calisher, "The Rabbi's Daughter." From *The Collected Stories of Hortense Calisher*. Copyright © 1953 by Hortense Calisher. Reprinted by permission of the author.

Olivia Evey Chapa, "Getting a Start," and "Knowing Who You Are." Excerpted from "Entrevista con Carmen Lomas Garza, Chicana Artist," *Tejidos*, III:4, 1976. Copyright © 1976 by Olivia Evey Chapa. Permission of Olivia Evey Chapa.

Lucille Clifton, "Turning." From *An Ordinary Woman* by Lucille Clifton. Copyright © 1974 by Lucille Clifton. Reprinted by permission of Random House, Inc.

Emily Dickinson, letters. From *The Letters of Emily Dickinson*, Thomas H. Johnson, ed., 1958. Reprinted by permission of the Belknap Press of Harvard University Press.

T. W. Higginson, letters on Emily Dickinson. From *The Letters of Emily Dickinson*, Thomas H. Johnson, ed., 1958, The Belknap Press of Harvard University Press. Reprinted by permission of The Public Library of the City of Boston.

Emily Dickinson, poems. "Some keep the Sabbath going to Church"; "She rose to His Requirement—dropt"; "This is my letter to the World." From *The Poems of Emily Dickinson* edited by Thomas H. Johnson. Cambridge, Mass.: Harvard University Press, 1955. "They shut me up in Prose"; "I dwell in Possibility"; "I'm ceded—I've stopped being Theirs"; "I think I was enchanted." From *The Poems of Emily Dickinson* edited by Thomas H. Johnson. Cambridge, Mass.: The Belknap Press of Harvard University Press. Copyright © 1951, 1955 by the President and Fellows of Harvard College. Reprinted by permission of the publishers and the Trustees of Amherst College. "They shut me up in Prose"; "I dwell in Possibility"; "I think I was enchanted." Copyright © 1935 by Martha Dickinson. Copyright © 1963 by Mary L. Hampson. *Complete Poems of Emily Dickinson* edited by Thomas H. Johnson. Reprinted by permission of Little, Brown and Co.

Kathleen Fraser, "Poem in Which My Legs Are Accepted." From *The Young American Poets*, copyright © 1968 by Follett Publishing Company. Reprinted by permission of the author.

Susan Griffin, "This Is the Story of the Day in the Life of a Woman Trying." From *Like the Iris of an Eye* by Susan Griffin, 1976. Reprinted by permission of Harper & Row, Publishers. Copyright © 1976 by Susan Griffin.

Elaine Hedges, "Quilts and Women's Culture." Copyright © 1977, 1978 by Elaine Hedges.

Erica Jong, "The Artist as Housewife." Excerpted from "The Artist as Housewife," *Ms.*, Dec. 1972. Copyright © by Ms. Magazine Corporation. Reprinted by permission of *Ms.*

Kaethe Kollwitz, "The Early Years," "From Her Diary," "From Letters." Excerpted from *The Diary and Letters of Kaethe Kollwitz*, ed. by Hans Kollwitz, trans. by Richard and Clara Winston. Copyright © 1955 by Henry Regnery Company, Chicago. Reprinted by permission of Arne Kollwitz.

Lisel Mueller, "A Nude by Edward Hopper." Originally appeared in *Poetry*. Copyright © 1967 by The Modern Poetry Association. Reprinted by permission of the editor of *Poetry* and by permission of Louisiana State University Press from *The Private Life* by Lisel Mueller, copyright © 1976.

Michele Murray, "At Sixteen." From *The Great Mother and Other Poems*. Copyright © 1974 by Sheed and Ward, Inc. Reprinted by permission of the publishers.

Holly Near, "It Could Have Been Me." From *Words and Music* by Holly Near and Jeff Langley. Copyright © 1974, 1976 by Hereford Music. Used by permission of Holly Near.

Holly Near, "You Bet." Excerpted from "You Bet" by Holly Near (lyrics) and Meg Christian (music). Copyright © 1978 by Hereford/Thumbelina. Used by permission of Holly Near and Meg Christian.

Linda Pastan, "Emily Dickinson." From A Perfect Circle of Sun. Copyright © 1972 by Linda Pastan. Reprinted by permission of The Swallow Press, Inc., Chicago.

Marge Piercy, "Looking at Quilts." Copyright © 1974 by Marge Piercy. Reprinted from Living in the Open by Marge Piercy, by permission of Alfred A. Knopf, Inc.

Bernice Reagon, "In Our Hands: Thoughts on Black Music." Originally published in Sing Out. Copyright © 1976 by Bernice Reagon. Reprinted by permission of the author.

Bernice Reagon, "There's a New World Coming." Words and music by Bernice Reagon. Copyright © 1975 by Bernice Reagon. Used by permission.

Adrienne Rich, "Prospective Immigrants Please Note." Reprinted from Snapshots of a Daughter-in-Law, Poems 1954–1962, by Adrienne Rich, with the permission of W. W. Norton & Company, Inc. Copyright © 1956, 1957, 1958, 1959, 1960, 1961, 1962, 1963, 1967 by Adrienne Rich Conrad.

Adrienne Rich, "Your small hands," from "Twenty-one Love Poems." Reprinted from The Dream of a Common Language, Poems 1974–1977, by Adrienne Rich, with the permission of W. W. Norton & Company, Inc. Copyright © 1978 by W. W. Norton & Company, Inc.

Wendy Rose, "Native American Studies, University of California at Berkeley, 1975." Copyright © 1977 by Wendy Rose. Originally published in Phantasm, vol. 2, no. 2, and reprinted in The Next World, Crossing Press. Permission of the author and the editors of Phantasm and Crossing Press.

Muriel Rukeyser, "Käthe Kollwitz," Copyright © 1968 by Muriel Rukeyser. Reprinted from her volume The Speed of Darkness by permission of the author and Monica McCall, International Creative Management.

Muriel Rukeyser, "Wherever." Copyright © 1973 by Muriel Rukeyser. Reprinted from her volume Breaking Open by permission of the author and Monica McCall, International Creative Management.

May Sarton, "Journal of a Solitude." Selections reprinted from Journal of a Solitude by May Sarton, with the permission of W. W. Norton & Company, Inc. Copyright © 1973 by May Sarton.

May Swenson, "The Centaur." From To Mix with Time, Charles Scribner's Sons. Copyright © 1963 by May Swenson. Reprinted by permission of the author.

Margaret Tafoya, "A Pueblo Woman's Heritage." From Seven Families in Pueblo Pottery, collected and assembled by Rick Dillinghmam. Copyright © 1974 by The Maxwell Museum of Anthropology, University of New Mexico. Reprinted by permission of The University of New Mexico Press.

Diane Wakoski, "Medieval Tapestry and Questions." Copyright © 1966 by Diane Wakoski, from Trilogy by Diane Wakoski. Reprinted by permission of Doubleday & Company, Inc.

Alice Walker, "Everyday Use." Copyright © 1973 by Alice Walker. Reprinted from her volume In Love and Trouble by permission of Harcourt Brace Jovanovich, Inc.

Ingrid Wendt, "Dust." Copyright © 1978 by Ingrid Wendt. Originally published in Calyx. Reprinted by permission of the author.

Jessamyn West, "The Vase." Copyright © 1945, 1973 by Jessamyn West. Reprinted from her volume The Friendly Persuasion by permission of Harcourt Brace Jovanovich, Inc.

Ruth Whitman, "The Divided Heart." Copyright © 1974 by Radcliffe College. Reprinted with permission from Radcliffe Quarterly.

Jade Snow Wong, "She Finds Her Hands." Excerpted from Fifth Chinese Daughter by Jade Snow Wong. Copyright © 1975 by Jade Snow Wong. By permission of Harper & Row, Publishers, Inc.

Jade Snow Wong, "No Chinese Stranger." Excerpted from No Chinese Stranger by Jade Snow Wong. Copyright © 1945, 1948, 1950 by Jade Snow Wong. By permission of Harper & Row, Publishers, Inc.

Virginia Woolf, "Shakespeare's Sister." Excerpted from A Room of One's Own by Virginia Woolf. Copyright © 1929 by Harcourt Brace Jovanovich, Inc.; copyright © 1957 by Leonard Woolf. Reprinted by permission of the publisher.